AMERICAN CHOPPER

AT FULL THROTTLE

AS SEEN ON

Discovery CHANNEL ®

entertain your brain ™

MEREDITH® BOOKS
DES MOINES, IOWA

AMERICAN CHOPPER AT FULL THROTTLE

Writer: Mike Flaherty
Editor: Larry Erickson
Art Director: Mick Schnepf
Contributing Designer: Matthew Eberhart
Principal Photographer: Dino Petrocelli
Cover Photographer: Robert Jacobs
Contributing Photographers: Eric Larson/Getty, David Surowiecki/Getty
Copy Chief: Terri Fredrickson
Publishing Operations Manager: Karen Schirm
Book Production Managers: Pam Kvitne,
 Marjorie J. Schenkelberg, Rick Vonholdt, Mark Weaver
Contributing Researcher: Jay Wagner
Contributing Video Editor: Tim Abramowitz
Contributing Copy Editors: David Krause, Jane Woychick
Contributing Proofreaders: David Craft, Gretchen Kauffman
Editorial Assistant: Renee McAtee
Contributing Editorial Assistant: Janet Anderson
Edit and Design Production Coordinator: Mary Lee Gavin

MEREDITH· BOOKS

Editor in Chief: Linda Raglan Cunningham
Design Director: Matt Strelecki
Managing Editor: Gregory H. Kayko
Executive Editor: Benjamin W. Allen

Publisher: James D. Blume
Executive Director, Marketing: Jeffrey Myers
Executive Director, New Business Development: Todd M. Davis
Executive Director, Sales: Ken Zagor
Director, Operations: George A. Susral
Director, Production: Douglas M. Johnston
Business Director: Jim Leonard

Vice President and General Manager: Douglas J. Guendel

MEREDITH PUBLISHING GROUP
President: Jack Griffin
Senior Vice President: Bob Mate

MEREDITH CORPORATION
Chairman and Chief Executive Officer: William T. Kerr
President and Chief Operating Officer: Stephen M. Lacy

In Memoriam: E. T. Meredith III (1933–2003)

All of us at Meredith Books are dedicated to providing you with information and ideas to enhance your life. We welcome your comments and suggestions. Write to us at:
Meredith Books, New Business Development Department, 1716 Locust St., Des Moines, IA 50309-3023.

If you would like to purchase any Meredith Books home, family, or lifestyle titles, check wherever quality books are sold. Or visit us at: meredithbooks.com

AMERICAN CHOPPER BOOK DEVELOPMENT TEAM
• Craig Piligian, Executive Producer, Piligian Films
• W. Clark Bunting, Executive Vice President,
 Discovery U.S. Networks
• Jane Root, General Manager, Discovery Channel
• Judy Plavnick, Executive Producer, Discovery Channel
• Sean Gallagher, Director of Program Development,
 Discovery Channel
• Sharon M. Bennett, Senior Vice President,
 Strategic Partnerships & Licensing
• Deidre Scott, Vice President, Licensing
• Carol LeBlanc, Vice President, Marketing & Retail Development
• Jeannine Gaubert, Graphic Designer, Licensing
• Erica Jacobs Green, Director of Publishing

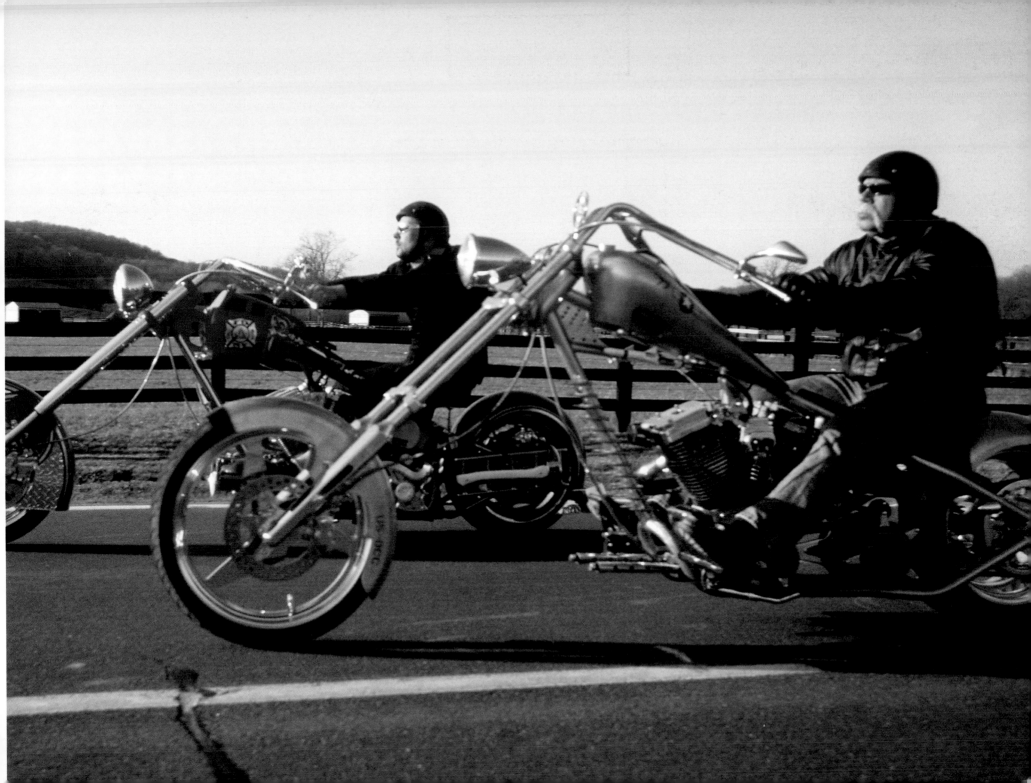

Contents

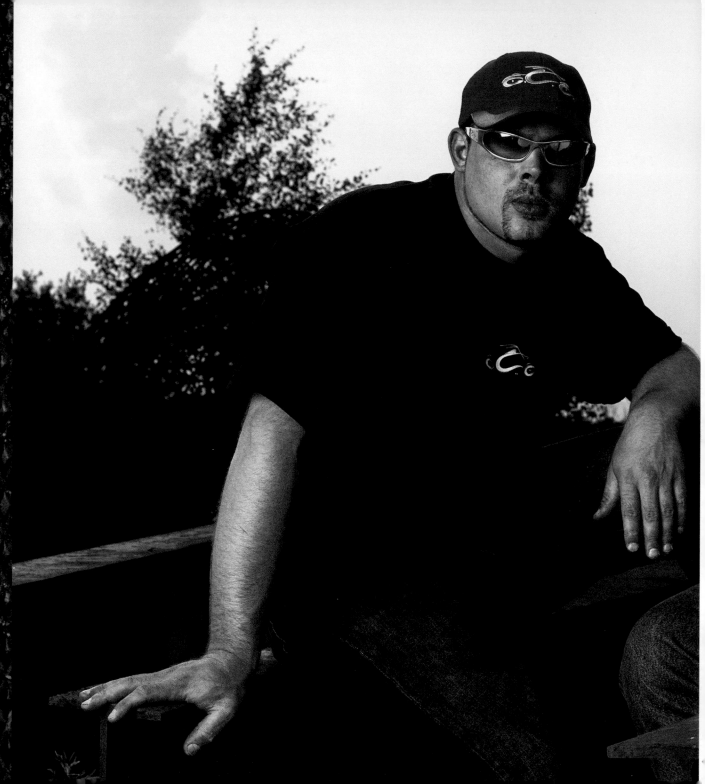

The Rush 6

Chopper Culture Goes Primetime
American Chopper represents a mainstream phenomenon.

The Show 16

Backstage Pass
Get the inside story to learn how episodes are created.

The Gear 28

Some Assembly Required
An arsenal of amazing machines makes chopper-building possible.

THE GUYS

38

SIMPLY IRRESISTIBLE!

Get even better acquainted
with the characters on the series.

THE BIKES

66

BOUND FOR GLORY!

Take a closer look at the bikes
and the episodes that featured them.

Jet Bike
Black Widow Bike
Fire Bike
Old School Chopper
Comanche Bike
Mikey's Bike
Tool Bike
Christmas Bike
Football Bike
POW/MIA Bike
Liberty Bike
Dixie Chopper Bike
Mikey/Vinnie Bike

THE RUSH

CHOPPER CULTURE GOES PRIMETIME

Sure, they built a jet fighter-inspired bike that celebrates American air power, a bike that saluted servicemen, and a two-wheeled tribute to the Statue of Liberty, but the most All-American thing about the Teutuls and AMERICAN CHOPPER may be the story of their rise from obscurity to megastardom.

Think of it: One day you're the proprietor of a hardworking metal shop, down in your basement tinkering with motorcycle parts. Before you know it, your hobby has turned into a business; the goings-on in your shop are being captured on videotape; that videotape is hammered into a television series that, in turn, becomes a fixture in Nielsen's cable top ten; AMERICAN IRON magazine ranks your chopper-building expertise among a dozen of the world's finest; demand for related

merchandising sparks a megabuck ancillary industry; you're dealing with pop stars (Wyclef Jean, Joe Perry), pro athletes (Roy Jones, Davis Love III, Bernie Williams), superstar actors (Ewan McGregor, Keanu Reeves, Will Smith), even your own personal American idol—the Easy Rider himself, Peter Fonda. And, oh yeah: You become role models and sex symbols.

If all that weren't enough to certify that we're dealing with something B-I-G, AMERICAN CHOPPER has reached a level of celebrity normally reserved for movies and network series: America is on a first-name basis with the show and its unlikely stars.

Star Search

AMERICAN CHOPPER grew out of an improbable, almost magical sequence of events. The Discovery Channel, having had some success with motorcycle documentaries, went in search of an East Coast base for a new series. They put reality-TV whiz Craig Piligian (SURVIVOR) in charge of the search.

The original idea was to have a motorcycle builder go to a junkyard, pick up a totally junked-out bike, restore it, and enter it in a contest at the Laconia bike show.

Piligian eventually found what he thought was the perfect prospect in a New Hampshire garage. They prepared papers, assembled a film crew, and set up a shooting schedule. Then, a couple of days before the cameras were to roll, Piligian realized he'd made a fundamental error: "By the fifth conversation with him, I said

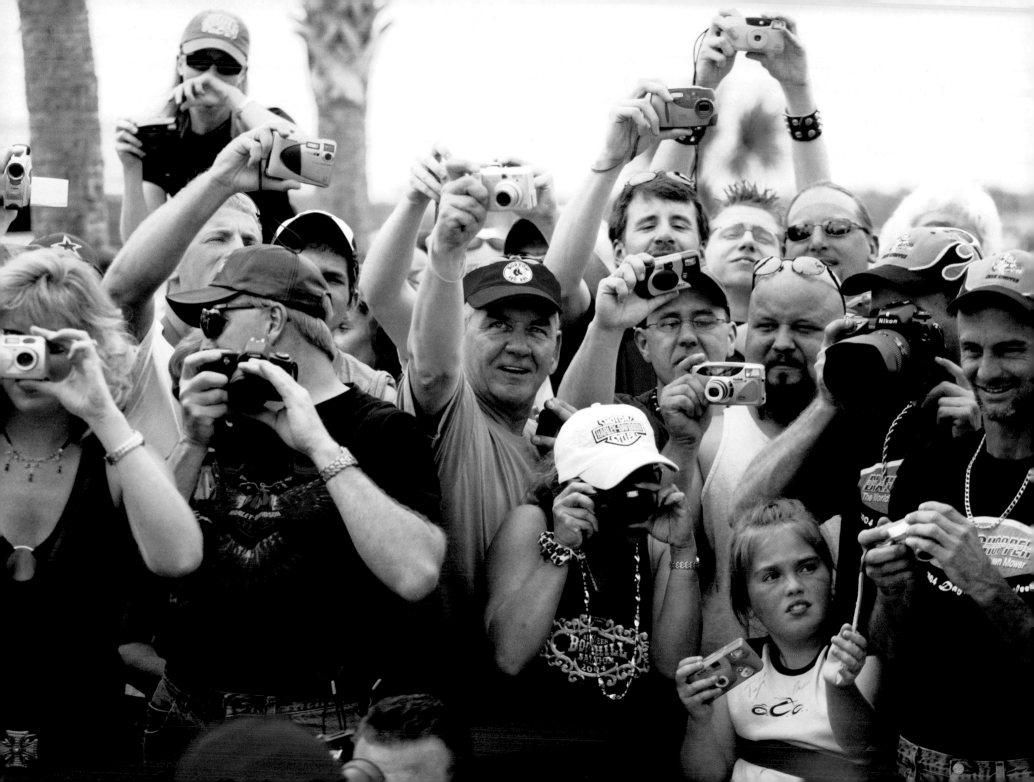

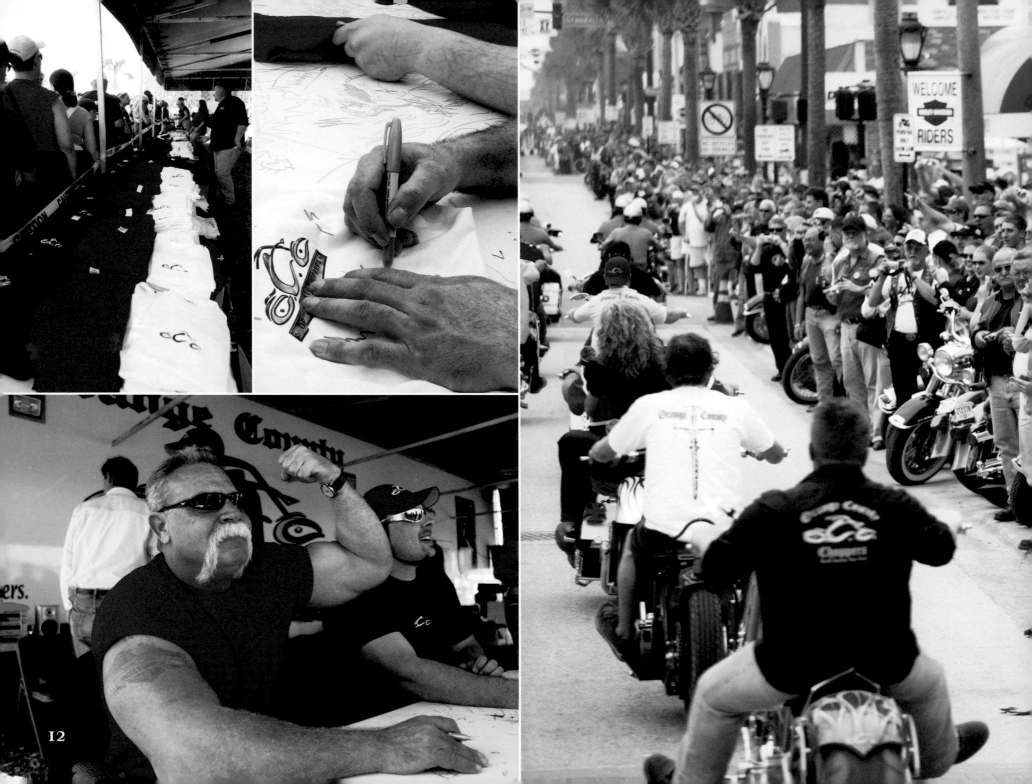

to myself, 'I got the wrong guy,'" he recalls. Their would-be protagonist, it turns out, was an accomplished mechanic but lacked broad experience in fabrication.

A replacement was needed, and fast. Piligian then remembered a father-and-son team from New York that he'd spoken with about a month earlier. They had an interesting look on their website, but as he recalls, "it seemed like they were busy."

The second time, however, was the charm: Piligian's Wednesday-morning phone call to Orange County Choppers found the Teutuls gruffly interested, so he contacted his L.A.-based crew, had their plane tickets changed from New Hampshire to New York, and scheduled shooting to commence that Friday.

Change of Plan

It did, but there was a snag: The Teutuls rejected the original premise of the show! Instead of rehabbing a junked bike, they said they'd make an original creation from scratch, a "jet bike." Even though Piligian had a "concept paper" from Discovery, there was no time to quibble, and he went along with the Teutuls' suggestion, changing the concept of the new program.

Another, more profound surprise came when Piligian got a gander at the raw footage that was coming from the OCC garage. "I'm going 'Whoa, this really isn't about building a bike. It's about the old man and his relationship with the kid,'" he says. "All they did was argue!

They were just raw." Most important, from a reality-TV perspective, he adds, "they lost track of the camera on day two."

Having struck gold, Piligian recalls, "we made the decision to put the weight of the show on the relationship and put the [bike-building] process in second position."

Back at Discovery, the network's Director of Program Development, Sean Gallagher— who would have to sign off on the now twice-tweaked concept—had reason to be concerned when he saw the first few minutes of footage; the rough cut was lacking in process shots.

"But then all of a sudden I started seeing the father-son bond, and then a huge argument," he says. "I mean, in your face! I was thinking, 'Oh my God! This is awesome!' and at that moment I said, 'It's not about the bike.'

"It was just a one-off," Gallagher remembers, "but when I went back and looked at all the dailies, I thought, 'Man, this is basically our version of THE OSBOURNES.'"

Boom-Boom-Boom

Discussion of a series began immediately, with Piligian suggesting a big-picture view: "The series is going to be like THE PRACTICE. It's a serial, a soap opera. Yeah, it'll culminate every two or three shows with a bike, but the real story never ends." Hence Piligian's term for CHOPPER's cutting-edge form: "dramality."

The debut of the "Jet Bike" pilot on September 29, 2002, scored big ratings with scant promotion. "Every quarter hour it was just

boom, boom, boom, boom—it went up and up and up," Piligian says.

One important viewer, however, was less than impressed by the on-screen scrapes. "The next morning, Paul Sr. went ballistic on me," Piligian recalls. "He thought we ruined his life, his work, that I made a mockery out of him, that they looked stupid in the industry."

As Paul Teutul Sr. recalls, "We were really upset to see that we were conducting ourselves like that on national TV."

Then the public response began. By noon the following day, OCC and Discovery had received thousands of glowing e-mails, Piligian says, and the Teutuls got hundreds of phone calls. Approval like that has a way of changing even stubborn Senior's mind.

"We felt one way, but the fans felt a different way," he admits. "We were getting real positive feedback and there was a lot of identification— you know, from other families."

And therein lies the proverbial X-factor that sets CHOPPER so far apart from other reality-TV fare. "Nobody's got [backbone] enough, or nobody's stupid enough, to expose themselves that way," Senior says of his and Paulie's bracing openness. For someone such as himself, he adds, "It could be a sign of weakness. A tough-guy biker is not gonna allow that to happen."

Because the Teutuls allow such personal exposure, says Piligian, "the elements of the show on many levels are subtle and very relatable. Anyone can sit and watch CHOPPER—male, female, old, young—and there's a moment in that 45 minutes where they say, 'Oh my God, that's my dad. I remember that.' Or if a father watches it with his son, it's like 'Boy, I act like that sometimes.' It is true family dynamics."

Senior has heard from the show's fans and readily agrees: "There's a lot of identification out there because we're not any different than most families."

> « It's all about passion, and how much we care about each other, that drives everything. »

A Price to Pay

Despite all the practice he's had with on-screen soul-baring, Paulie says there's a price to pay. "It's hard to be in front of the camera sometimes," he admits. "It's imposing and very personal."

The constant camera coverage has led to a misconception that the Teutuls are a dysfunctional family. To the contrary, Paulie insists, the free expression represents an air-clearing openness that's nothing but healthy.

"We come from a background of knowing that when you share your problems with other people, it's helpful," he explains. "People are inspired by what we do. The show is so much about how it affects people's lives, and we're very tuned in to that."

Following a second pilot in January of 2003, AMERICAN CHOPPER: THE SERIES made its debut on March 31, 2003, with the saga of the Black Widow Bike. The show's fame had been skyrocketing and, originally, strangely covert; a cult-like following spread not by the usual channels of advertisement and on-air promotion but by giddy word of mouth.

In an astonishingly short time, the trappings of stardom became evident. Paulie's first taste, he says, came that May at the Louisiana Motorcycle Expo in New Orleans, where he and his pop were "mobbed" by fans.

Mid-June brought the Teutuls' first late-night exposure with an appearance on CBS's LATE SHOW with David Letterman. The following month, Gallagher recalls, Discovery flew them out to the annual Television Critics Association press tour in Los Angeles. After leaving an L.A. restaurant, Paulie says, "We couldn't walk down the street without every third person stopping us"—to shake their hands, get autographs, or to say "I love you guys."

July also saw the Teutuls' initial guest spot on THE TONIGHT SHOW with Jay Leno. They would go on to become a favorite attraction for Leno, a motorcycle fanatic.

Sort of a Thrill

"We don't have too many guests that are interested in motorcycles," Leno said. "Usually it's 'Jay, we're gonna play some theater charades later. Do you want to come?' So to have somebody on the show that actually likes them as much as I do is sort of a thrill."

As the year wore on, there were tons of motorcycle-mag covers (four for AMERICAN IRON alone), and then the mainstream publications came calling: ENTERTAINMENT WEEKLY, ROLLING STONE, TV GUIDE, FHM, and countless newspapers, among them the NEW YORK POST, the WASHINGTON POST, New York's NEWSDAY, BOSTON GLOBE, NEW ORLEANS TIMES-PICAYUNE, DALLAS MORNING NEWS... Then more key TV appearances: THE DAILY SHOW with Jon Stewart, LAST CALL with Carson Daly, and Leno again.

To cap off that incredible year, the AMERICAN CHOPPER holiday special would garner over 3 million viewers, the show's best rating yet—a certified lollapalooza in the world of cable television.

Pitchmen

In a January 2004 interview with TIME OUT NEW YORK magazine, Senior crowed, "We're so marketable, we could sell ice to the Eskimos." It was no empty boast; the Teutuls' first product endorsement would bring them to the pinnacle of television advertising: a commercial during the Super Bowl. Not just appearing in a one-time deal, the Teutuls (including Mikey, who quickly emerged as a star in his own right) were cast in a hilarious six-spot campaign for the internet giant America Online.

For Derek Koenig, AOL's vice president of Advertising in Brand Management, the Teutuls were a fresh but obvious choice. "When you go into the Super Bowl, you have to go in with your best game, something that is pretty mainstream and right on the precipice of pop culture," he explains. "They're about as American as you can get—entrepreneurs who build motorcycles out of their own garage. When you think of AOL as being an Americana brand, it was a great fit for us."

Six months later, Paulie still can't quite believe it happened. "I don't know if I fully appreciate it," he says. "It's like everything else we've done—it went from ground level through the roof. The first thing we wanted to do was a commercial, and it doesn't get any bigger."

Small-Town-Minded

With the show's new season in full swing, Paulie is grateful not only for his success but for the support that has allowed the CHOPPER guys to ride the star-making roller coaster without losing themselves in the process.

"Fortunately, we're so small-town-minded, such genuinely good people, that it's not hard," he says. What is difficult, he adds, is balancing likability and self-preservation—an ability that was tested at 2004's Daytona Bike Week, when throngs clamored for a face-to-face hello.

"You have to be your normal nice self who's willing to talk to anybody," Paulie says. "On the other hand, you have to be the person who knows when to tell people to back off."

Mikey agrees: "It's nice to have Cody, Vinnie, and my father and brother to share the fame with, to keep you grounded." He adds, "It's probably very lonely to be famous by yourself." Among the Teutuls' company these days is a complement of security guards.

Their daily schedules are fast becoming as crowded as their Biketoberfest display booth. "That's the hardest thing to deal with right now," says Paul Sr. "Just trying to accommodate all the stuff that's being presented to us."

But as Paulie is quick to assure you, don't expect them to "go Hollywood" anytime soon. "At the end of the day," he says confidently, "people out there know that it's all about passion, and how much we care about each other, that drives everything."

THE ROAD

A LONG, STRANGE TRIP ✦ FROM FRANCE TO ORANGE COUNTY

The newest bikes on AMERICAN CHOPPER have a long heritage.

Although the first contraption to feature two wheels and an engine appeared in France back in 1868, it was in the United States that this "iron horse" really came into its own. In both form and function, the motorcycle embodied the American values of autonomy, speed, and adventure.

In hindsight, early-20th-century motorcycling seems downright genteel: countryside tours on essentially motorized bicycles. Early racing clubs featured riders in stylish jodhpurs and flowing white scarves.

The roots of the chopper lie in the 1930s, in a bike called the bobber. Its name came from the practice of bobbing (chopping off) stock parts in an effort to increase speed by reducing weight. If, along the way, the leaner bike became meaner looking, well, so much the better.

"The idea was you didn't want it to look like your dad's or your grandfather's Harley," notes Chris Maida, editor of AMERICAN IRON magazine. Bobber riders, Maida adds, were "a little hell-bent for leather, and determined to have some fun."

That sense of adventure appealed to GIs returning from World War II. With modest means but a surplus of kitchen-sink ingenuity, they stripped down and souped up their Indians and "Hogs," willfully running afoul of the American Motorcycle Association's regulations. Their transgressions spurred the rise of "outlaw" clubs with names like the Boozefighters, the Galloping Gooses, and the Coffin Cheaters (the term outlaw originally denoted bikers who simply favored desert riding).

Bike culture continued to gather steam in the 1950s, fueled by postwar prosperity, a new, boisterous soundtrack of rock and roll, and a burgeoning youth market. Those elements would erupt in the blaze of rebellion, psychedelia, and social upheaval that was the '60s. The open road was seen anew as a path to self-realization. From that decade's anything-goes cultural whirlwind, the modern concept of a chopper emerged. It raised the stakes in motorcycle design with long forks, sissy bars, jump seats, "ape hanger" handlebars, and pop art paint schemes. Expression, not performance, was the overriding goal.

"It's like a woman in six-inch stiletto heels," says Maida. "Looks great, looks sexy, but don't expect her to run fast." That was a '60s chopper.

In the '80s, the chopper's cachet diminished. Its footloose reputation had caught up with it, and consumers were opting for better-handling, less ostentatious bikes.

By century's end, however, a renaissance was on the horizon. A newly humming economy was flush with disposable income. This time around, the chopper had a dual following: mature baby boomers who finally had the time and money to buy the choppers they could only long for in their youth, and nostalgic Gen Xers, for whom everything old was new again.

Along the way, the chopper shed some of its political baggage and its unsavory reputation and it gained some technological advances. Its rebirth has been greatly aided by computer engineering and new sources of custom parts. Today's most idealized choppers are most often custom bikes rather than worked-over stockers.

Paul Teutul Sr. and Paul Jr. stand as living, breathing, battling symbols of the chopper's two lives: a grizzly '60s survivor with a few tricks still up his sleeve; and his protégé, a Young Turk striving to take an inimitable creation to new artistic heights.

THE SHOW

Backstage Pass

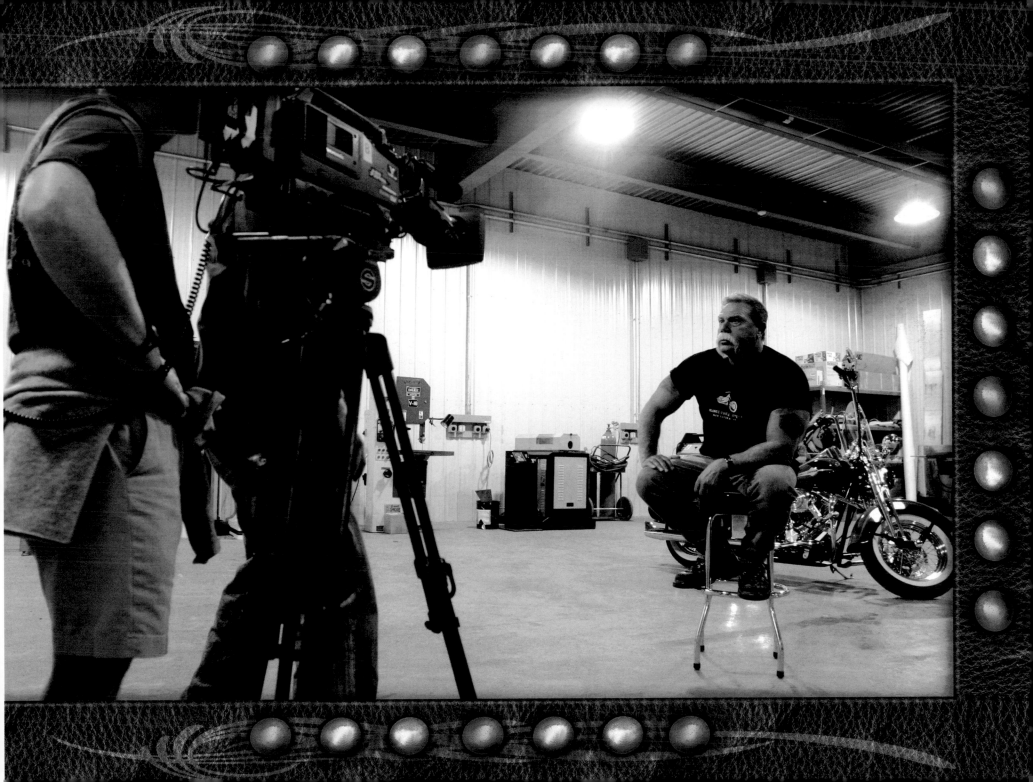

"LIGHTS! CAMERA!...
AGGRAVATION!!!"
IF ONLY IT WERE
THAT SIMPLE. TAKE
A PEEK BEHIND
THE SCENES AT
THE MAKING OF
AMERICAN CHOPPER.

Reality happens every day. That's life. But it doesn't necessarily make good television. The goal in creating AMERICAN CHOPPER was to find riveting characters, put them in difficult situations, and have camera crews in place to record how they would play the cards they were dealt—then layer on the artistry of beautiful custom motorcycles.

Sounds easy, huh? Well, yes and no, at least in the case of AMERICAN CHOPPER. The key, however, is to make it look easy. And that's the job of Pilgrim Films, the show's production company. On a regular schedule, Pilgrim descends on the placid burg of Rock Tavern, New York, to explore the art and science of motorcycle fabrication and observe the family Teutul in its natural habitat.

And there's lots of observing. Each episode of CHOPPER is the product of several weeks of shooting; roughly 50 hours of footage is whittled down to 45 minutes. Why such a lengthy shoot? "Because in a few weeks, life changes," explains the series' creator and executive producer, Craig Piligian. The appeal of the show, he says, depends on the Teutuls evolving along with their bike projects: "You must let drama unfold, and that's the schedule that allows us the drama."

Two-Story Building

Every CHOPPER episode contains two stories, a sort of "before and after." First, of course, is the predetermined, official storyline that chronicles the creation of a particular theme

bike. The Teutuls themselves pioneered that framework in the show's first hour when they dismissed the original concept of restoring a junked bike.

"We had to figure out how to structure the show. What was the endgame for us?" Piligian recalls. "So we figured the bike was the one thing we could latch onto, the catalyst that perpetuated everything. Would the bike get done? Would the paint job be good? Are we gonna be missing parts?

"That's the reason there's tension," Piligian adds. "We use the bike as a character."

Then there's the episode's secondary plot or subtext—usually based on the drama surrounding the Teutuls' clashes. This second storyline becomes apparent once the shooting is wrapped, Piligian says.

He cites classic television history to describe the process that follows: "I look at it like those old '50s shows. They always had one scene: Lucy gets a job. Ricky loses his guitar. Ralph Kramden finds a suitcase full of money." In the case of AMERICAN CHOPPER, Piligian says, "it's, 'What's this show about? Paulie's late? The bike parts are missing? The shop isn't cleaned up?'"

The show's more personal storylines provide much of each episode's comedy and drama. They also contrast nicely with the bike fabrication in that they often involve ongoing, open-ended conflicts—the aggravation continues long after the chopper is unveiled. Viewers are drawn into the drama and return to follow the family tension. In that extended serialization, Piligian believes CHOPPER broke new programming ground.

More conventional reality shows tend to focus on a process and wrap up their story within each episode, Piligian says. With AMERICAN CHOPPER, "life goes on."

Running Shoes

For the production crew, catching that golden, serendipitous footage is what frays nerves and wears out soles.

"There's some very organic moments that happen," says supervising producer Steve Nigg. "These guys are highly volatile—maybe 'spirited' would be a better word—so we're always scrambling to get the shot." That being the case, he adds, "we try to put all of our cameramen in running shoes."

> **"When he starts yelling at you as soon as you get there, it's a good day... he's getting it out of the way. If you don't hear anything, something's creeping up on you and you're going to be taken out."**

It's a combination of quick feet and quick thinking that puts the cameras in the right place at the right time. Some of that thinking comes in careful planning; some involves getting into the rhythm of the shop work, anticipating the action and staying out of the way.

"When they're filming and you're just doing your job," Paul Sr. says, "you don't even know that they're there."

As his title implies, Nigg oversees the crew that expanded with the start of season two. More people were needed for AMERICAN CHOPPER to make the leap to high-definition taping. They now use a three-camera shoot; only two cameras were used to capture the show initially.

"We have a wide-angle to catch our master shots," Nigg explains, "and a regular camera to just 'punch' and get a lot of the reaction shots." And he's talking a very wide angle: The series is now shot in a widescreen format (known in the industry as 16:9, or anamorphic, ratio).

Filming in high-definition can only add to the show's unstaged look, because it requires even less light than when it was shot on regular "DV cam." Says Nigg: "It's so much more realistic. The high-def picks up on the skin tones so much better than the regular stuff does." In fact, he adds, with the new format, "if you light it, it looks too good, too much like a movie."

The show's prominent upgrade to HDTV is a kind of reward for its success, according to Nigg. "This is Discovery's number one show,

and it's only growing," he says. Adding the third camera and expanding the crew reflects the show's growth in stature and technology.

The Shoot

A typical shooting day begins when the OCC mechanics and fabricators arrive at 7 a.m. One of the first orders of business is to gauge the mood of the show's subjects.

"It's like approaching the sleeping dog... especially with one of the Teutuls," Nigg says. "When he starts yelling at you as soon as you get there, you know it's going to be a good day because he's getting it out of the way." Conversely, he adds ominously, "If you don't hear anything, something's creeping up on you and you just don't know when you're going to be taken out."

Assuming a "good" and normally productive day, says associate producer Brian O'Banks, "We'll take a break before lunch, go over all the morning's events, and do interviews with everyone who was involved." The shoot-review-interview process is repeated through the afternoon and often well into the evening.

About those interviews: O'Banks is referring to "stand-ups," the confessional-esque recordings in which the Teutuls and others in the gang at Orange County Choppers comment on the action that's just happened or introduce an upcoming turn of events. Their most practical purpose is to fill in storyline gaps, a function that became even more

important after the second pilot episode ("The Cody Project"), when the show dispensed with its narrator. In effect, the Teutuls took over that role... some more readily than others.

Ask Paul Sr. how he feels about having cameras around him all the time and, even all these episodes later, he'll confess that the interviews can be "nerve-wracking."

Nigg praises Paulie, in contrast, as "the Bitemaster," able to issue pithy, concise, on-camera reflections with little effort. But Nigg says it wasn't always that way: "He told me that during the first season he was so much in his head, trying to think of how he was being portrayed and what he was going to say, that his voice lowered and he got real soft."

That's certainly changed, says Nigg, as he imitates Paulie's eventual, smooth signature style: "You know, I gotta be honest with you..."

And then there's Mikey, the show's dependably undependable wild card. "He is so funny and gregarious and willing to do just about anything to get a laugh that you have to be on your feet," says Nigg. "Behind the camera, I find myself laughing when he does something, and I have to bite my lip and walk away a little bit so I don't step on what he's doing." Alone among the CHOPPER "cast," Mikey will directly address the camera at any point in a scene, happily engaging the TV audience in what Nigg describes as a "Ferris Bueller moment." Subversive and hilarious.

"Everyone has their place in the show," Nigg

sums up. "Senior is like the business maverick; Junior, he's an artist, and his talent sort of carries [the business]; and Mikey's the one who's probably going to end up doing something for television someday."

Real Fireworks

The $64,000 Question for any reality show is, Is it accurate? Or in CHOPPER's case: Can the Teutuls' fireworks be for real? OCC mechanic Christian Welter replies without hesitation: "It really is. It may be exaggerated at times, but I think that's the initial reason they got the show," he says of the sparring Pauls. "It's a father yelling at his son—people are attracted to that kind of thing, and pretty much everyone can relate to it."

Teutul protégé Vinnie Dimartino is close enough to the fireworks to get burned. Reality? "It's more similar than people think," he says. "Senior's gonna freak out—whether the camera's here or not. A lot of people think that's put on for the show, but it's not."

In fact, Vinnie is still smarting from an all-too-real incident when a fed-up Senior followed through on his threat to send him home without pay if the shop wasn't sufficiently tidy. With that, Vinnie followed him outside, hoping to reason with the big dog in private. No chance.

"I hate seeing that scene," Vinnie says.

Sure enough, a fleet-footed cameraman made sure that the chagrined mechanic wound up pleading his case to Senior in front of a national television audience.

"If I get into a fight with my boss, which everybody does at some point, I don't want everybody to see it, nor do I want it to be on camera," Vinnie laments. "What do you do in that predicament? I can't say [to the production crew], 'Hey, get out of here,' so we ended up talking it through."

Wrangling

It bears remembering that the term "reality TV" is shortened from the genre's original moniker: reality-based TV. Taken literally, the

only pure reality TV comes from a surveillance camera. Realistic? Sure. Boring? Absolutely.

So while the Teutuls don't wear makeup and there's no script as such, stories are put together methodically, scenes are planned, and chronology is sometimes tweaked.

"You get cameras in front of them and make sure they're shot properly," Nigg says of a typical setup. "We have to sort of explain, 'These things are going to be said, or these things are going to happen.' We have to know when, so we can be there for it."

Though fans might be surprised to learn that "Action!" and "Cut!" are heard during a CHOPPER shoot, Nigg defends the show's verisimilitude. "There's reality in the sense that it's going to happen; it's just that we have to time it so we can shoot it," he says.

Nigg obviously enjoys and respects the stars of the show. Still, he adds with a twinkle, "These guys are crazy. If we just let them run wild, it would be chaotic, so you have to wrangle them a little bit." Thus, when a scene

begins with Senior, Paulie, Vinnie, and Rick all entering the shop simultaneously, that's probably not a coincidence.

An Editor's Dream

"At the end of the day," Piligian maintains, "you've got to build a show; you've got to get your shots." Without any management of the action, it would take more like 500 hours of footage rather than 50 to create a sufficiently entertaining episode.

"You're prepared for things," says Vinnie. Gesturing to the clip-on microphone he wears, he adds, "You've got to put one of these on you, so you know something's gonna happen."

Then there's the saving grace of every reality show: editing. It became even more important after CHOPPER chose not to use narration. According to Piligian, every two weeks' worth of footage spends another eight weeks under the splicing knife. "It is an editor's dream," he says. "Some shows are created in the field; this show is created in post-production."

> ## " Reality? "It's more similar than people think," Vinnie says. "Senior's gonna freak out—whether the camera's here or not. A lot of people think that's put on for the show, but it's not. "

✝HE MOMEN✝

In one poignant, pivotal scene, headbutting gave way to heartwarming, and AMERICAN CHOPPER would never be the same.

For the men of Orange County Choppers, early 2003 was the winter of their discontent. The Teutuls were struggling to deal with newfound celebrity and increased business. And they were under the gun to complete yet another theme bike before an upcoming Cincinnati bike show. Stuck in a public cauldron with the heat quickly rising, the Pauls were at each other's throats. Something had to give, and it did when a fed-up Paulie finally declared, "I can't work like this anymore!"

Executive producer Craig Piligian recalls the moment well: "They had been arguing a lot—more than ever—and they had come to a realization: 'Is this our lives? We gotta talk about this.'" This time around, it was going to take more than an afternoon of bowling to let off steam, so they hunkered down in Pop's living room to hash things out... but got (and gave) much more than they'd bargained for.

It started predictably enough:

"You've gotta make an extended effort," Senior scolds, "and I've gotta be up your ass to make that happen."

Paulie isn't buying that. "Nothing you do motivates me," he counters. "None of your comments, or even your suggestions, get anything done any quicker."

They exchange a few typical barbs before Senior suddenly questions Paulie's example to the staff—and more personally, his loyalty:

"You're supposed to be part of the business with me, OK?" he demands, then shockingly slips into a misty-eyed confession: "I've already spent half my life building one business that took half the life out of me, and here I am again starting another business. I don't have it in me. You know? I can't do it all…"

Paulie appears as dumbstruck as viewers undoubtedly were by his dad's vulnerable plea and manages only an understanding "Believe me, I know" in response.

But Senior goes on: "I realize that you do a lot—but a lot of times when you're the only guy that I really think I can rely on… when you don't come through, it's like a smack in the face… 'cause I honestly feel like I'm by myself."

Visibly affected, Paulie responds quietly and sincerely. "We're from two different schools," he says. "I'm not you and you're not me.… I understand we both have legitimate gripes, but we have to find how to handle it better."

Having gone so far out on this unfamiliar emotional limb, father and son agree that a long, carefree vacation is in order. With that, they rise to profess their love for each other

and share a healing hug. Unblinking cameras catch it all.

Looking back on the landmark exchange, the Teutuls are still a little surprised. "When we sat down, we just wanted to talk; we didn't want to get emotional," Paulie recalls. "Do we look like criers? That's the last thing a guy wants to do. But things came up that were real deep. We were in a relaxed setting at my father's house, and it just came out the way it came out."

Piligian was pleasantly shocked by the unexpected outpouring. "It shows you how, by episode three, they had forgotten about the cameras, because you cannot just cry," he says. "It's heartbreaking, because you see the pain. The son's saying, 'Dad, this is not good for me,' and the father's saying, 'You don't respect me… I built this from nothing.'"

What a difference 4 minutes and 38 seconds makes. In the Teutuls' case, a single scene has added an entirely new dimension to characters that their audience had known simply as a pair of funny mechanics who fight a lot. They are forever humanized, their fans forever smitten.

"Neither one of us expected all that to happen," Senior reminisces, "but once it started, you couldn't shut it off."

Amen to that.

> « Neither one of us expected all that to happen, but once it started, you couldn't shut it off. »

THE GEAR

SOME ASSEMBLY REQUIRED

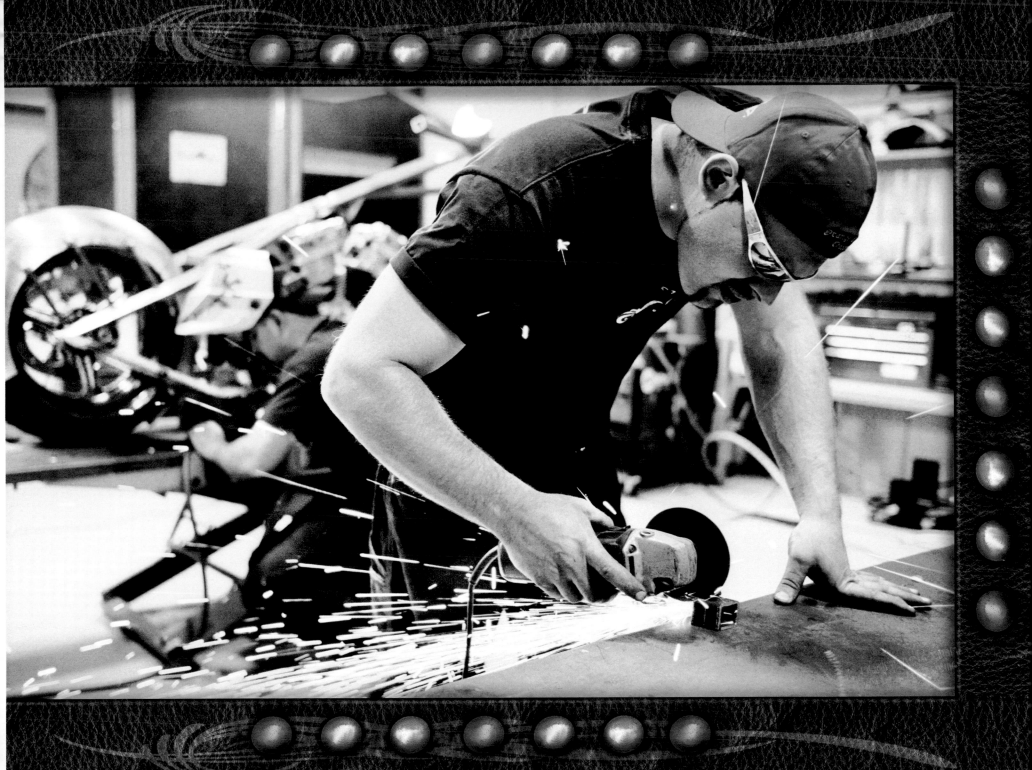

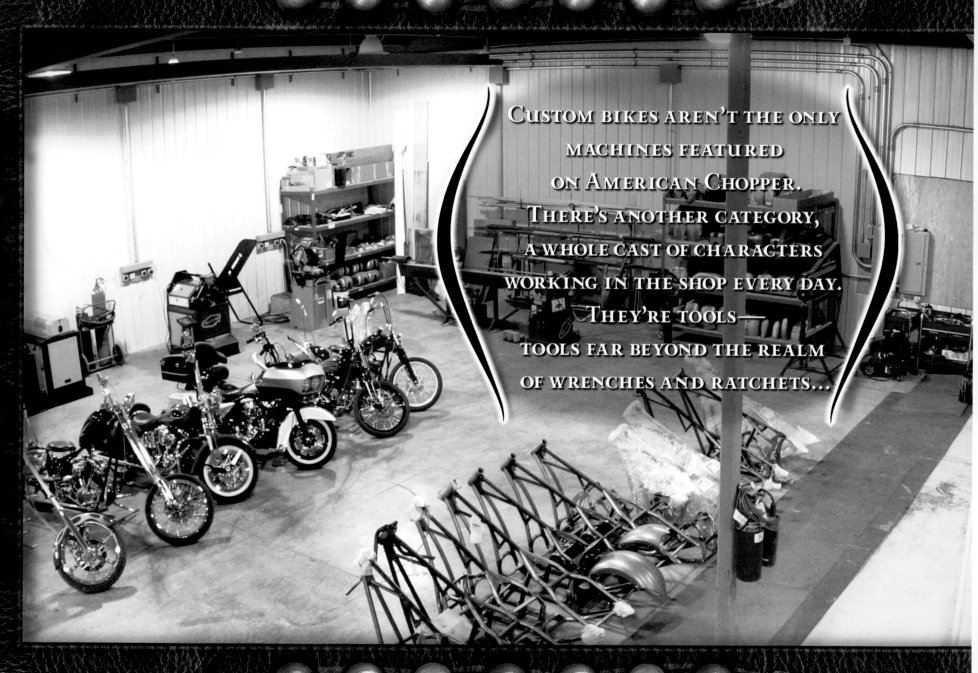

Custom bikes aren't the only machines featured on American Chopper. There's another category, a whole cast of characters working in the shop every day. They're tools— tools far beyond the realm of wrenches and ratchets...

Awesome in their size, power, and technology, these machines are the centerpieces of workstations

around the OCC shop. They expand the fabricator's capabilities and the designer's imagination. You've seen the guys arguing in front of them, toiling away on them, and turning away from them in frustration. But what exactly do all these things do, anyway?

Drill Press
One of the shop's most heavily used tools is also one of its most self-explanatory. Simply put, the drill press creates a hole in any kind of metal by pressing a drill bit into it. The hole is often then "tapped" to create threads. A manual crank controls the vertical movement of the quill, which holds the spindle, which holds the chock, which holds the drill bit. Got it? Good.

English Wheel
Reputed to be centuries old in origin, this metalworking device is actually two wheels: a large one with a flatter working surface that sits above a smaller one with a more visibly curved surface. How tightly the two clasp the metal between them determines the degree to which it will be stretched. OCC's Rick Petko has found the wheel indispensable for gas-tank fabrication. "It takes a long time and a lot of patience" to become proficient, he says, but once mastered, "you can get metal perfectly smooth like glass." A rare nonelectric machine, this wheel needs no reinventing. As Rick says, "Some things you just can't improve on."

Roller
Although it's capable of bending any kind of metal bar stock, Rick maintains that this roller (which resembles a ship's steering wheel) is best used for the flat or square variety. Round bar, he says, is likely to curve or kink. A bottlejack (akin to those compact little numbers you use when you change a flat tire on your car) applies pressure to the bar stock to be curved, which is then "rolled" through the apparatus. Aged, yes, but oh so dependable.

Cold Saw
When you need a precisely accurate cut on a piece of steel or aluminum—such as an axle spacer—Rick says the cold saw is the way to go. It's so named because a steady stream of coolant is sprayed on the interface between blade and part, which prevents sparking and the buildup of grit and soot on the blade. What it loses in speed—the circular blade moves remarkably slowly—it more than makes up for in overpowering torque.

Reducer/Expander
This electronic wonder comes in handy for exhaust fabrication. To attach two sections of pipe in a "slip joint," the end of one section must be expanded—stretched in diameter—in order to fit over the compressed (or "reduced") end of the other. The reducer/expander does it, says Rick, through sheer pneumatic force in the neighborhood of 25 tons. It's also capable of flaring, or "swaging," the end of a pipe to prepare it for attachment to a manifold.

Tube, Pipe, and Profile Bending Machine
Rick calls this a large version of the old-fashioned wheel roller. True, except the TPPBM is better at handling round bar, and it specializes in wider-radius bends, like those used in handlebar fabrication. Changing the position of the central roller (via digital programming, naturally) will tighten or loosen the bend radius. Ah, technology.

Mandrel Pipe Bender
One of the Teutuls' newer acquisitions, this elongated bender is a standby in muffler shops, says Rick. It's adept at creating tight, accurate corners for thin-walled metal, such as exhaust pipes. (A mandrel is a reinforcing metal shaft that fits inside the pipe to prevent kinking.) "It has a digital readout so you can program and make repetitious parts," Rick explains. Fabricating symmetrical pieces and mass-producing a particular bike type—à la Senior's signature Old School line—just got easier.

Stationary Band Saw
Ideal "for cutting just about anything," Rick says, this band saw features a heat-treated, flexible steel blade looped around two pulleys. The object to be cut is positioned on the affixed table. Although the blades generally last pretty long, Rick notes that, ironically, they get "eaten up" by softer metals like aluminum. And chrome? Fugghedaboudit.

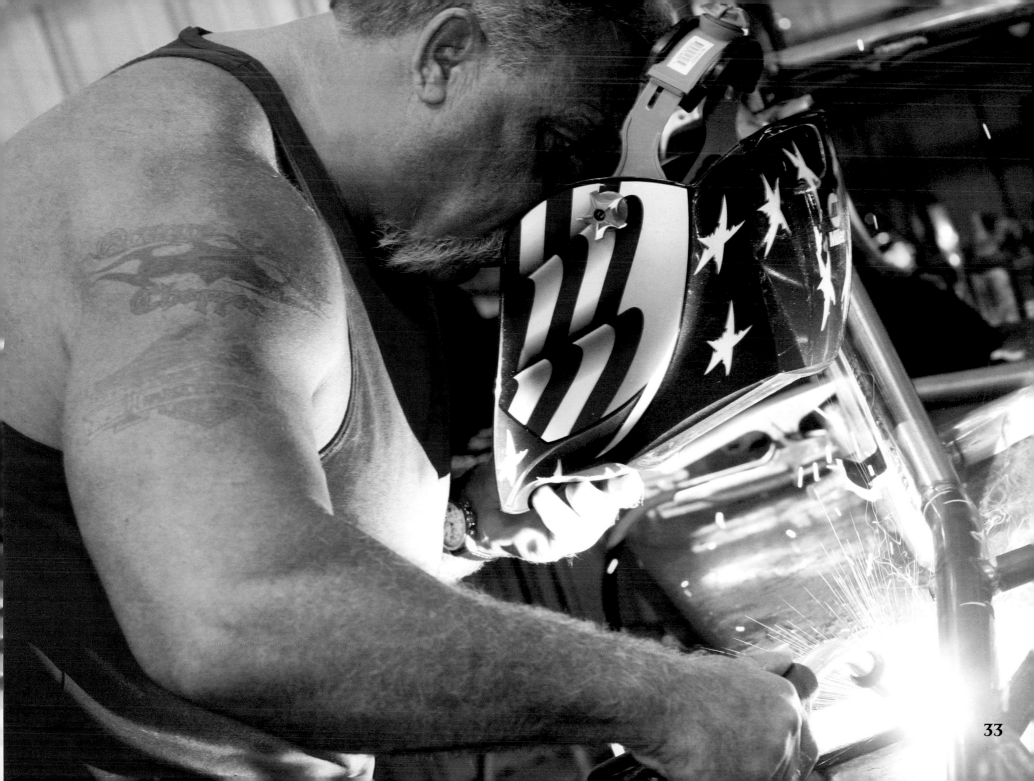

Integrated Flying Bridge
Also known as the "Flow Jet," OCC's most sophisticated electronic contraption is capable of precisely cutting elaborate shapes into metal (or nearly any other substance, for that matter). The amazing part? It does it all with water, combined with an acrylic abrasive and focused like a laser beam at a pressure of 40,000 pounds per square inch. Think of it as a computer-programmed, industrial-strength dentist's drill. "It makes me a little nervous," says Vinnie, the sole OCC'er trained to operate the "awesome" fabricator. "I feel like I can hit the wrong key and screw the whole machine up, which wouldn't make Senior too happy."

Horizontal Band Saw
As opposed to the stationary band saw (which in turn functions much like a jigsaw), this variation "is more or less for straight cuts," says Rick. And since its sawing element moves side to side, it can also make mitre cuts.

Belt Sanders 1,2
When the cutting and the bending are done, the action moves over to these babies, which grind down the ragged—and often dangerous—edges left behind by a saw's blade. They're identical, save for the type of abrasive installed on their belts. Strangely, Rick points out, the rough sanders' gnarly-looking surface "won't take down anything nearly half as quick" as its smoother-looking counterpart. The reason? "It's rougher, but it's softer," he explains.

Belt Grinder
For faster and more precise shaping, says Rick, this is the go-to machine. The small table fronting the grinding belt makes more exacting cuts possible. Attachments can form the belt's leading edge into a point and allow for tight-radius shaping.

Polishing/Buffing Wheel
No, it's not a shoeshine machine for Senior's size 12s; it's the final fabricating stop after you've cut, welded, ground, and sanded your stainless steel and aluminum creations. A dab of rubbing compound and a go-round on the fuzzy polishing/buffing wheel will leave 'em clean, smooth—and downright pretty.

Hydraulic Press
Raw, unyielding power—that's the name of the game here. "This is for pressing bearings into primaries or smashing something if you really need to," says Rick. The former definition sounds the more relevant, but Three Stooges fans, or those struggling with a particularly stubborn walnut, can let their imaginations run wild. Whatever your objective, this H-frame model can lend up to 50 tons of support. Heavy!

Milling Machine
In fact, it's a thoroughly modern milling machine, capable of creating slots, grooves, and all manner of angled depressions. It's all made possible by that table in front, which can be slid from back to front and side to side. That's the major feature that distinguishes this tool from a drill press; another is the special, ultra-hardened bits it uses, which can drive through solid steel. According to Rick, this particular Taiwan-manufactured model is about to be replaced with one made in America.

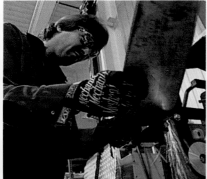

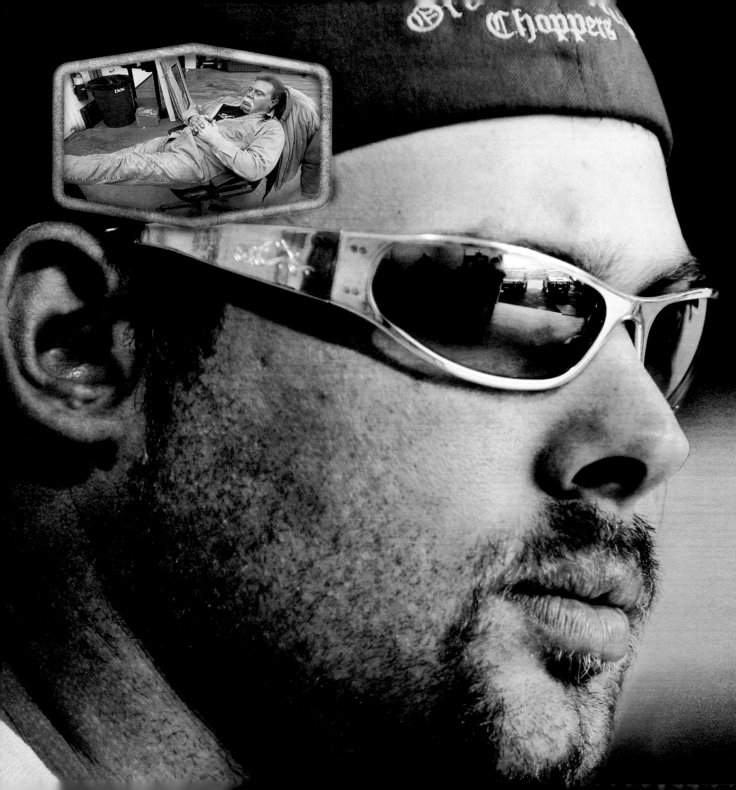

Working Overtime

Ok, you've seen how the machinery works. What about The Real Question nagging fans of AMERICAN CHOPPER: Who does more work around the OCC shop, Paul Sr. or Paul Jr.?

Sr: All you do is do one thing…. I do 50 @#$%-ing things.

Jr: That's not true.

Sr: No, it is true!

Jr: Ask anybody around here who puts in more time, me or you.

Sr: I do three times what you do… I do everything around here. Everything!

Sr: What do you do? Tell me what you do! You build bikes.

Jr: I make us who we are by designing bikes the way I do.

Sr: No, you don't—I do that too.

Jr: You help do that.

Sr: And I do every other @§#%-ing thing too!

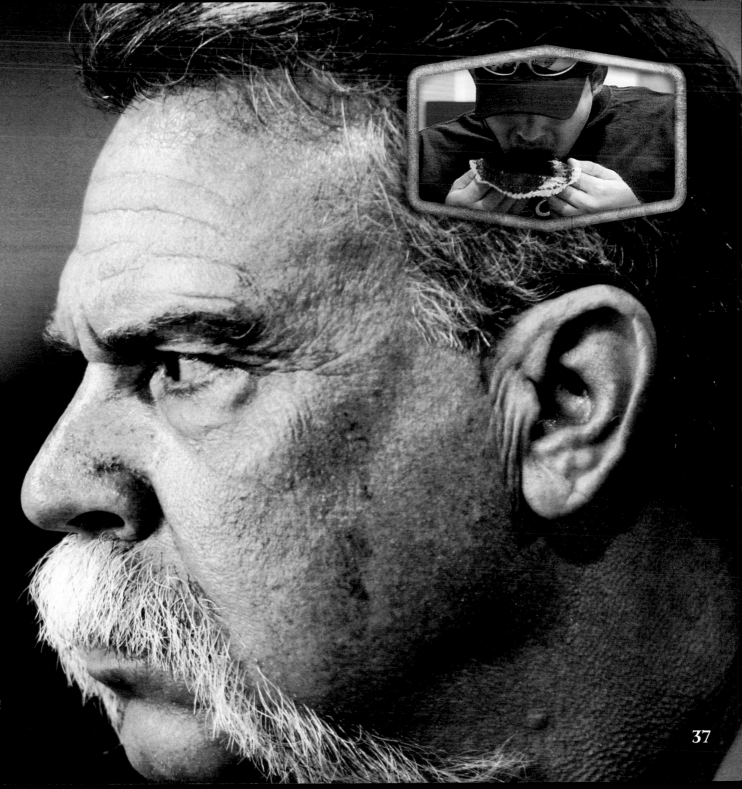

At 14 years old, I was working 80 hours a week…

Sr: Listen, at 14 you were putting applications in at McDonald's and not even getting hired, so what the hell are you talking about?

Jr: I know who does more… who's here more. I am here more than you!
Sr: No, you're not here more than me!

Sr: That would be me washing bikes out there while you're in here picking your nose. I don't ever see you sweeping the floor. I sweep the floor!
Jr: Get the violin out.

Jr: I get seven days to build a bike that's gotta look like $150,000!

Paulie has no conception of what I really do…. If he really knew, he'd never be questioning what I do, because pretty much I do everything.

Sometimes I don't think my father understands or appreciates the creative process…. It's not like a light switch that you can just turn on or off.

I'll say whatever the @§#% I want to say, 'cause I run this place, not you!

37

The Guys

Simply Irresistible!

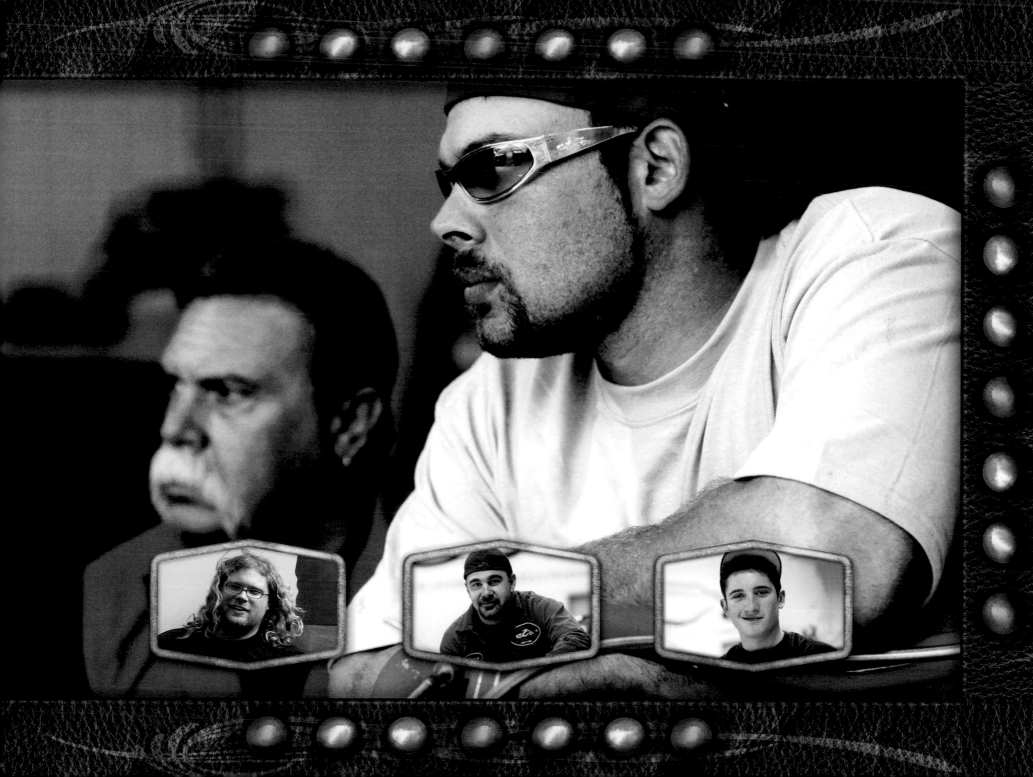

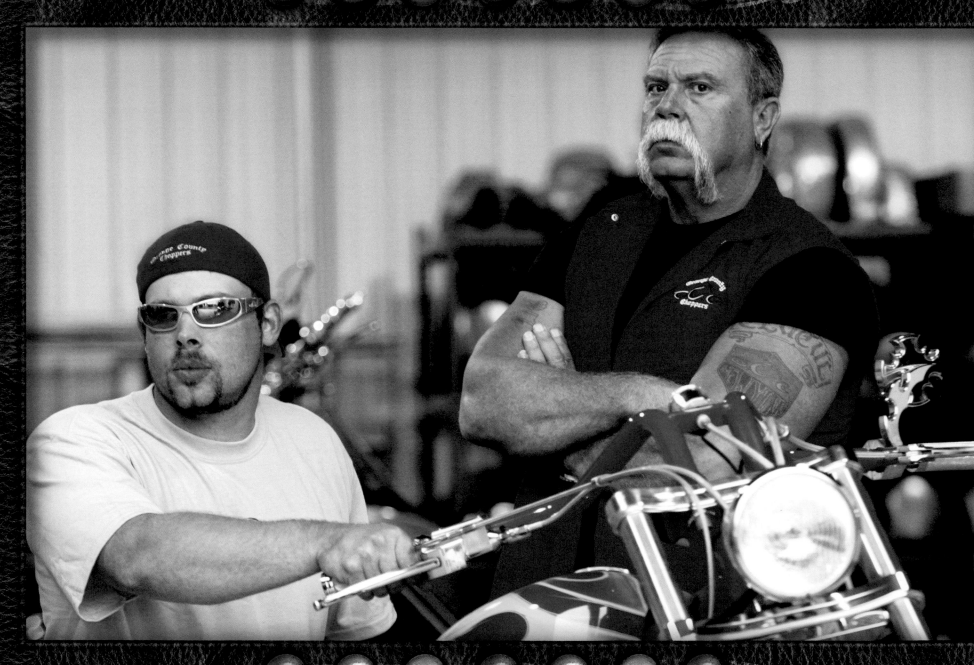

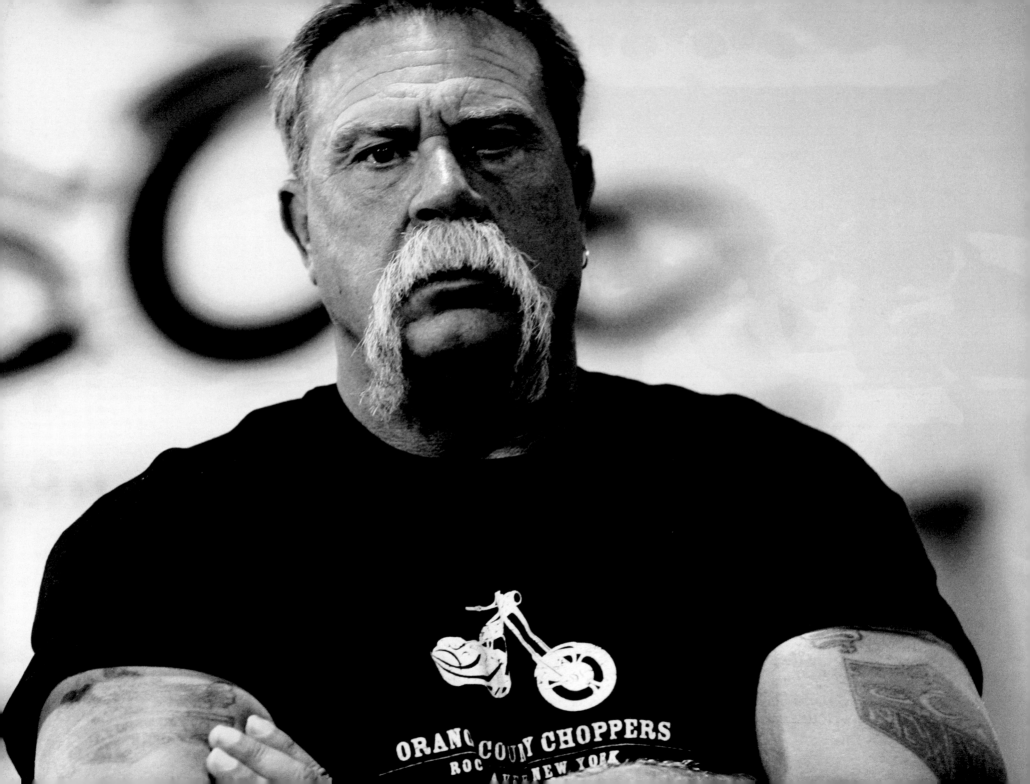

PAUL SR.
{A.K.A. THE BOSS}

Entrepreneur. Craftsman.

Family man. Patriot. Visionary. Grouch. Wiseacre. Force of nature.

Some mix of those terms may begin to define the phenomenon that is

Paul Teutul Sr. Even then, mere words come up pitifully short. He's

something to be experienced—a mold-breaking original, yet instantly

RULE #1

Cleanliness, they say, is next to godliness. It's never far from The Boss's critical concerns, that's for sure.

✦ "How hard is it to understand that when you're done with something, put it back? Or if you make a mess, clean it? What am I running, Romper Room over here?"

✦ "Sometimes it's like working with a bunch of monkeys that you gotta train. I just don't get it. What's so hard about keeping things organized?"

✦ "When I repeatedly tell people that I expect the shop to be clean, and they disrespect that, I take that personal...That's an insult to me. And it just gets me to the point of rage."

✦ "I'm a freak when it comes to this stuff and that's not gonna change. The only way that's gonna change is by keeping it the way I want it."

✦ "Clean the place up first, then hang whatever you want to hang. Clean the place up first!"

✦ "Rule Number One: This shop is going to be clean and organized. Everything's going to have a place—there ain't gonna be no tools, rubber gloves, coffee cups, or whatnot laying all over the place. Those days are over!"

✦ "Every time I turn around I see a missing link somewhere."

✦ "I leave for what, two days? And the next thing you know the whole place is trashed.... It's like a freaking bomb went off in the shop!"

✦ "There's plenty of time to keep things organized around here and still get work done."

✦ "Clean the shop up, and that's it. That's it! That's it!!"

✦ "I'm not gonna say it again!"

familiar to anyone who's ever felt oppressed by a boss, a teacher, or especially, a father. Senior's impassioned tirades may leave TV viewers appalled, nostalgic, perplexed, or guffawing; one way or another, his words have effect. That's more than can be said for most performers on primetime sitcoms and dramas.

Unlike television's legion of trained actors, Senior has carved out a place for himself in TV history just by showing up. "When we started doing the show, it was like, 'How are you gonna act?' and 'What are you gonna do?'" he recalls. "And I had resolved to pretty much be who I am. So that's why you saw what you saw, and you still see it today—because that's the way it is."

Of course, that kind of personal seasoning doesn't come cheap. Hard times are said to *build* character, not turn a person *into* a character. Over the course of Senior's 55 years, however, they've done both. It's a metaphorical twist that would make Dickens proud: The main character, a metalworker by trade, finds himself hammered into completion by hard living and hard knocks.

Jack-of-All-Trades

Born in Yonkers, New York, in 1949, Paul Teutul graduated from Pearl River High in New York's Rockland County. A jack-of-all-trades, he worked in commercial moving, roofing, and carpentry before joining the merchant marine at age 19. In that capacity, he made deliveries to war-torn Vietnam and a variety of other places. Back on dry land once again, he struggled in a

truck-driving gig with the Teamsters, then did a stint in a steel shop. That would set the stage for the watershed year of 1973, when he bought a '69 Chevy pickup and, for $50, a four-cylinder welder (the latter from a friend who was liquidating his assets before heading off to a stretch in prison).

With that, Paul's Welding was open for business. He initially made do with Johnny-on-the-spot farm equipment fixups, then branched out to create wrought-iron railings and more sophisticated work. And with expansion came a new name: Orange County Ironworks.

Inspired by a fellow steelworker's hobby, he made an even more prophetic decision that year: He purchased his first motorcycle, a 1971 Triumph Bonneville. With his business and riding enthusiasm flourishing, the next year saw the purchase of his first Harley (which he still owns).

Roughneck Rebound

But while his career was taking off, his personal life was on a dangerous descent. Like many young men of his era, Senior had chronic problems with drugs and alcohol.

"Being a drug addict or an alcoholic, you spend half your life in a coma, really," he says. "You have one goal, and that's to get high. Meanwhile you have a family, and you think that you're part of that, but you're not."

Inevitably, addiction got the better of him. "When I fell, I hit concrete," Senior recalls quietly. "I was a real abusive addict, and I paid for my mistakes."

In 1985 he sought help in 12-step programs—too late to save his marriage with wife Paula, but leaving him a fighting chance to make amends to his four children: Paul Jr., then 10; Daniel, 8; Michael, 5; and Kristin, 3. He's been clean and sober—and grateful—ever since.

"By the end, all of my friends had died," he says of those reckless years. "They were all dead—at 30, 35 years old... horrible deaths. So for me to be able to come out of that and then pick up from there, to succeed to where I am, I feel pretty good about that."

With the Ironworks growing comfortably, a clear-headed Senior began to dabble in motorcycle fabrication, a sideline that finally led to building his first chopper in the basement of his home in 1997. When that bike went on to win a design competition at a motorcycle show, he says, "I knew I had something."

He had something else too—an enthusiastic protégé in son Paulie. Together they opened Orange County Choppers two years later, leaving the Ironworks in the capable (but rarely seen on AMERICAN CHOPPER) hands of second son Danny Teutul, 27.

Lessons of Humility

Sure, to TV viewers, Senior's approach to parenting and management may seem to give comically new meaning to the term "tough love." But he's the first to admit that his sternness with Paulie, his seeming enthusiasm for taking his son down a few pegs from time to time, is serious business. The way Senior sees

it, he's merely trying to impart the lessons learned during his hardscrabble struggle, his fall to the bottom, and his journey back up.

"It's all about humility, and that's where I have a problem," he says of Paul Jr. "I worked for everything in my life. I never got anything given to me."

The fact that he's now materially comfortable beyond his wildest dreams actually presents a dilemma to Senior, who wonders how much material comfort is good for his adult kids: "You don't want your children to go through what you went through, so you try to protect them," he says, "but in a sense you're almost doing some harm, because you're not allowing them to have exposure to the world's knowledge."

He never hesitates to expose them to his opinions, his moods, his objections, or his rage.

"My father has a certain method of being a boss, and that's one of sheer will," Paulie says. "He has to have it his way, and that's it. It doesn't have to be right.

"That's the key. It doesn't matter to him, because he's The Boss. That's what you deal with, and that's the way it is."

Nevertheless, and despite all his button-pushing and occasional disdain, number one son is ultimately nothing but respectful of his father's prerogatives: "He built himself an empire from a pickup truck, so he has earned anything that he wants to do." It's that acceptance that allows Paulie to blithely deflect Senior's gibes about neatness and deadlines and to carry on with his work.

Same Name, Different Men

"My father is who he is," Paulie says. "I worked for him in the steel shop and it was the same way, and it's never going to change. We have different personalities. He's always on edge and most of the time I'm laid-back, [so] there's a confrontation there."

"As difficult as it is, I think families like to stay together," Senior muses. "The hardest thing to do is work with your family, but if you can, there's a big reward in that."

He's all about rewards these days, and why not? "It's a gift," he says of his hard-won second chance in life, which has brought him a granddaughter, Gabriella, now 3, and a steadfast companion in his girlfriend, Lucy.

"How many times did you ride by the flower bed and not see it, and now all of a sudden you ride by and you see it?" asks the new and improved Paul Teutul Sr. It's the little things, even the big two-wheeled little things, that make it all worthwhile.

"I've been in this business a long time," he says, "but when a bike starts taking shape, I'm kinda like a kid with a new toy—a very big toy."

And you know how kids are with their toys.

"I started out in the basement and worked hard to get to where I am," he says, his voice darkening. "So anything that's a threat to me, I'll go after that aggressively. I'm not willing to give up what I've gained, not at any cost."

You've been warned.

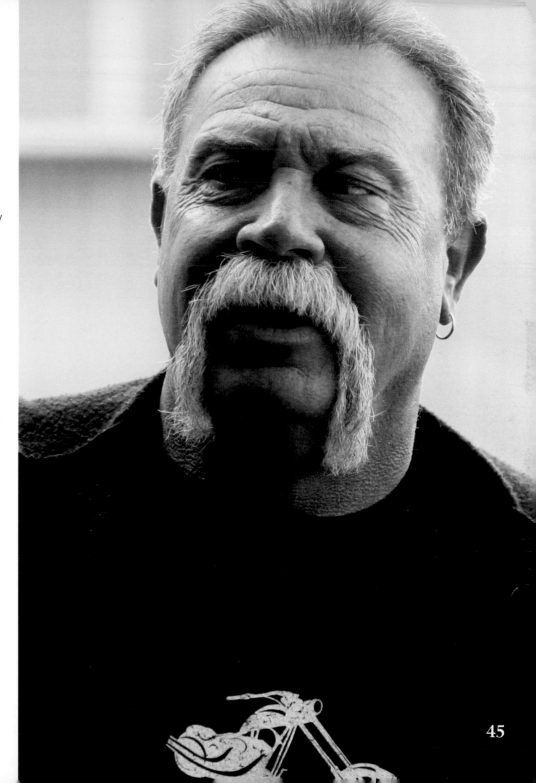

45

「「Sometimes you just hafta getta getto the getting, you know what I mean?」」

—Paul Xenter

47

PAUL JR.

{A.K.A. JUNIOR, PAULIE}

 CHILD SHOULD BE PUSHED ASIDE

WITH THE LEFT HAND AND DRAWN CLOSER WITH THE RIGHT.

THAT 1,500-YEAR-OLD ADAGE HAS BEEN VIVIDLY DEMONSTRATED TO MILLIONS

FROM THE VERY FIRST HOURS OF AMERICAN CHOPPER.

IN THE SHOW'S DEBUT, PAUL TEUTUL SR. FACES THE DISCOVERY CHANNEL'S

A SON'S PERSPECTIVE ON FATHERLY INPUT

As ready as Paul Sr. is to chip in his "two cents worth" during a bike build, Paulie stands just as ready to explore the not-so-fine line between mentoring and hectoring. Some perspectives on Pop, as shared by Paul Jr. during the first two seasons of American Chopper:

✦ "It's not like my dad really wants to help me get work done here—it's more like he wants to feel like he's helping me get work done. Usually what that means is he comes in, touches a few parts, stands by the bike, and gives me grief."

✦ "He likes to hang around until things don't go just perfect, and then he's out-ey."

✦ "He gets involved in a project—'Oh, I'll do it, I'll do it' or 'I'll do it myself' or something to that effect—and then the first time he runs into a problem, he goes and sits at the desk and puts his feet up.... Don't offer your services and then take off in the middle of it."

✦ "My father thinks because he screams and yells that people actually respond to it, and it's just not true."

✦ "People don't work harder for you because you freak out on them all the time."

✦ "I've learned over the years [to] just keep going until he burns himself out."

✦ "Sometimes there's just no making my father happy.... But, you know, sometimes it's easier just to let him have his way."

relentless camera and speaks with obvious pride: "I think his gift is fabricating," he says of his namesake son. "It allows him to be creative, and he's extremely talented." By the next episode, however, this warm Ward Cleaver has turned into the Great Santini, as Senior asks of the same crew, "Can you shut the camera off for a minute so you don't see me beating the @#$% out of him?"

"Him," it turns out, is Senior's most benign term for the young man who shares his name, if not his temperament. Viewers have come to recognize a litany of withering epithets: "Mr. Innovator," "Picasso," "King of the World," "Goddess," "Romper Room Guy," "The President," "Mr. Procrastinator," "Mr. Confident," "Mr. Superhero." These are a few of the derisive names Senior has been known to use—that is, when he isn't gushing proudly about his son's two-wheeled masterpieces.

Wacky, you think? So it might seem at first, but as Paul Teutul Jr.'s triumphant story attests, Ol' Size 12 must have been doing something right. Paulie now reigns as one of the most famous and admired craftsmen in the world, his creations regularly splashed across the covers of motorcycle magazines, his face a fixture on national television, his mere presence at a bike show enough to attract thousands of fans willing to wait hours for a handshake or an autograph. And in spite of the pressures he bears so publicly, he's generally happy and comfortable with his life. After all, it isn't like he didn't see it coming.

Destiny's Design

"I knew in my heart at a very early age that I was gonna do something special—an extraordinary thing," Paulie reveals. "Did I ever think it would be this big? No. But did I know the possibilities? Absolutely."

That's foresight talking, not immodesty.

"In some ways my father probably has more confidence in my capabilities than I do," Paulie has said. One thing's for sure: Pop certainly provided an environment where the young tinkerer could fulfill his promise. Paulie grew up riding quads (four-wheeled, all-terrain vehicles) and snowmobiles and shaping steel with his father in the hard-edged realm of Orange County Ironworks.

"I wasn't artistically inclined by any stretch of the imagination," Paulie says of his childhood. However, he adds, "I was always mechanically inclined."

He was also inclined to grow up fast. By the time he reached his teens, Paulie had made some meaningful decisions about the direction of his life—both good and bad.

As a high school student in Montgomery, New York, he signed up for a state-sponsored program that emphasizes trade-related training. By the age of 17, he had his first Harley-Davidson Sportster. Before he was even able to ride it, he customized it.

Unfortunately his teen years marked the debut of a less wholesome "like father, like son" dynamic, as Paulie plunged into drug and alcohol abuse. He languished in the fog of

addiction until his early 20s when, he says, he crashed emotionally—bottomed out and broken down. His salvation would come with a renewed dedication to his religious faith.

"God has a way of allowing you to do the wrong thing for long enough," he explains, "and when it catches up with you, you always resort back to him."

Personal Fulfillment

By 1999, Paulie was working at staying clean and sober and working full-time at the Ironworks. Paul Sr. was running that business and dabbling at building custom motorcycles on the side. Seeing so much of himself in his eldest son, Senior suggested forming a whole new family business, Orange County Choppers.

Paulie recognized the call of destiny and leapt on board as the shop's chief designer. In that role he has found his own future in his father's zeal for choppers. Stretching a common destiny over two Teutuls is sometimes a tight fit: "It's not like I don't appreciate my father's ideas and input," says the Chief Designer, "but I can see the bike in my head, and I know where I'm going with it."

The rest, as they say, is history and more—the history of one of the most successful, cantankerous, nerve-wracking, hilarious partnerships the manufacturing and television worlds have known.

For all the scrapes that father and son get themselves into, for all the slammed doors and bruised egos, Paulie is quick to dismiss one

oft-used description. "I wouldn't call it a love-hate relationship, because that sounds very drastic," he says thoughtfully. "There's never any hate there—just maybe some severe disagreements where it can get pretty nasty sometimes."

When that happens, Paulie is at no loss for diversions. He enjoys spending time with his girlfriend (and now OCC office staffer), Whitney McGuire, as well as doing service at his church. He has fun tearing up the wintry terrain on his snowmobile, as well as fishing and watching NFL football, an activity that he and Senior enjoy together.

Speaking of Senior, as long as Paulie is on the record, he wants to set one thing straight: "I never missed a deadline when I made rails for him, and I've never missed a deadline when we were building motorcycles."

Paulie says that with confidence, with certainty; then he continues with resignation: "But that never matters," he says, referring once again to his dad. "He thinks that's because he freaks out all the time."

Of course, Paulie has tried to tell Senior that bluster and bullying aren't effective motivators. He pleaded that case publicly during their on-air heart-to-heart in the first season of the series. They acknowledged how different they were—and still are. It doesn't matter. Their characters are cast, and at this stage of the game all Paulie can do is shrug. "He's not gonna change, and I'm not gonna change." Promise?

51

“I understand that schedules and deadlines are really important, but for me what really matters is building a great bike, and I don’t want to compromise my work.”

—Paul Junior

53

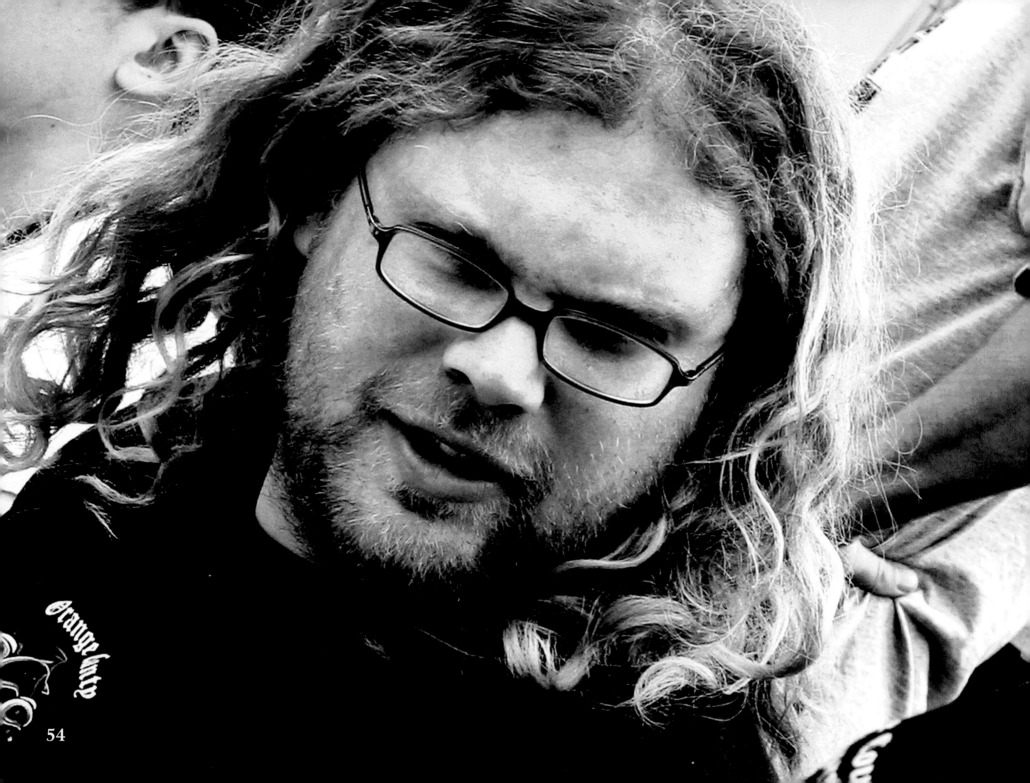

54

MIKEY

{A.K.A. MICHAEL}

THE ULTIMATE MIKEY MOMENT MAY HAVE BEEN DURING THE BUILD OF HIS BLUES-THEME BIKE, WHEN A CONCERNED PAUL SR. ASKED IF HIS YOUNGEST SON HAD A GAME PLAN FOR THE BIKE'S DESIGN AND FABRICATION. "NOT AS SUCH," MIKEY REPLIED, AS IF THE PROJECT'S MOST IMPORTANT CONSIDERATION HAD NEVER CROSSED HIS MIND.

> **"My father looks to Paul as the heir to the chopper business, and Daniel runs the iron shop… You kind of start to slack from Day One, knowing that there are two others waiting to take over."**

Specifications? Deadlines? Life goals? They're dismissed by Mikey with a carefree, daydreamy nonchalance. That "no worries" quality, combined with a knack for blurting out just the right wisecrack at the right time, has made Mikey a sentimental favorite of AMERICAN CHOPPER fans.

For Michael Joseph Teutul has thus far been the proverbial rolling stone, gathering no moss, flying by the seat of his… shorts, as he's tried to realize his destiny. That quest took him, at age 20, on a soul-seeking relocation to Tempe, Arizona, where he explored a series of less-than-enlightening career paths, including gigs as a bouncer, busboy, telemarketer, and parking attendant. Upon his return to New York, the wanderer worked as a maintenance man on a golf course, then tried carpentry for a year before finding his way to the Teutul family's bedrock business, Orange County Ironworks.

Discovery

That wasn't working out either, but fate intervened when the self-described deadbeat was spotted reclining, feet up, by CHOPPER executive producer Craig Piligian.

"I called my producer and said, 'Put this kid on the show. Have him walk through and do something stupid, whatever,'" he recalls. With that, Mikey was brought aboard as OCC's phone answerer/trash disposer/package wrapper/snow shoveler/errand runner.

This jack-of-no-trades has mastered at least one crucial skill: He can instantly defuse his father's trademark rage. "He has a different effect on my father than I do," Paulie observes with a flair for understatement. As an older brother, Paulie concedes that he may not have quite the patience for Mikey's shenanigans that others do.

The difference is pretty clear to their dad: "With Paulie, if I say 'Black,' he says 'White,' no matter what," says Paul Teutul Sr. "If I say 'Black' to Mikey, Mikey will say, 'Okay, it's black.'"

Senior admits that Mikey's status as the brood's baby boy might put him a little less under the gun. "I think it's a standard procedure in every family," he says. "There's always those roles that are played by the individual children, [determined] by when they're born and what rank they're in."

Nevertheless, Senior adds quickly, "Don't think for one second that I don't want to snap his head off once in a while too."

Mikey has his own explanation for his approach to life: "My father looks to my brother Paul as the heir to the chopper business, and my brother Daniel runs the iron shop, so I guess I'm kinda like a bonus, if you want to call it that. So I think you kind of start to slack from Day One, knowing that there are two others waiting to take over."

Simply put, Mikey wasn't set on any particular path and has yet to select one of his own.

"I'm not sure as to my role in the company right now," Mikey continues, "but I'm pretty sure as to my role in the family—and it's a family-run business, so as far as my father goes, he's stuck with me."

A Natural

Ironically, Mikey's latest menial position may have provided the key to his ultimate calling, thanks to the wonders of reality television.

"Mikey's a great third banana," Piligian notes, "a great foil for everybody."

Put another way, he is what showbiz folk call a natural, able to bring a grin to viewers' faces with a single look, capable of puncturing the tension, cutting dramatic moments with a wry comment or an off-the-wall observation.

The secret to Mikey's comic success? "I have the least pride," he deadpans.

"The format becomes kind of humdrum after a while," he adds more seriously. "I always like to spice it up."

Regarding his gregarious willingness to step out of an episode's drama and speak directly to the camera—and to the audience at home—Mikey says, "I think I found what I enjoy."

So what's next for the clown prince of Rock Tavern, New York? Mikey says he'd like to learn acting, with an eye toward working in comedy.

He's not the only one taking that idea seriously. "I actually think that when all this is over for these guys, Mikey may become the biggest star," says Sean Gallagher, Discovery's Director of Program Development. "I could see him in movies or a sitcom."

Stay tuned.

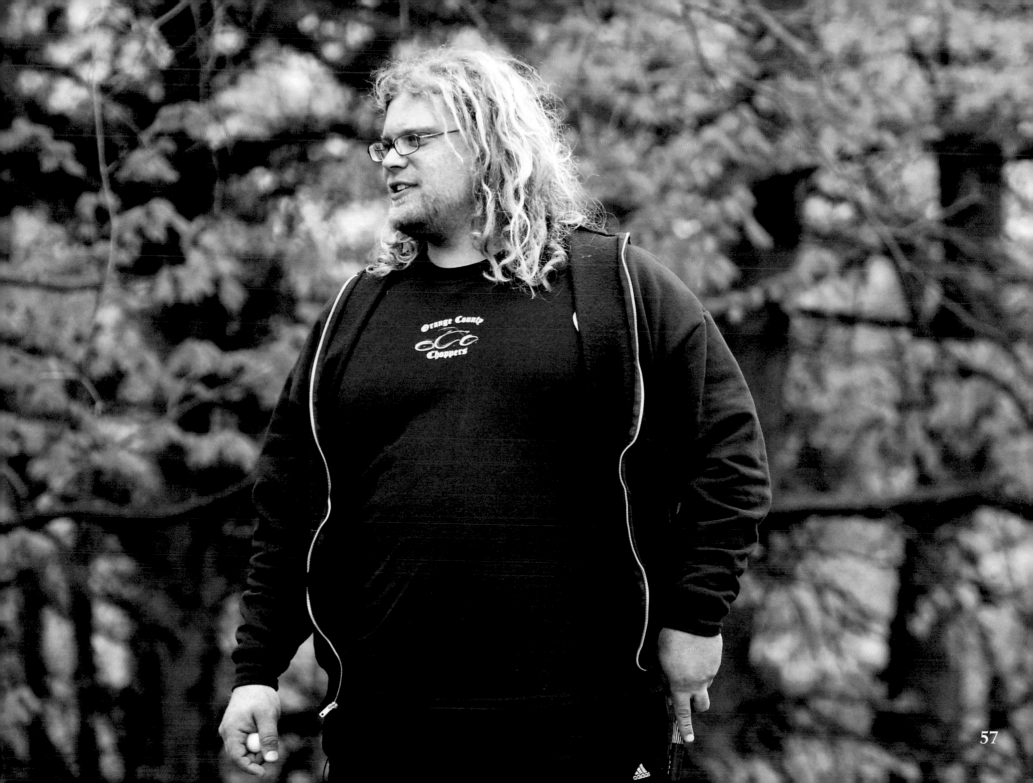

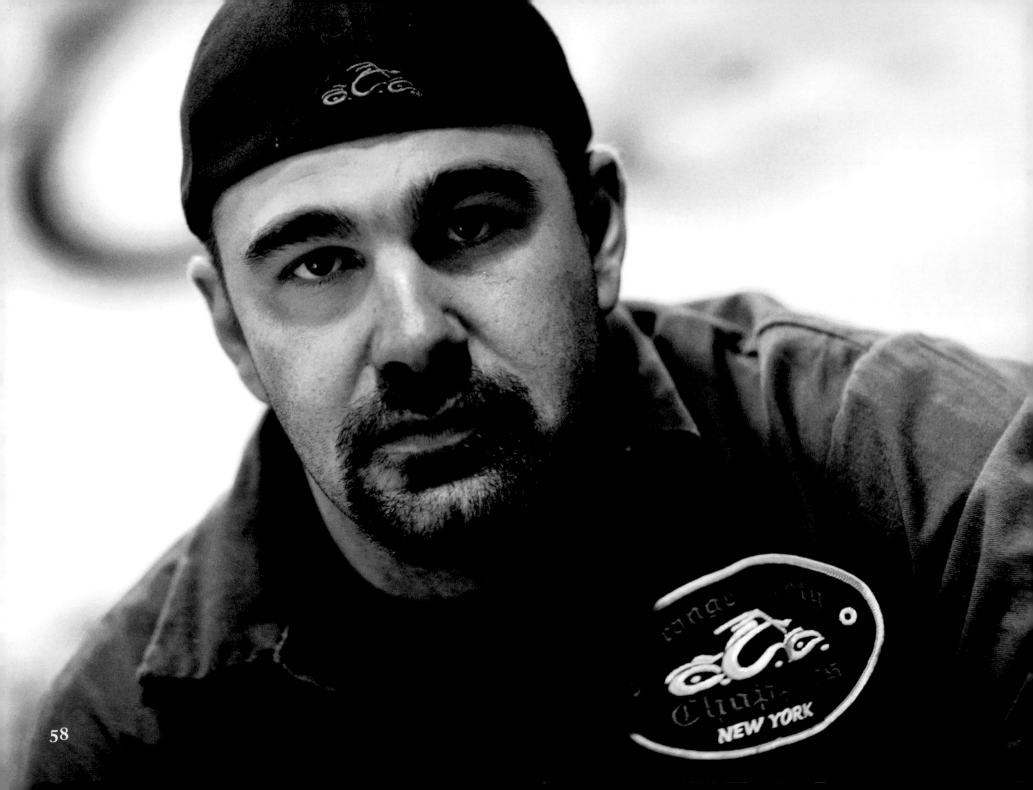

VINNIE

{A.K.A. VANCE}

merican Chopper viewers may be exhilarated by the battling Pauls and tickled by the ever-irreverent Mikey, but the man they may appreciate most is Vinnie Dimartino, the unflappable calm at the center of the Teutul storm. "Vinnie turned out to be a star, but in a

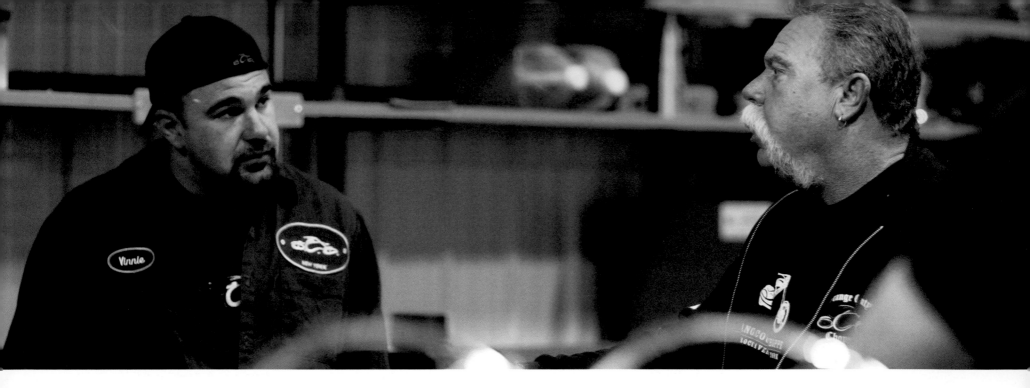

totally different way," says Discovery's Sean Gallagher, who sees in him a classic character type—"an understated can-do guy that American people love."

Mechanical Prodigy

Vinnie signed on at OCC in October 2002, but he goes a lot farther back with the boys at the shop. Not surprisingly, it was things that go vroom that brought the Teutul and Dimartino clans together. Vin's father owned a service station where Paul Sr. would get his trucks repaired and gassed up. The station was also Vinnie's first place of employment. And why not? He'd started riding when he was just 3. By age 9—around the time he met Paulie—he was able to rebuild his own engine!

So it was that Vinnie's career essentially began right after fourth grade. Although he'd go on to high school, he was not a big fan of the homework. "I barely made it through," he recalls. Favorite classes? "Gym and lunch."

Mechanics would continue to be a part of his life, either as a full-time gig or as a sideline during jobs at a golf course and as a trucker of hazardous materials. He gave up the big-rig gig when he realized that the long hours behind the wheel were keeping him from seeing his girlfriend, Melissa, who is now his wife.

What keeps him away from home now is fabricating exotic theme bikes and attending out-of-town bike shows. Vinnie became a celebrity at the same time that he became a family man; his daughter, Vanessa, was born in

October 2003. "Now's the time you want to see your baby, so I miss her," he laments. But, he adds, "When you get back home, it's nice."

Of course Vinnie isn't missing any wailing or whining. There's plenty of that on the job, as he invariably finds himself in the middle of Senior and Paulie's throwdowns. "They've always been like that, so I'm pretty numb to it," he says. "I know when to walk away."

Whose Side?

The fact that he's had his beefs with Senior ("I know he's got decisions to make, but it gets kind of tiring when he expects me to know where Paulie is all the time. After all, I'm not his babysitter.") as well as with Paulie ("It's kind of tough when he just leaves in the middle

of a project and I'm expected to just pick up where he left off.") is testimony to his neutrality, Vinnie contends.

"Everybody always asks me, 'Whose side are you on?'" he says. "I don't want to pick sides."

Vinnie insists that his non-bias is less than accurately portrayed on camera. "It always seems like they put me against Paulie on the show," he says. "You'll always see me making wisecracks toward him about him not doing this or that, but they never show me saying anything nice."

Luckily, he adds, "Paulie knows I don't really have a choice in it—it's just the way you do something, and then the way it's shown on TV."

Welcome to showbiz, Vance.

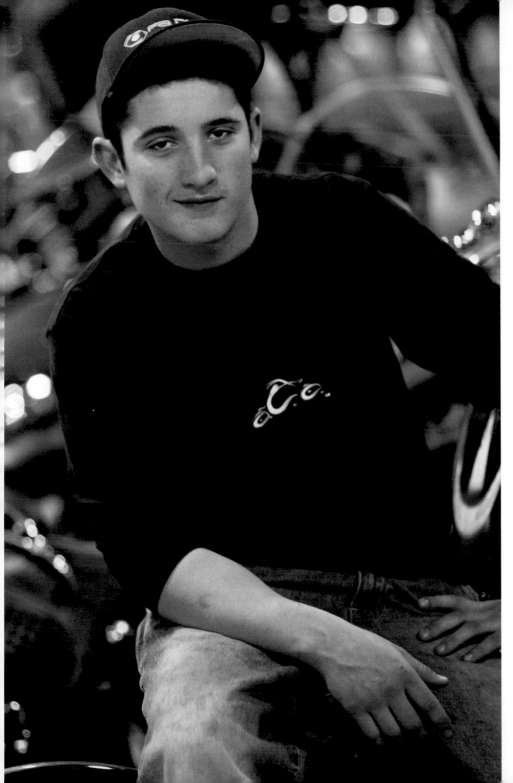

THE BOYS IN THE BACK(GROUND)

While the Teutuls keep viewers howling, OCC's team of mechanics keeps the business humming.

OK, so maybe they don't get to throw the tantrums or make the wisecracks or bask in the applause or go on THE TONIGHT SHOW. But without the gritty expertise of Orange County Choppers' "supporting cast," the company's monthly order of roughly 15 custom bikes would never get filled.

Though they're the unsung backbone of the business, most of the guys in the shop have had at least a few minutes in the spotlight of one episode or another.

Cody

A particular favorite among CHOPPER fans is bike-building prodigy Cody Connelly, who by age 16 had co-designed not one, but two of the show's highlighted creations: the Cody Project and the Old School Chopper.

Although he's lived his whole life about two minutes from the headquarters of Orange County Choppers, Cody might never have met the Teutuls if his mother, Darcy, hadn't taken it upon herself to drop in and ask if they had any odd jobs around the shop that needed doing. Paul Sr. was immediately impressed by the new kid's perseverance. He recalls sending Cody

outside to rake some rocks on a 100-degree scorcher, then forgetting all about him. "At the end of the day," Senior says, chuckling, "we walked outside and he was still there raking rocks! He never put the rake down!"

Luckily, there was room for advancement, as Cody had been riding dirt bikes since he was 5 years old. It wasn't long before the Pauls began teaching him the bike-building trade.

"Paulie kinda took me under his wing and just helped me along through this process," Cody says. Paulie, for his part, was only too pleased to take on the role of mentor. "I got an opportunity to pick up things at a fairly early age," he says. "It really makes me feel good to be able to have an effect like that on his life."

Eventually, Cody became a full-time employee, continuing his education at nearby Valley Central High with evening classes.

"Everybody here is like a big brother to him," says Senior. The elder Teutul, who has noted that his own demons kept him from fully participating as a young parent, seems to relish the chance to nurture Cody's talent. "I think he does look up to me," Senior says. "Whether it's as a father or a good friend, I don't know, but he seems to respect what I tell him."

Respect indeed, plus appreciation from Cody's proud mom. "I don't even know how to thank them," Darcy says of the magnanimous Teutuls. As for her son, she keeps it sweet and simple: "He's a good kid, and I am proud of him and what he's done." Her beaming face says the rest.

The ever-ambitious Cody's next move will be enrollment in the American Motorcycle and Marine Institute in Daytona Beach, Florida. There, he'll follow in the footsteps of two of OCC's most stalwart gearheads.

Nick

Pennsylvania native Nick Hansford graduated from AMI, then stayed down south and plied his trade at Pompano Fats and Daytona Choppers, where he met Paul Sr. during Bike Week 2000. Soon he was servicing OCC bikes and selling them as the company's southeast distributor.

Two years later a family crisis necessitated Nick's move to New York. Once he learned that his new home was a mere 45 minutes from Rock Tavern—well, fate took care of the rest.

Since then OCC's staff has grown from 5 to nearly 20, and the physical size of the shop has tripled, Nick says. "Other than that," he jokes, "it's been pretty much the same."

He views the Teutuls in much the same way. "They're characters," Nick admits, "but they're real people." Pointing to their peerless motorcycle fabrication as well as their ripsnorting clashes, Nick says, "That's who they are, and that's what they do."

A visit with Nick can make a CHOPPER fan nostalgic. He toils in OCC's downstairs shop, the cluttered, worn-in garage where TV viewers first got to know the Teutuls. Although the upstairs shop (completed in 2003) has become the primary site for the televised action, downstairs remains the money-making nerve center and the assembly site for most of OCC's customer bikes. That's just fine with the camera-shy Nick, who'd rather spend his days fabricating than fulminating.

"I want to be a mechanic and I want to work at a bike shop," he says. "I like coming to work, putting my time in, riding the bikes, and going home." If he has his druthers, his future will hold more of the same. "Hopefully, I'll be here till... whenever," he smiles. "I love this place."

Christian

Perhaps one reason for Nick's contentment is that, like Paulie and Vinnie, he gets to work every day with a good buddy. He'd gotten to know New Jersey native Christian Welter when the two were roomies at AMI.

After graduation in 2000, Christian put his diploma to use at a series of motorcycle dealerships. Two years later, he got a call from Nick, who suggested he trek up from the shore to join him in the wilds of New York's Orange County.

But first, Christian had to get past his job interview with the "definitely intimidating" Paul Sr., an experience he won't soon forget. "Actually," he laughingly recalls, "the week before I started working here, I was sitting with my father watching the Jet Bike episode, and he was like, 'You're going to work for *this guy*?' But, it turns out, he's really cool. He barks a lot, but he's fair."

Since the OCC expansion, Christian notes, the volume level in the lower shop has definitely decreased. The drama moved upstairs. "I mean, here and there some arguing happens," he says, "but not half as much as what it used to be."

Senior still pays the occasional visit to dole out some abuse but, says Christian, "We try not to give him a reason to. He mainly focuses on Paul Jr. and Mikey for that. If anything, he'll come down just to talk and crack jokes."

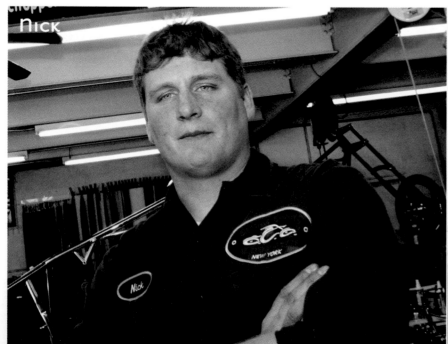

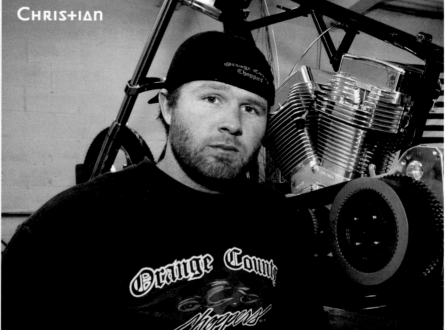

Rick

Bridging the gap between the theme bikes upstairs and the customer bikes downstairs, Rick Petko describes himself as a cross between Paulie and Vinnie.

"I don't have quite the creativity that [Paulie] has, but I've got some," he says. "Vinnie's really good in other areas that Paulie's not, and vice versa, so I feel like I fit right in the middle."

TV coverage may create some stresses that don't exist downstairs among the customers' bikes, but Rick says he feels less pressure working on the high-profile theme bikes.

"On the show, you have more of a plan for what you're going to be doing," he says. He sees the CHOPPER bikes as more collaborative. "I like getting a lot of people's input. I ask Vinnie and Paulie, even Cody and Mikey, a lot of things, which is nice."

However, on television at least, Rick has worked most closely with Senior. "I'm more his boy," he admits with typical self-deprecation. "We've got a certain kind of relationship."

Campo

The same is true of the shop's other metalworking whiz, Mike Campo. In one memorable exchange, Campo (who has the distinction of a last-name-only moniker) informs his burly boss, "I'm not about to do anything just half-assed, no matter who's breathing down my neck." Senior's response is remarkably respectful: "Whatever," he says, "you're the artiste."

Though it was an unlikely path to OCC, Campo's four-year college education seems to command some respect around the shop. He is often assigned the most aesthetically challenging fabrication details. Who can forget his festive reindeer fender? And remember the stirring mesh-and-silhouette work he did on the POW/MIA bike?

"Since I've been at OCC, I've only worked on a few of their theme bikes," Campo says. "So any time I can get involved, I jump at the chance." The reason for his only-occasional appearances is that the shop's "mental sculptor" (as Senior affectionately calls him) is first and foremost its driver. While Senior, Paulie, and the rest are building and blowing up, manufacturing and mugging, Campo is often behind the wheel of one of OCC's highway rigs, transporting their creations to the many bike shows the company attends.

Sadly, Campo's most-involved bike project also led to his greatest disappointment: Paulie commissioned him to create a Lady Liberty face for the Liberty Bike's rear fender. After days of drawing, hammering, shaping, and smoothing, he proudly presented the bas-relief model, only to have it rejected. It was no comment on Campo's work, as Paulie strenuously assured him, just a misconceived idea in the first place.

Despite that letdown—and the regular razzing he gets from his colleagues—Campo's abilities are highly respected. "It's a shame they don't give him as much working time as he'd like," Rick says.

Senior is genuinely complimentary: "He's really good at what he does."

In fact, they all are good at what they do, as fans of OCC's backshop boys have come to recognize week after week on episodes of AMERICAN CHOPPER.

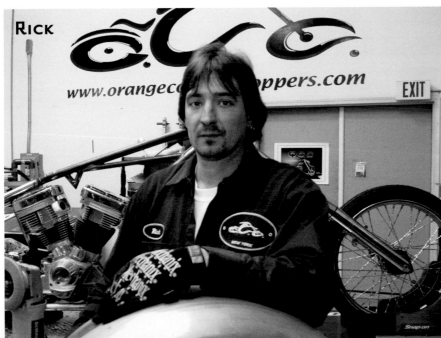

RICK

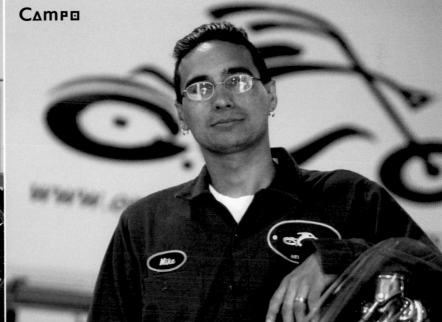

CAMPO

Fun Under the Gun

All work and no play? Not on American Chopper!

A day at Orange County Choppers can build tension as well as bikes.

Toiling away under intense pressure to create amazing theme bikes on deadline— and engaging in nasty, full-throated arguments with bosses, employees, and relatives—is nobody's idea of a day at the beach. So the boys at OCC need to escape and enjoy some leisure time every now and then.

"It's always business with us," says Paulie. "So to get out and just burn off some steam and kinda clear your head—it's a good thing to do." Though single-minded at work, the Teutuls enjoy an eclectic mix of recreational pursuits. They play indoors and outdoors, on land and sea, up in the wintry north and down in the sunny south, with balls, rackets, fishing rods, and motor vehicles. Ah, the sporting life!

Bowling

Senior took the crew for a few afternoon lines during the Black Widow build. "Going bowling," he says, "you really just get to relax a little bit and just be who you are." Although The Boss played poorly (he claimed the ball was too shiny), he had no regrets: "It was a great time."

Tennis

While Paulie was busy sweating out the Comanche build, Senior and Mikey took to the courts. "I'm just getting warmed up," says Mikey after a well-placed shot. The ever-succinct Senior's response? "Yeah, warm up this." Spoken like a true sportsman.

Alligator Wrestling

"That one would make a nice pair of boots, huh?" That was Senior's idea of a joke when the Teutul clan visited Gatorworld during a Florida trip. His next stunt? Riding a 14-footer named, appropriately enough, Pop.

"The part where I started to get a little bit nervous is [when] he was heading for the water where the other alligators were hanging out."

Football High Jinks

To get in the mood for their New York Jets chopper project, the Teutuls spent an afternoon attacking the ramming posts and trying to kick field goals at the NFL team's training camp. Paulie, who spent some time on the gridiron in his high school days, made a quiet confession: "I'm a Giants fan, so I feel kind of weird here."

Snow Tubing

The guys took some liberty from the Liberty Bike with a day of snow tubing. Not surprisingly, the hefty Mikey made for the fastest downhill projectile. But fat? No, he says. It's all "twisted steel and sex appeal."

Basketball

During a break in one project, the crew took time to settle a score on a basketball court.

"There's always been kind of a rivalry between all the guys at the chopper shop and the guys over at the iron works," Paulie recalls.

The ironworkers prevailed by a score of 48–30, with Senior, the game's whistle-blowing referee, remaining impartial to the end: "I think both teams really sucked."

Fishing

When Mikey's blues bike went out for painting and chroming, the Teutuls hung the "Gone Fishin'" sign and took to the water. The Pauls invited Mikey along and were happy to critique his methods. "Stop slapping the worm in the water," Paulie exhorted. In the end, Mikey caught a few fish and a ton of flak. "This is not relaxing," he protested. "This is abusive."

Cruising with Leno

Motorcycle aficionado Jay Leno got to take the test ride on his OCC-designed bike and got a Teutul escort along the way. "It's a completely different feel than a traditional bike," the king of late night remarked. "They did a great job. It's a lot of fun."

The Bikes

Bound for Glory!

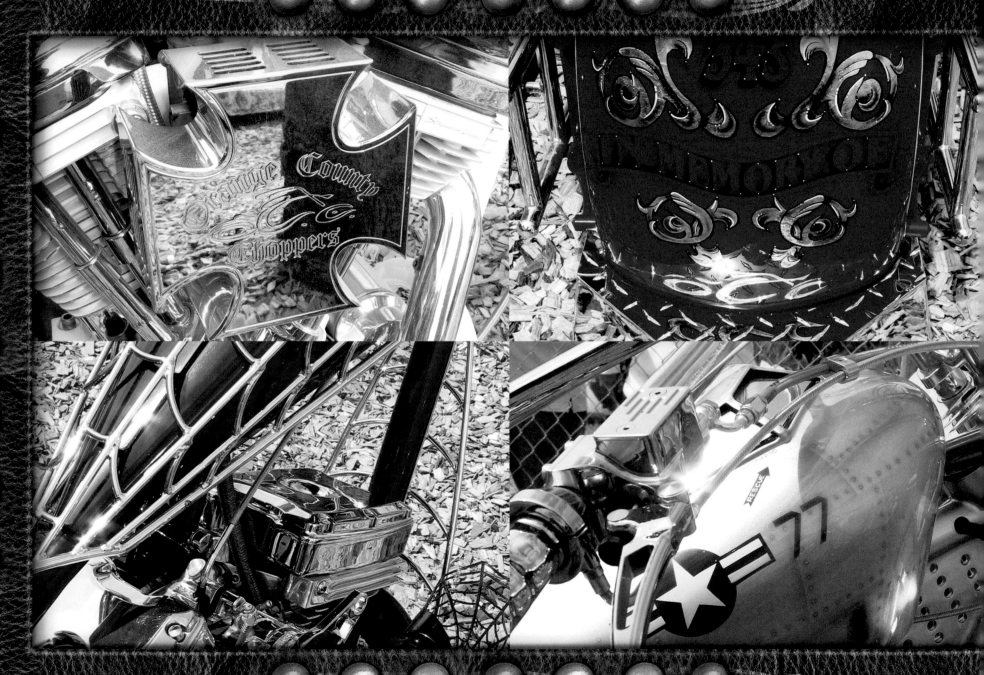

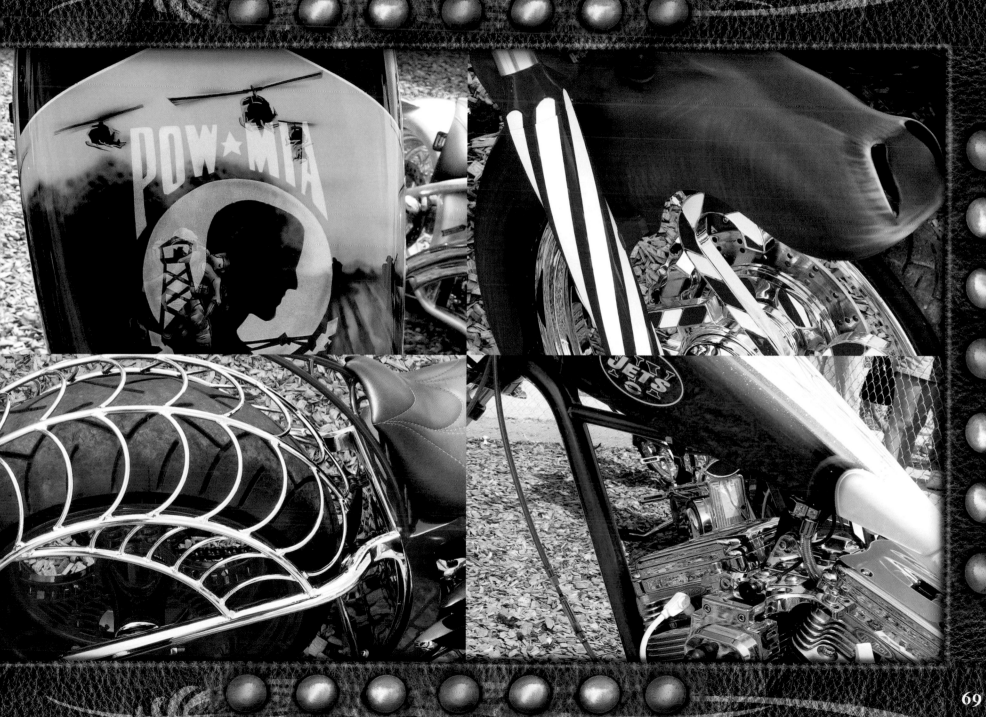

JET BIKE

"A father, a son, and the 45-day battle to build the ultimate American chopper." With that deceivingly simple summary, an ominous offscreen narrator introduces the Teutuls of Orange County Choppers to the TV-viewing world.

THEIR ASSIGNMENT: BUILD A BIKE from scratch to be entered in the design contest at Laconia Bike Week.

At an OCC strategy session, Paul Sr. suggests that a theme bike is the way to go. With that, Paulie offers the idea of a bike modeled after a fighter jet and takes off on a research mission. Luckily, the Intrepid Sea-Air-Space Museum lies just an hour away on Manhattan's West Side, displaying a cornucopia of Yankee airpower on a 900-foot flight deck.

"The jet is really symbolic of our military," says an admiring Paulie. "When a jet is sitting there, it almost looks like it's moving—the wings are slightly tilted back, and the cockpit is rounded." As Paulie sees it, "You get the same effect out of a bike."

Paulie, too, is often moving when he appears to be sitting still. Like during the design phase, where *his* wheels start turning so that, 45 days later, the Jet Bike's will. In its day-by-day countdown of production progress, AMERICAN CHOPPER's inaugural hour is a fly-on-the-wall tutorial on the art of bike building… and browbeating.

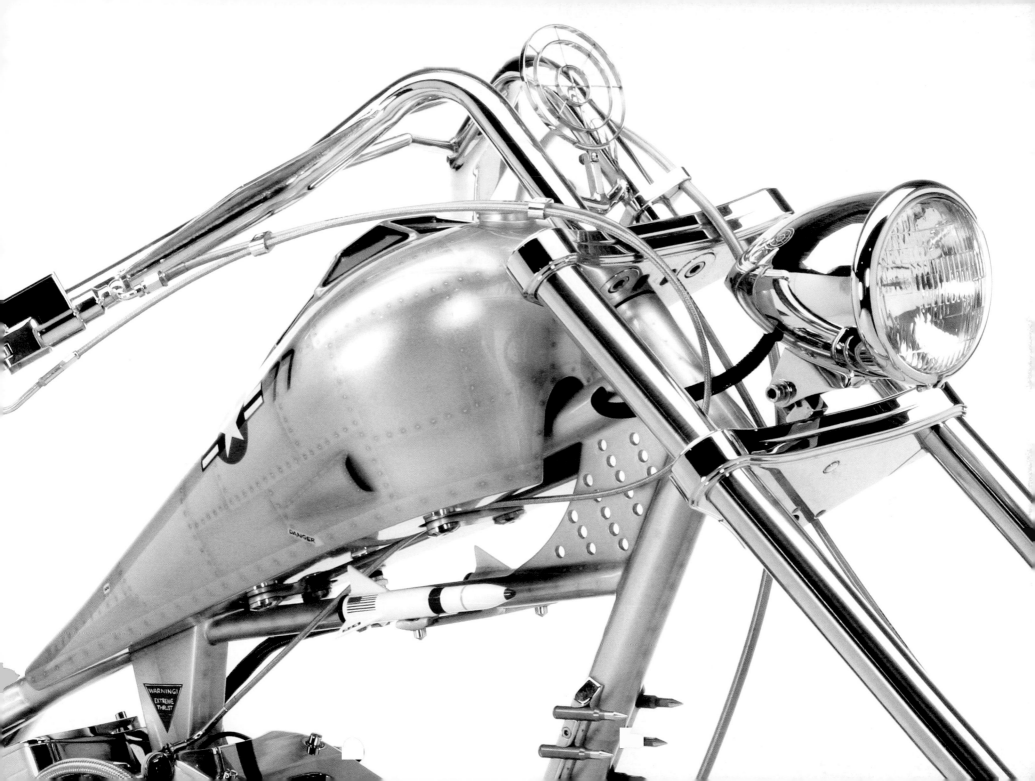

REAR FENDER

With the fenders ordered but running late, Paulie finds himself struggling to unify two utterly mismatched pieces that are lying around the shop. "When things go wrong, you have to be innovative and go into mechanically creative mode," he says. "Because there's no 'not fitting'—you have to make it work." The finished fender brandishes two fins that emulate an F-16's tail.

FRAME

Paulie wants an aerodynamic, "extended" look, and that calls for an unusual frame, featuring a 10-inch backbone (instead of the customary 5-incher) that leads all the way to the bike's tail. To reduce vibration, he opts for beefier tubing.

WHEELIE BAR

With only two weeks left till Laconia, Paulie takes it upon himself to create a wheelie bar that mimics a jet fighter's tailhook. An impatient Paul Sr. contends that Paulie has "bitten off a little more than he could chew" with the deceptively simple piece. "The wheelie bar seemed like it took forever," Paulie admits afterward, but his long night of fabricating paid off with one of the bike's most distinctive features.

OIL TANK

It's the bomb, in more ways than one! But as Paulie explains, no easy feat to fabricate, what with its rounded nose, tubular shape, decorative fins, and crucial, locomotive purpose. "If I make it wrong and the motor doesn't get oil, you're gonna burn [it] up, so there's a delicate balance of form and function."

ENGINE

The engine perfectly suits the Jet Bike's demands for power and pizzazz. It's a chrome-and-blue, 130-horsepower V-Twin that will propel the bike from 0 to 60 mph in less than four seconds.

GAS TANK

Seeking an elongated gas tank, Paulie heads next door to Orange County Ironworks. "I pretty much grew up around it," Paulie says of the steel business. Right at home, he "bends, bangs, and bullies" a sheet of metal until it seamlessly envelops the tank. The process adds 6 inches and takes eight hours, but it's worth every minute. "I kind of think of the tank like a painter's canvas," Paulie says, "because it is the focal point of the bike."

HANDLEBARS

Says Paulie: "My two main concerns with the handlebars were 1) that they swept with the pitch of the tank naturally, and 2) that they didn't sweep so low that they hit the tank." They also had to be long enough to complement the extended frame. So it's back to the metal shop, where he reshapes two 30-inch sections of steel pipe, first at an angle to clear the tank, then at another angle to get a comfortable width.

COCKPIT

Paulie tacks steel rods to the gas tank, forming a framework for sheet metal that will mimic the form of a cockpit. With this detail in place, the chopper takes on the unmistakable character of a jet fighter.

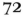

STYLE Q'S AND TECH SPECS

THEME INSPIRATION Military tribute, jet fighters			
WHEELBASE 96"		**OVERALL LENGTH 142"**	
ENGINE 130hp V-Twin			
FRONT	**WHEEL 22"**	**REAR**	**WHEEL 18"**
	TIRE 80/90-21M		**TIRE 240/40R18**

MISSILES

"When you're building a theme bike, it's very important to find things to work with to save on time," Paulie says. In this case, modifying some .50-caliber rounds that he had lying around added military muscle to the chopper and answered that nagging question of what to do with one's leftover large-caliber ammo. The ammo cache will come in handy once again on OCC's other military-inspired masterpiece, the Comanche Bike.

PAINT

For appearance's sake, Paulie opts for a shinier finish than the matte look of a real fighter. Then come the details. As painter Robert "Nub" Collard puts it, "I felt like I was building a model." And an intricate one at that—one fender alone required more than 100 painted rivets! That's in addition to the subtle shading on the faux seams and numerous military emblems and labels. "If you look at how uniform everything is," says Paul Teutul Sr., "it's like I can't even conceive how somebody could do that. It just blows my mind."

Paulie's Private Passion

Teamwork may be important to the production process at Orange County Choppers, but Paulie Teutul knows the pressures and pleasures of solitude. While marking out the "cockpit" that will sit on top of the Jet Bike's gas tank, Paulie alludes to his design process, in which ideas go straight from his head onto the raw metal. "I have no art skills or anything of that nature," he says.

"I'd be lucky if I could draw stick figures, so everything I do, I build as I go."

It's painstaking and often lonely work: "When I begin to fabricate a bike, I like to work alone," he says. That habit, among others, will soon raise the hackles of his coworkers.

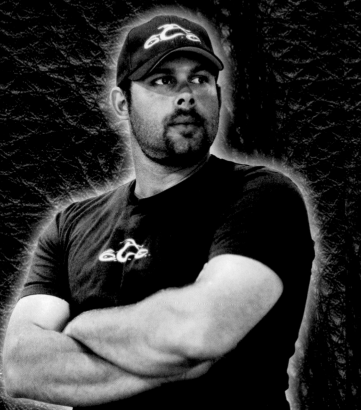

74

From a Whisper to a Scream

Although the narrator of the first AMERICAN CHOPPER pilot episode adds a jarring, melodramatic tone to the proceedings, even more striking is the kinder, gentler commentary from the Teutuls. It's a kick to see a beaming Paul Sr. calmly praising his son's creative talents. But the efforts of the two video newbies to put their best feet forward are exhausted by about the halfway point, when the camera begins to capture the conflict and aggravation that will become the show's "money shots."

Twelve days into the project, when Paulie decides to enjoy some "R and R" on the golf course, Pops Teutul is none too pleased. "Paulie's carefree attitude compared to my attitude—that's one of the biggest conflicts that we have," he grumbles, still managing to keep his cool.

When Paulie arrives at the shop later that day, however, Senior starts sounding some notes that will become very familiar to AMERICAN CHOPPER fans:

✦ "You just show up when you want to show up!"
✦ "You don't get involved in anything that you gotta get your hands dirty with!"
✦ "Get on it!"

Ah, that's the stuff!

Adding fuel to the fire is mechanic James "Dee" Clark, who offers this critique of Paulie: "His dad gets real mad, but he has a good reason.... If you let Paulie stray away, he kinda loses the whole vision of what we're doing."

Assembly on the Jet Bike begins on day 42 and is expected to take three or four days; the deadline is in jeopardy. That won't do, so Paulie stays late to mount the rear fender. But as the narrator so direly puts it, "Paul Jr.'s late-night assembly would have unexpected repercussions."

Sure enough, the following morning finds him in the doghouse. "Paulie is all about Paulie, and it's not a team thing," gripes Dee. "Everybody should be involved and be a part of what we're doing, because it's Orange County Choppers, and that's us."

Paulie apologizes, but not without offering a defense. "There's definitely friction there, even a certain amount of jealousy," he alleges. "Everybody feels like they do so much— and they do—but what sells our products? My designs and ideas."

Dee takes a broader view of Paulie's actions. "You have no respect for either one of us," he says. But he might have misunderstood what "us" means in the OCC shop. "Dee thought that Paulie was kinda stepping on his toes," says Paul Sr., "though he was kind of overstepping his boundaries at that point, which I was a little upset about myself."

Dee Clark soon disappeared from view on AMERICAN CHOPPER and from the shop at OCC. Senior said Clark had decided to pursue other interests. Viewers would quickly get acquainted with a whole new crew.

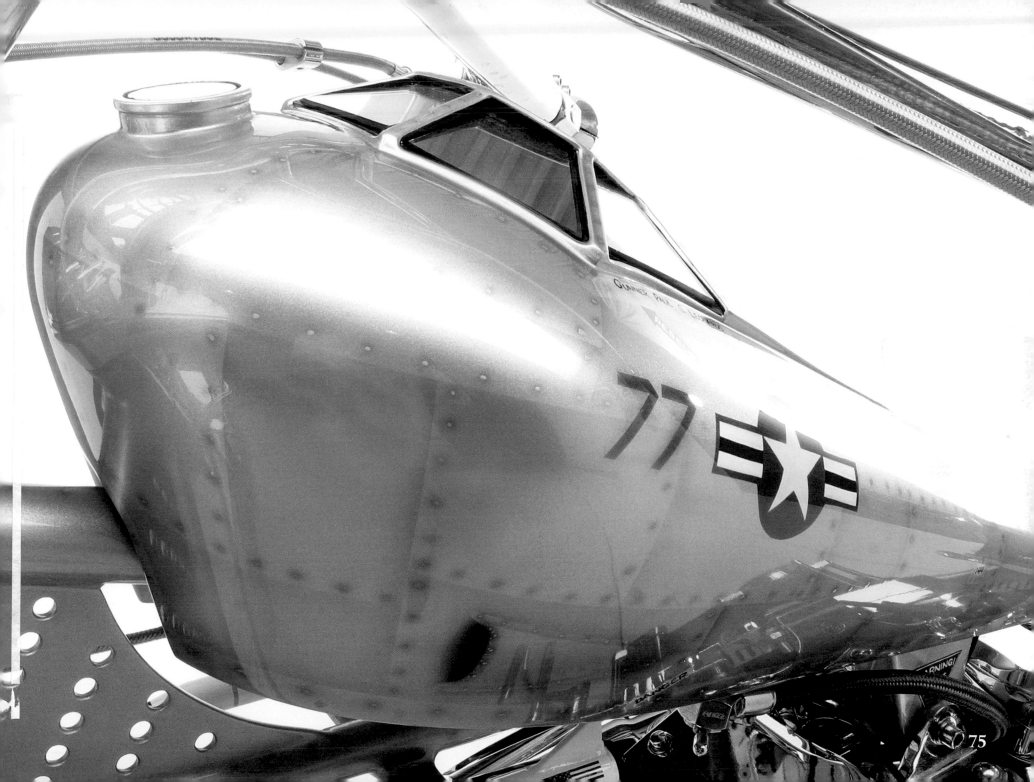

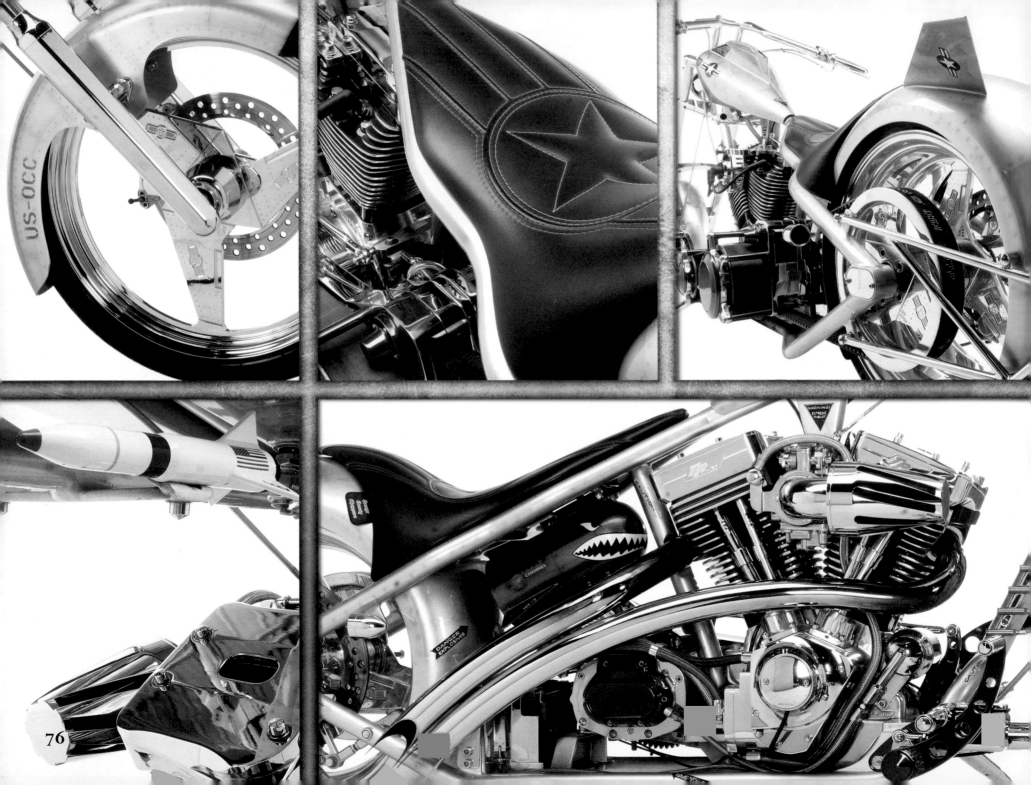

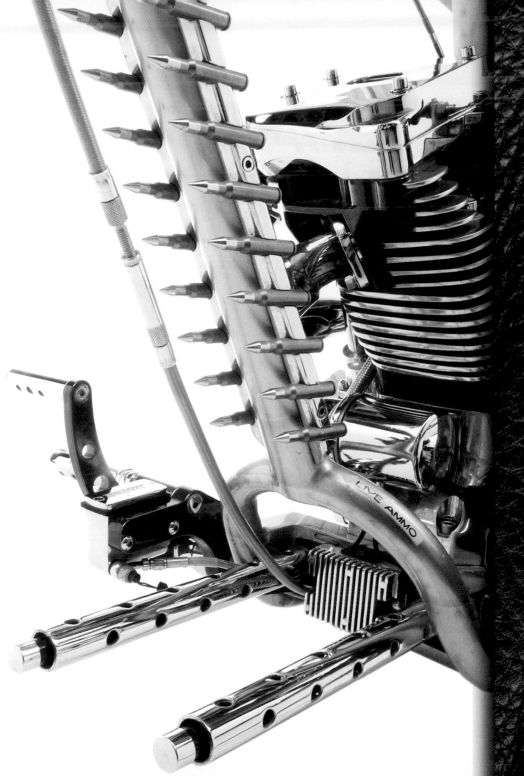

Senior Moments

"I don't ever see you sweeping the floor. I sweep the floor," Paul Sr. gripes, fed up with Paulie's avoidance of the shop's less glamorous duties. "I'm the only guy that has the right to do nothing!"

SPARKS FLY!
It wasn't just Paulie's torch that had sparks flying in the pilot episode. Viewers soon recognized the tension between characters in the dramatic environment of Orange County Choppers.

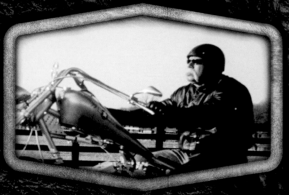

FLIGHT RISK
Senior takes off aboard the Jet Bike, blasting down an Orange County roadway. His test-flight takes full advantage of the bike's powerhouse 130hp engine. So despite the cold, he's delighted by the ride.

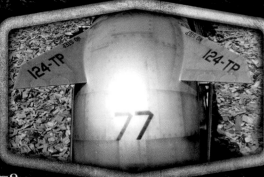

JET SET
A pair of fins and paramilitary numbers add to the Jet Bike's look of raw air power. The finish has a little more gloss than the Pentagon might favor, but the effect is totally combat-ready.

Paulie and Dee are able to put their differences aside, finishing the assembly just in time to load up the Jet Bike and head out to Laconia Bike Week. The New Hampshire confab, established in 1923, is the longest-running motorcycle bash in the country. But there's nothing old-fashioned about these seven days of bikes, babes, and ballyhoo. "It was like complete pandemonium… a freak show," says Senior.

Some of that pandemonium erupts when the Jet Bike rolls into the jam-packed Broken Spoke Saloon & Museum. Basking in the crowd's hooting and hollering approval, a pleased Paulie remarks, "Most of my reward comes by people's reaction to the bike." That's going to have to be good enough for him, as a day-long downpour puts the kibosh on Laconia's design contest.

All Hands on Deck

Paulie is bummed but philosophical about the cancellation. "It was a little bit disappointing," he says, "but really, in the end, it's not all about winning a contest; it's more about pushing the envelope of fabrication and really trying to outdo myself."

Maybe so, but it still feels like a coup when the Jet Bike is chosen for a cover story in AMERICAN IRON magazine. To sweeten the deal even more, the magazine's photo shoot takes place on the deck of the USS INTREPID, bringing the Jet Bike project full circle.

There, photographer Robert Feather piles on the praise: "This bike is all at once striking… There's just a number of great styling cues," he says. "I love to see motorcycles where people have done something a little extra, things where people have… made something truly original and custom."

Whaddaya know? It seems the Teutuls, a pair of true originals themselves, have crafted the ultimate American chopper after all.

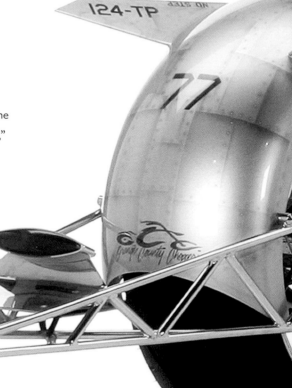

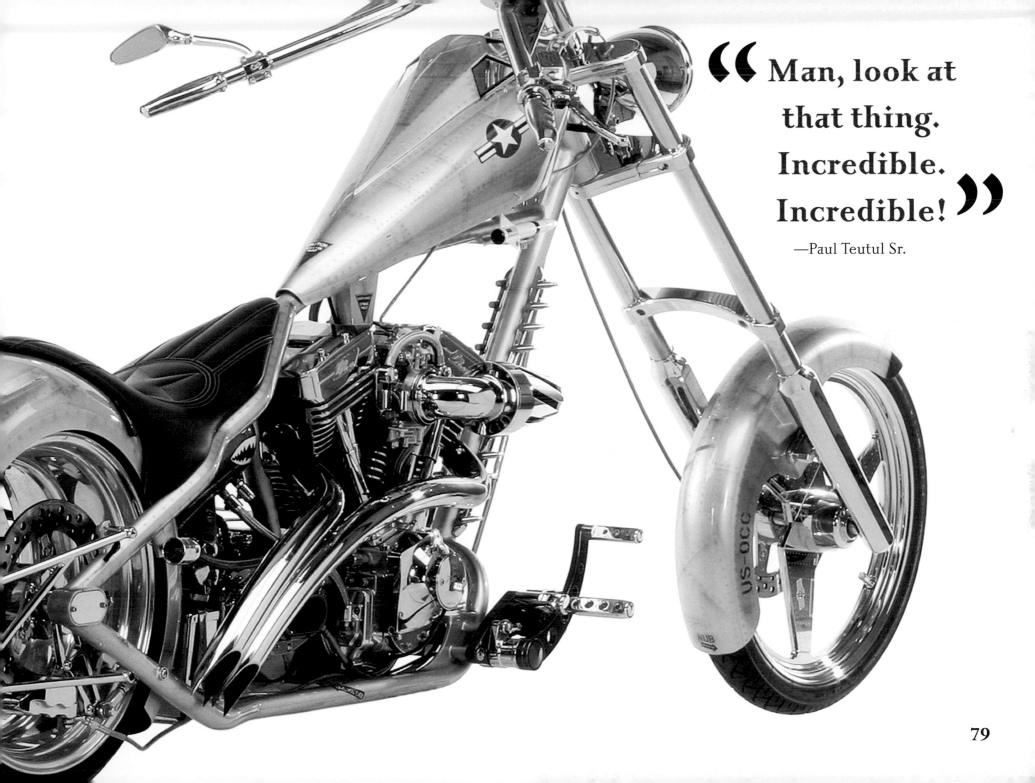

" Man, look at that thing. Incredible. Incredible! "

—Paul Teutul Sr.

It's arachnophobia, Teutul style, as a dreaded trip to the dentist, an impending bike show in New York City, and Paulie's latest high-pressure creation combine to create a tangled web of aggravation for Paul Sr.

THE BLACK WIDOW PROJECT MARKS A GIANT STEP for the Teutuls and AMERICAN CHOPPER. Based on the success of two CHOPPER specials, the Discovery Channel launched AMERICAN CHOPPER: THE SERIES, giving fans a weekly fix of the Teutuls' distinctive on-road and in-house fireworks. Meanwhile, back at the shop, Paul Sr. has taken on a few new employees to keep up with customer demand. One is 15-year-old intern Cody Connelly, who'll earn credit from his trade school for his work-study program at OCC.

The Teutuls are looking to earn some credit too, at New York City's International Motorcycle Show, a mere four weeks away. To wow the Gotham crowd, Paulie knows he'll have stiff competition—even from his own recent past. "You've got to keep outdoing yourself," he says. "You basically have to shock people to stay on top of things."

There's a little kid inside every chopper fan, and Paulie's "inner child" has an infatuation that inspired this bike's theme. "I'm fascinated by webs," he confides, "just because they look cool." With that in mind, he decides that the Black Widow will feature them wherever possible, along with its menacing spideresque colors of red and black.

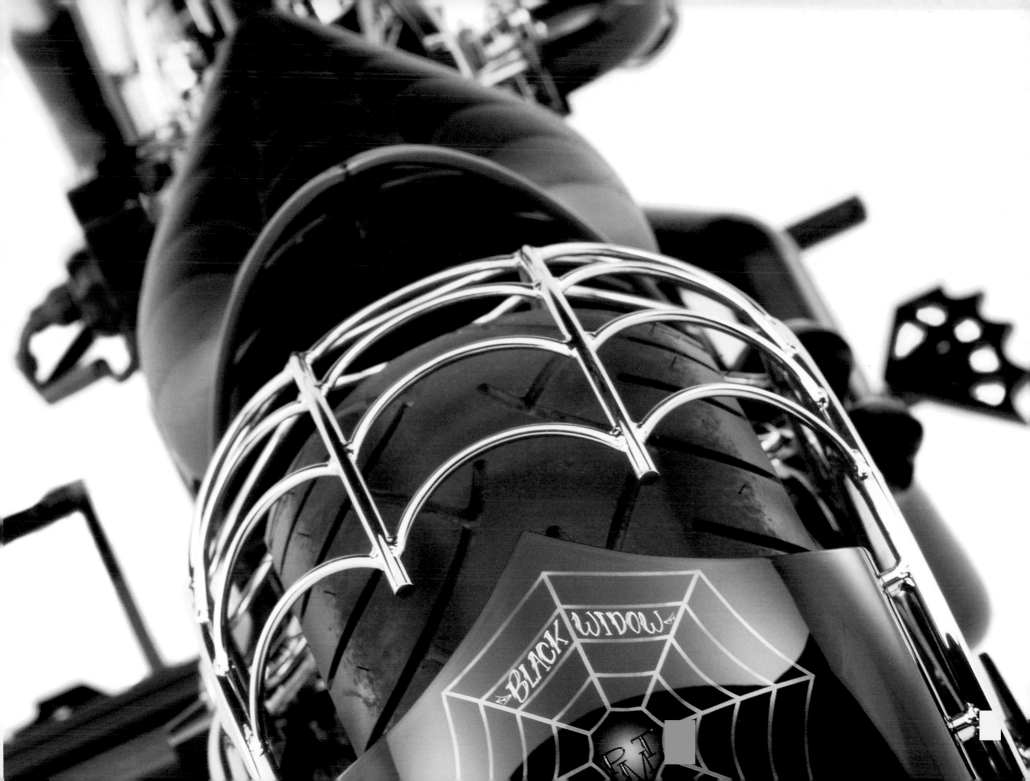

WEB MASTERS

Paulie soon realizes that fabricating the webbing is as time-consuming and tedious as it is essential. To speed up work on the bike's tins, he brings in journeyman welder Dennis Vittum. They bend, cut, and bond bits of cold rolled bar stock, which will later be chromed.

"It just floats," Vittum says admiringly of Paulie's vision, which has the webs sitting just above the surface of the gas tank and fenders. "I come from an art background," Vittum beams, "and believe me, that's art."

The compliment is not lost on Paulie: "Anytime I have an old-timer or an old-school craftsman really admire what I'm doing, I always really take that to heart."

CUSTOM WHEELS

For the Widow's webbed wheels, technology steps in: Paulie's sketch of his concept is replicated using a computer design program. The computerized design and a solid aluminum wheel "slug" get fed into a computerized machining center. Inside the booth-like device, a rotary forge stabilizes the wheel-to-be while it is attacked by drill bits of differing sizes and shapes. Three hours later and voilà! a one-of-a-kind wheel emerges. A run through the polishing machine, and it's off a very happy Paulie. "When you see the third dimension to them, they shine," he beams. "Awesome!"

SADDLE SECRET

Black with thin red stitching, the bike's seat just doesn't deliver the visual bang that Paulie had hoped for. With no time to get a new one made, he breaks out a secret weapon. How do you perk up a ho-hum saddle? "I just kind of improvised," Paulie confesses. "A little Armor All... got it to shine."

LATE BUT GREAT

Sometimes even the best-laid designs sprout post-assembly snafus. In the Widow's case, Paulie decides that the bike needs more visual contrast. The solution is small but significant: Send out the chromed air cleaner for black powder-coating.

Small or not, late design changes are risky: They may not work and they often cause political fallout. "A lot of times, when we come up with these last-minute decisions," Paulie explains, "my father freaks out—he doesn't want to go for it." The silver lining this time: "Even he agreed that I was right."

HITTING THE BARS

This just in, one day before the Widow's scheduled chroming: "For some reason, my father took it upon himself to mock up the handlebars," says Paulie. "That might not have been the best idea." Apparently not—they're set so low that the gas tank can't be opened and they're missing a necessary stop to keep them from turning 360 degrees. It's back to the metal shop to fabricate a new pair.

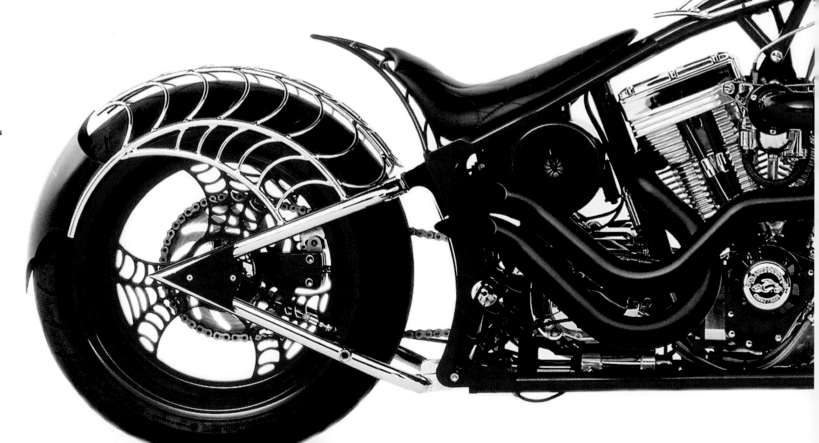

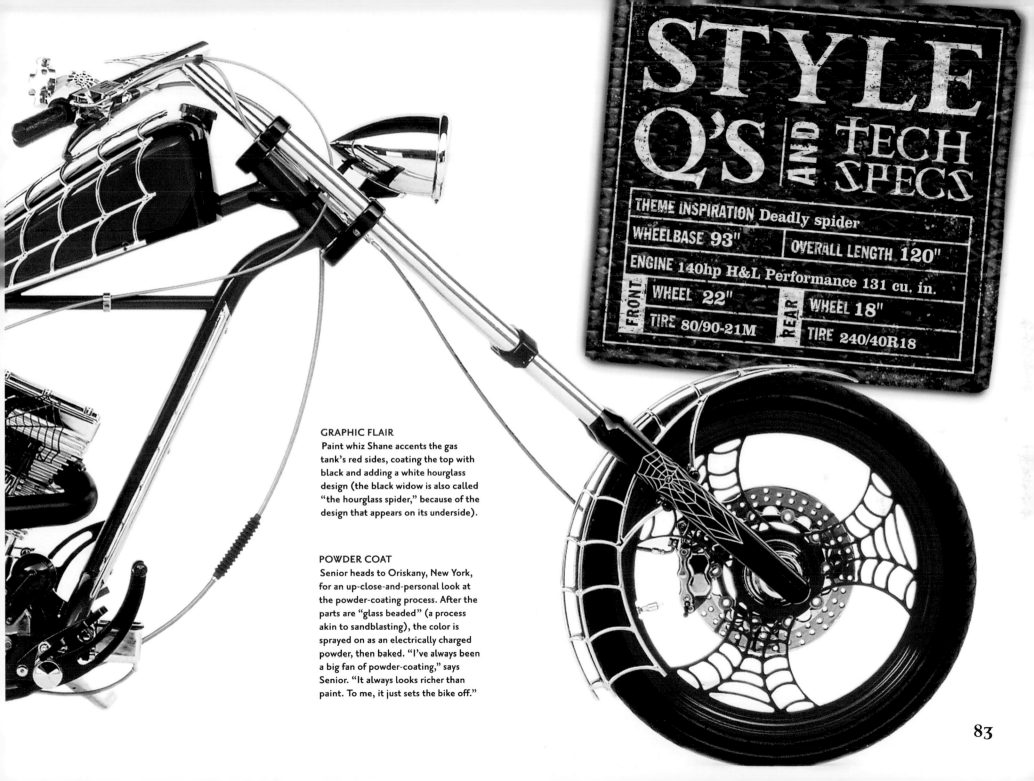

STYLE Q'S AND TECH SPECS

THEME INSPIRATION	Deadly spider	
WHEELBASE 93"		**OVERALL LENGTH 120"**
ENGINE 140hp H&L Performance 131 cu. in.		
FRONT	WHEEL 22"	**REAR** WHEEL 18"
	TIRE 80/90-21M	TIRE 240/40R18

GRAPHIC FLAIR
Paint whiz Shane accents the gas tank's red sides, coating the top with black and adding a white hourglass design (the black widow is also called "the hourglass spider," because of the design that appears on its underside).

POWDER COAT
Senior heads to Oriskany, New York, for an up-close-and-personal look at the powder-coating process. After the parts are "glass beaded" (a process akin to sandblasting), the color is sprayed on as an electrically charged powder, then baked. "I've always been a big fan of powder-coating," says Senior. "It always looks richer than paint. To me, it just sets the bike off."

Two Pauls, No Waiting

Two fairly intense drivers, one small parking lot... What could go wrong?
"My father and I were kind of fooling around a little bit, and we started
backing out of the driveway a little too fast," Paulie recalls. "We were both
being idiots. And I basically smashed his bumper with my truck."
Senior responds in his inimitable fatherly fashion, inquiring of his son,

"What the heck's the matter with you?!!"

Then, surveying his damaged truck, Teutul the Elder offers a helpful
suggestion: "Get a chain and hook it on there and rip it right out.
Rip it out of there! RIP IT OUT!!"
Oh, it ripped all right. Tore a chunk right off the truck. Naturally, by this
time, a small crowd had formed, and everyone was convulsed with
laughter. Even a Teutul's famous Force 4 Fury can't stand up against the
entertainment value of busted vehicles. Junior laughed; Senior laughed.
"Hey, that's a lot better," Senior says. Paulie is quick to agree:
"That kind of thing just takes the edge off."

Takes one edge of a truck off too.

Web-meister Paulie is delighted by the praise from veteran welder Dennis Vittum, who assisted with the tins. However, the other old-school craftsman in the shop isn't so upbeat. In fact most of the Black Widow project finds Senior by turns worried, miserable, and downright bugged. For starters, he's suffering from a toothache, dreading his upcoming root canal, and chafing at Junior's teasing. Then, as the webbing process drags on, he declares that the design "might be a little too ambitious."

Concern turns to irritation when Paulie delays supplying The Boss with a list of their attendees for the upcoming New York show and balks at schlepping parts to the chromer on a Sunday. The percolating volcano that is Paul Teutul Sr. finally erupts when an under-the-weather Paulie shows up late to work, not once but twice.

"You got like 10 people here waiting on you—on the king!" he bellows sarcastically. Sick, as an excuse? Senior isn't buying it: "You know what? Suck it up a little bit! Suck it up!"

The clash between father and son bangs into full-contact mode when their trucks collide in the parking lot. "I figured I'd just take off a little quick and show off a little bit," Paulie recalls. "And he must have thought the same thing and somehow we kind of met in the middle there." The silver lining in this clash of storm clouds? Breaking fenders also broke some tension. As Paulie says, "Neither of us had laughed that hard in months."

Ladies and Gentlemen: Michael Joseph Teutul

More comic relief arrives with the debut of OCC's new "phone answerer." The youngest of the Teutul men, Mikey describes his transfer from Orange County Ironworks as his "last straw" in the family businesses.

"I was a deadbeat as an ironworker, and I really didn't like doing it, so my dad gave me the opportunity to come down here," says the shaggy-haired, shorts-wearing free spirit, whose duties also include taking out the trash and shoveling snow. As Mikey quips, "This is what you get if you don't know how to build a chopper."

❝I was a deadbeat as an ironworker, and I really didn't like doing it, so my dad gave me the opportunity to come down here.❞

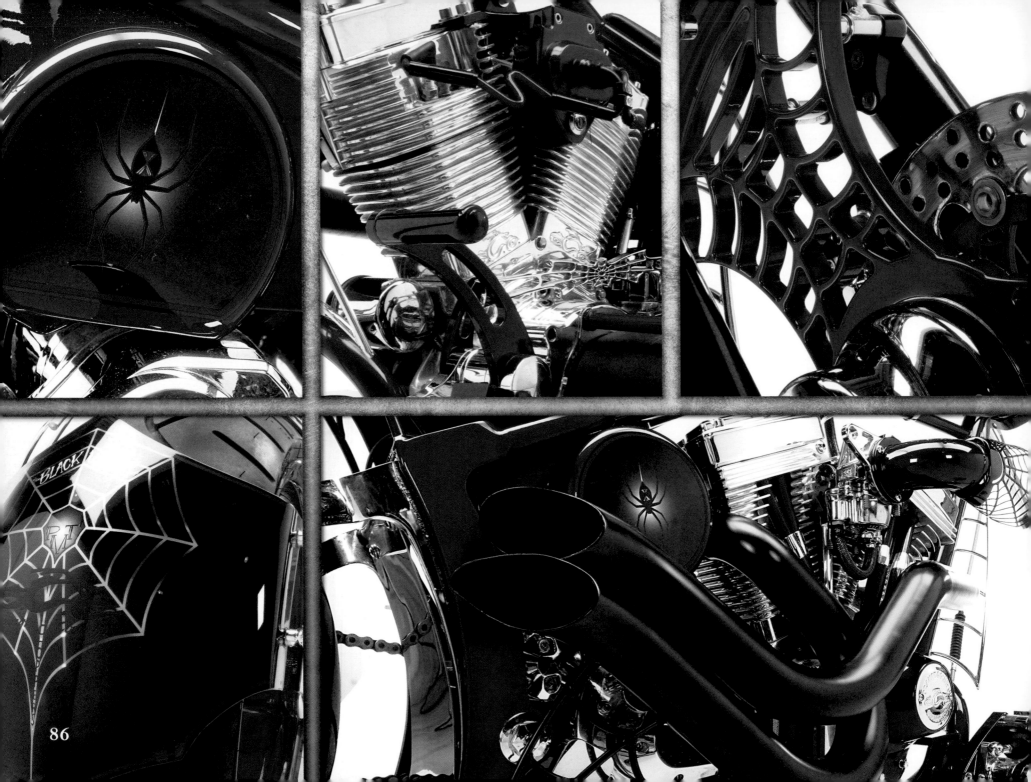

Flare-Up!

Mikey's easygoing nature helps ease the stress level around the shop. But nothing can stop the occasional blowup. Viewers can see it coming sometimes, as when Senior storms into the midst of Black Widow assembly:

"What is all this crap anyhow?" he roars when he finds his shop less orderly than he wants it to be. A solution comes to mind: "You know, you know what I'm gonna do? I'm just gonna fire everybody." Then he launches into a speech that any parent knows by heart:

"How hard is it to understand that when you're done with something, put it back? Or if you make a mess, clean it? What am I running, Romper Room over here? Really! I feel like I got kids that I got to run around and clean up after. It's @#$%! It's @#$%!!"

A few days later, the Widow is ready to roll. Senior, his aching tooth repaired, is especially

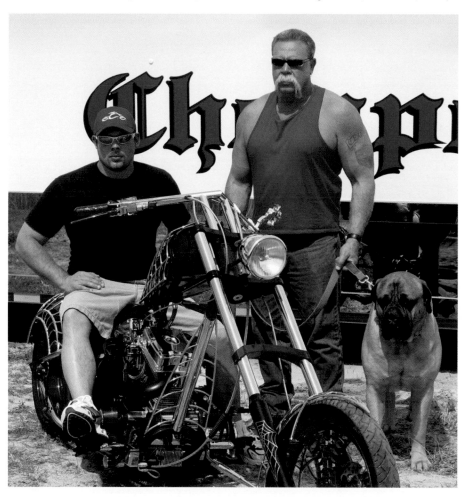

SENIOR MOMENTS

Terms of Endearment

Almost everyone uses favorite nicknames and pet names for dear family members. You know, "Snookums," "Kiddo," "Sweetie," "Punkin..."
Paul Teutul Sr. shares a few favorites for son Paul during work on the Black Widow Bike:

• "NUMSKULL OVER THERE IS WHISTLING DIXIE."

• "MONDAY MORNING QUARTERBACK." ("AFTER YOU MAKE THE DECISIONS, THEN HE'S GOT SOMETHING TO SAY ABOUT THEM.")

• "CHUCKLEHEAD OVER THERE IS SCRATCHING EVERYTHING UP... AND IT'S DRIVING ME CRAZY." Awww, DAD.

Genius at Work

"HEY, DO SOMETHING, WILL YA?" BARKS SENIOR, WHO'S TYPICALLY ANXIOUS AND IMPATIENT AS THE SHOP CREW SCRAMBLES TO GET A BOOTH SET UP FOR THE NEXT BIKE SHOW.

EVER ADEPT AT PUSHING POP'S BUTTONS, A BLASÉ PAULIE STATES MATTER-OF-FACTLY, "I'M A DESIGNER AND FABRICATOR. OTHER THAN THAT, I DON'T DO ANYTHING. YOU KNOW THAT."

"YEAH," SAYS SENIOR WITH A DEFEATED FROWN, "WE ALL KNOW THAT!"

THE ROOT OF THE PROBLEM
Nothing shortens your fuse like a toothache. Facing a root canal and a big bike show, Senior is just a wee bit on edge during the Black Widow episodes.

SPIDERMEN
Cutting, shaping, and welding, Paulie and Vinnie painstakingly assemble the metal webbing that will become the Black Widow Bike's amazing rear fender.

GRAPHIC VIOLENCE
The deadly black widow spider carries an hourglass-shaped marking on its abdomen. Under Paulie's watchful eye, Shane lays out a similar motif on the chopper's gas tank.

happy that the bike came in on schedule. He has nothing but compliments for the work.

"Everything flows. Everything's beautiful," he says. "Between his fabrication and the components, the bike is just gonna kill."

Senior is so psyched that he volunteers for a spin on the frigid, snow-caked local roads. "I usually enjoy test-riding each bike, but when it's two below zero outside... I gotta tell you, it's enough to make a grown man cry." Post-defrosting, he reflects: "Besides freezing my @#$ off... [it] was a great ride."

Escape to New York

New York City beckons, but first the Black Widow has a date with magazine photographer Bob Feather. As a veteran lensman who's shot many a two-wheeled beauty, his compliments carry a lot of weight.

"One of the things I like best is the use of open space," he says of the Black Widow Bike. "The web fenders are not solid; they're more of a skeleton over the bike; and amidst all this open space, there's this big, bad-ass 240 [that's the width, in millimeters] tire along with the engine, the 5-inch belt drive, and the artistically cut primary-drive guard."

His conclusion is glowing: "This particular bike ranks in possibly the all-time top three that I've photographed."

Rave On

More praise awaits the OCC crew as they roll into the Jacob Javits Convention Center on opening day of the international show. Throngs of fans crowd around seeking a photo or an autograph, but Paulie is most wowed when the Black Widow gets a thumbs-up from famed bike designer Roger Bourget.

"It kind of blew me away a little bit," Paulie says, explaining that Bourget "pretty much inspired me right from the beginning.

"I've only been building bikes for about three and a half years," Paulie adds, "so when I see someone whom I really respect admiring my work, it really makes all the grinding and welding and shaping and fabricating worthwhile. And it really inspires me."

FUN FACT
Wonder what those exotic theme bikes are worth? Only the market can say for sure, but Senior has his opinions. In episode 2, he says during a photo shoot that the Black Widow is a $150,000 bike.

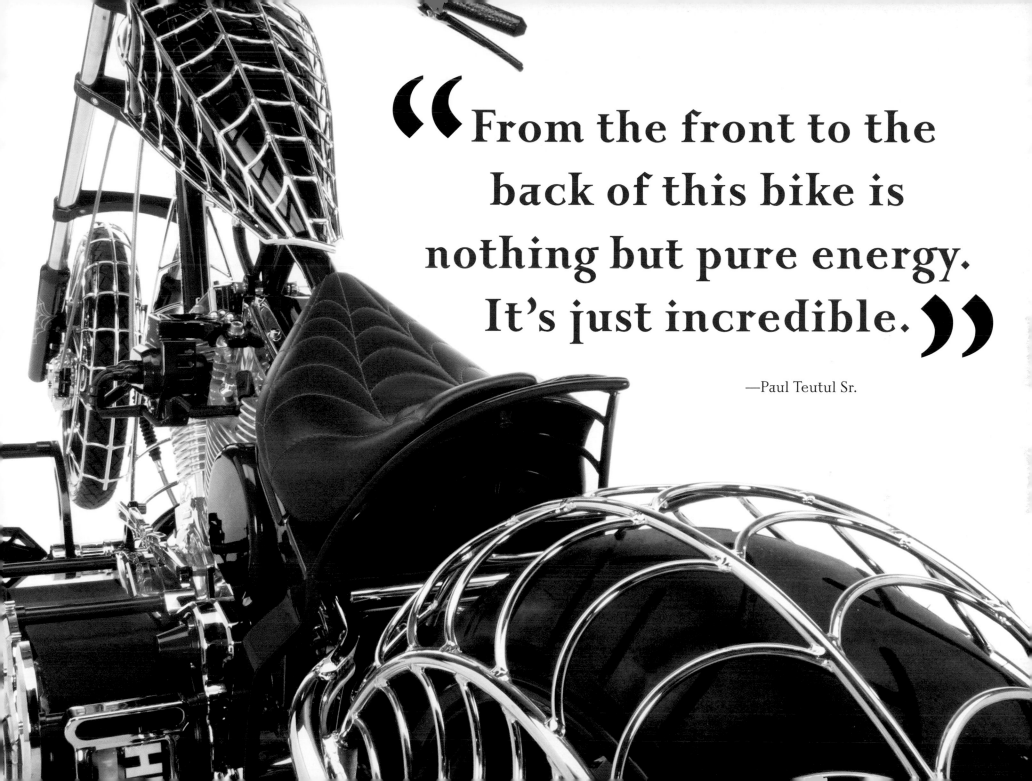

"From the front to the back of this bike is nothing but pure energy. It's just incredible."

—Paul Teutul Sr.

A Tribute to Heroes

If it hadn't already been clear that American Chopper was more than just a TV show about motorcycle construction, that point would be driven home, heartbreakingly, with the Fire Bike. A work of stunning beauty and sorrow, this tribute to firefighters who perished in the attacks of September 2001 filled its creators as well as viewers with an abiding sense of honor, pride, and reverent respect.

As the world cannot forget, the events of that fateful blue-skied morning brought Americans together in anguish and awe. Perhaps it was only fitting, then, that hardworking shops from all over the United States would join in building this monument to the men and women who lost their lives attempting to save thousands of strangers. The Fire Bike would boast a carburetor from Texas, a gas tank from California, wheels from New Hampshire, and a swing arm from Oklahoma.

"It's going to be one of our greatest projects ever," Paulie announces at the outset. He got that right, as the Fire Bike would soon take shape as American Chopper's most popular project and surely its most meaningful.

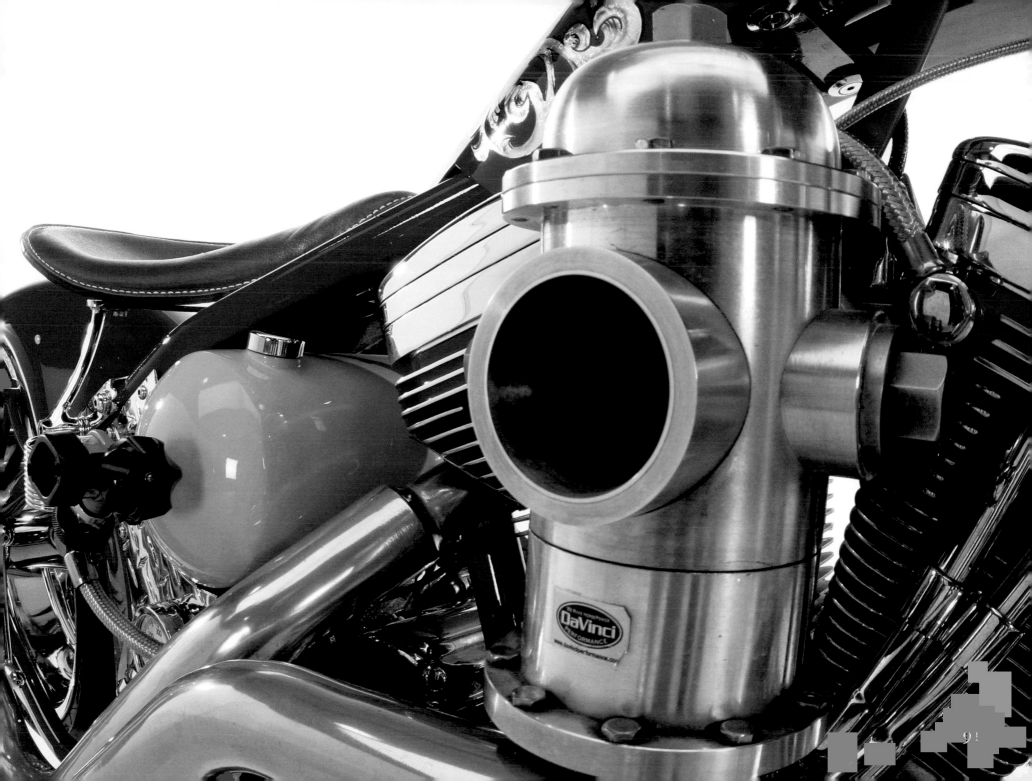

STYLE Q'S AND TECH SPECS

THEME INSPIRATION Tribute, firetruck

WHEELBASE 93"	**OVERALL LENGTH 120"**

ENGINE RevTech 100

FRONT		**REAR**	
WHEEL 21"		WHEEL 18"	
TIRE 80/90-21M		TIRE 240/40R18	

ONE OF A KIND

Striving for a "really exceptional" gas tank, Paulie hires ace fabricator Mike Stafford at MGS Custom Bikes in Lancaster, California. "He wanted it to resemble a firetruck but still have the real fluid lines of a gas tank," Stafford says. Making the tank as long as possible, Stafford added recessed "window panels" and small orange and red reflector lights. The result: a rare level of detail, a gesture of respect, and a source of pride. "We poured our heart and soul into it," Stafford says. Paulie's reaction: "Awesome!"

REAL DEALS

• The oil tank was created from a bright yellow oxygen tank, obtained from a fire-fighting supply house.

• Gauges are mounted on diamond-plate side panels, the same type of material that's found on firetrucks.

• To get the beefier look he's aiming for, Paulie opts for a classic natural-leather Indian seat and fabricates wide-arc handlebars that mimic the broad steering wheel of a bona fide hook and ladder. "The challenge when you're creating a theme bike," Paulie says, "is to know when enough is enough."

INSPIRED IMPRESSIONS

A small ladder is integrated into the swing arm (the back section of a soft-tail frame that holds the rear wheel). "Incredible," says Paulie, who worked with Sam Wills's Racing Innovations in Oklahoma City to come up with this attention-getting detail.

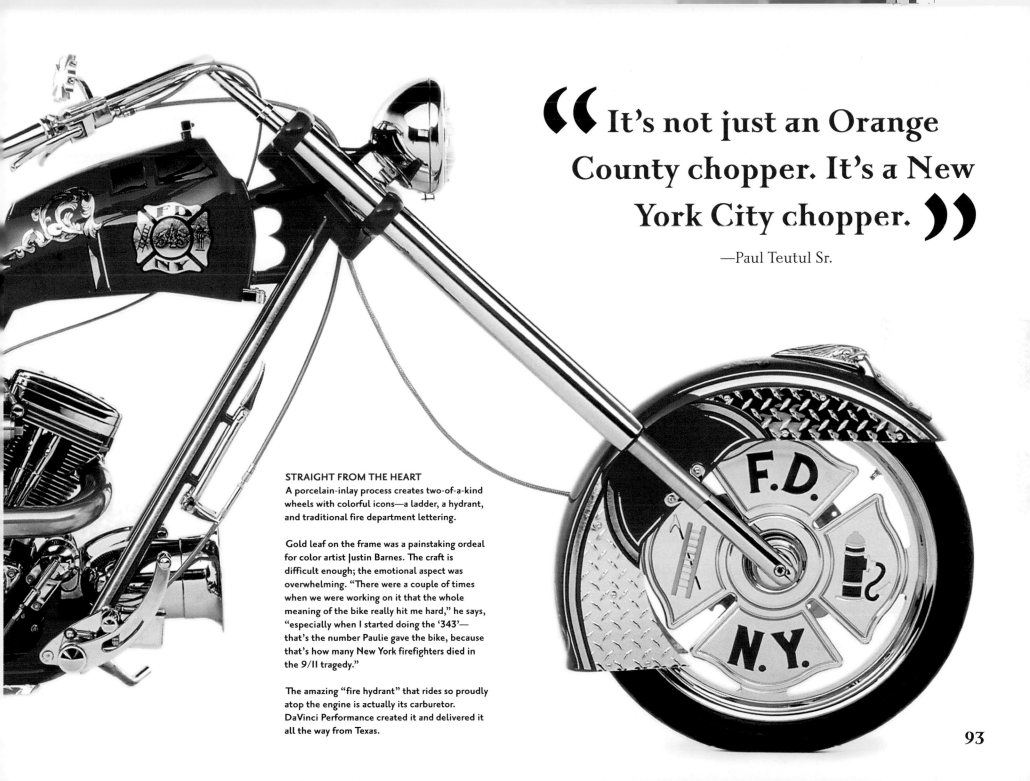

> **"It's not just an Orange County chopper. It's a New York City chopper."**
>
> —Paul Teutul Sr.

STRAIGHT FROM THE HEART
A porcelain-inlay process creates two-of-a-kind wheels with colorful icons—a ladder, a hydrant, and traditional fire department lettering.

Gold leaf on the frame was a painstaking ordeal for color artist Justin Barnes. The craft is difficult enough; the emotional aspect was overwhelming. "There were a couple of times when we were working on it that the whole meaning of the bike really hit me hard," he says, "especially when I started doing the '343'— that's the number Paulie gave the bike, because that's how many New York firefighters died in the 9/11 tragedy."

The amazing "fire hydrant" that rides so proudly atop the engine is actually its carburetor. DaVinci Performance created it and delivered it all the way from Texas.

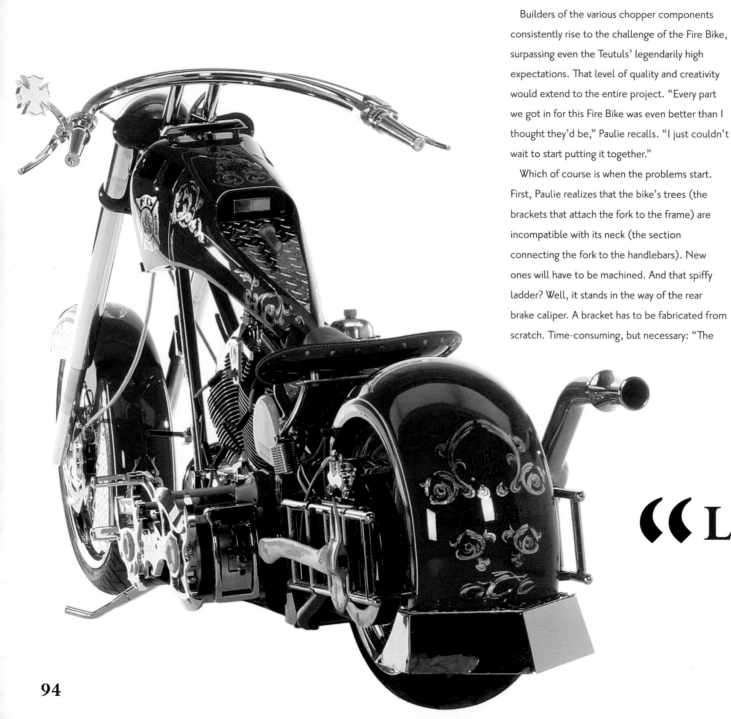

Builders of the various chopper components consistently rise to the challenge of the Fire Bike, surpassing even the Teutuls' legendarily high expectations. That level of quality and creativity would extend to the entire project. "Every part we got in for this Fire Bike was even better than I thought they'd be," Paulie recalls. "I just couldn't wait to start putting it together."

Which of course is when the problems start. First, Paulie realizes that the bike's trees (the brackets that attach the fork to the frame) are incompatible with its neck (the section connecting the fork to the handlebars). New ones will have to be machined. And that spiffy ladder? Well, it stands in the way of the rear brake caliper. A bracket has to be fabricated from scratch. Time-consuming, but necessary: "The

tricky thing about building theme bikes is that they not only have to look good, they have to function," Paulie says. "It's not a still sculpture—people actually ride these things, and you want to make sure they're going to be safe."

Those glitches, combined with some annoying modifications to center the rear wheel, throw the bike off schedule. Really off schedule. "This is the first time that I'm not going to make a deadline that I set for myself," Paulie admits at one low point. "But it really doesn't matter, because this bike is more important to me than any deadline or bike show."

Even Paul Sr. is forgiving on this very special project: "Daytona Bike Week is just around the corner, and there's no way that he's gonna finish in time, but it's not because he didn't really try."

Pop is a little less agreeable as Paulie hunkers down to create a nearly full-enclosure rear fender that will support a rack on top and feature a chromed triangular box on its tail. The Boss questions the fender's "severe" roundness, insisting that firetrucks typically have a square

"Let's get cranking here!"

—Paul Teutul Sr.

Prototype Tank
FOR THE FIRE ENGINE BIKE
as seen on the
DISCOVERY

THE DETAILS
Paulie tests the handlebars, trying to capture a sense of the wide, flat wheel on a hook and ladder truck.

THE SPIRIT
Mikey takes a moment to speak sincerely about the character of firefighters and the spirit of service that is so much a part of any firehouse.

THE CHARACTER
Like any newbie on a firehouse crew, Mikey and Paulie take a turn at kitchen duties. The experience gives them a taste of firehouse life, a chance to steep in the traditions of this gallant profession.

95

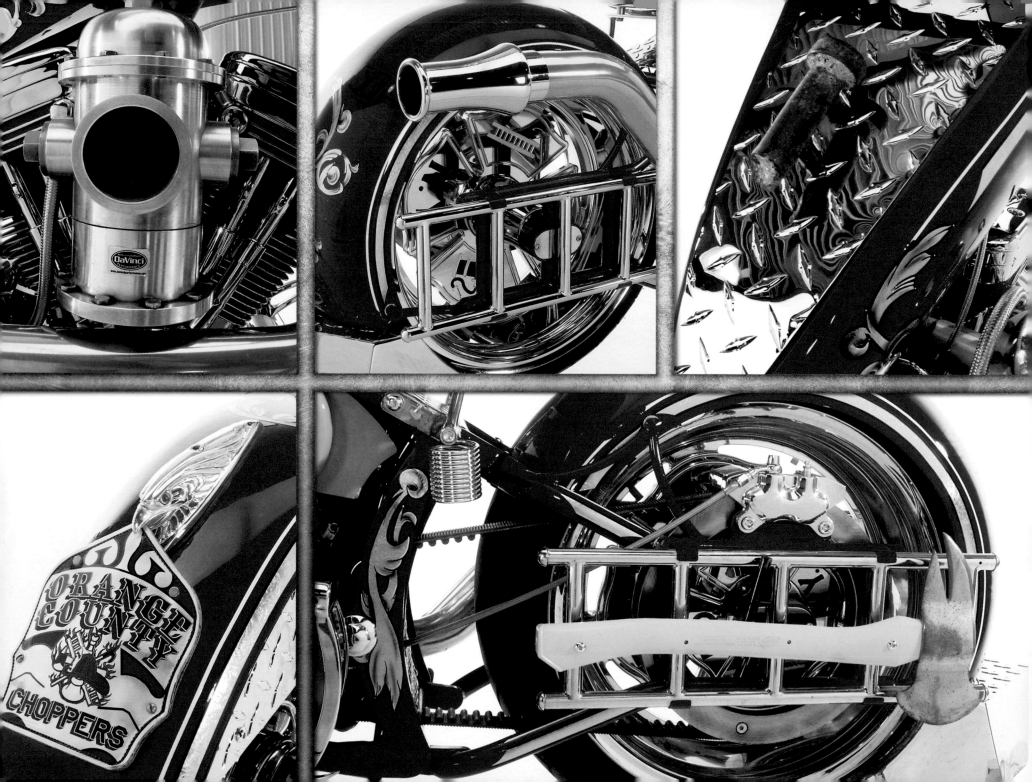

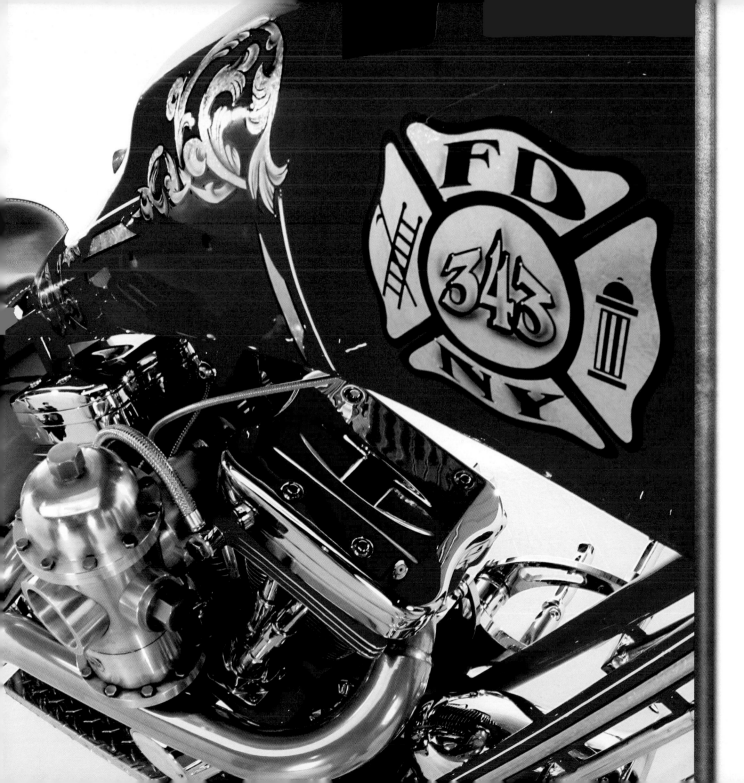

shape. "I may not be a designer, but I got an eye," Senior asserts, "and that's where he got his eye from." But Paulie holds firm: "It's not like I don't appreciate my father's ideas and input, but I can see the bike in my head and I know where I'm going with it."

About a month into the project—an eternity in OCC time—Paulie finds he needs inspiration and pays a visit to Mikey's old friend Al Ronaldson, a firefighter at Engine 75/Ladder 33 in the Bronx. Hanging out, goofing off, and eating with the company turns out to be fun and inspirational.

"Ever since I was younger, I've admired firemen," Paulie says. "And getting a chance to spend some time with these guys really helped me to see a little more into the meaning of the project." He gets so psyched that he promises the bike will be ready in two weeks. *Uh-oh....*

Dad, Denied

Newly energized, Paulie and Senior head off to a fire-fighting supply shop, where they snag an oxygen tank, gauges, and an eardrum-splitting siren—"just the kind of stuff I was looking for to achieve that authentic look that this bike has to have," Paulie says.

That's a bummer for Senior, who had hoped to make a personal contribution by crafting a decorative toolbox. Paulie thinks it would make the bike look "too cluttered." Mikey's take? "He took the time to make this box, and Paulie pretty much looked at it like it was nothing," he says, adding with his usual self-deprecation, "but what do I know? I just order parts and take out the trash." Alas, Senior's labor of love ends up on his desk holding misfit nuts and bolts.

ALL SMILES
Senior beams as Paulie helps hook up Vinnie's test-drive helmet. The long hours and emotional investment are about to pay off as the Fire Bike fires up for the first time.

SHINING EXAMPLE
Sunlight glints off the long forks of the Fire Bike as Vinnie roars through Orange County back roads. Viewers shared in the pride after watching the creation of this tribute chopper.

SHEER AWE
Paulie shows OCC's latest creation to some of the firefighters who helped inspire its details. Their enthusiastic response was gratifying for the builders and touching for viewers.

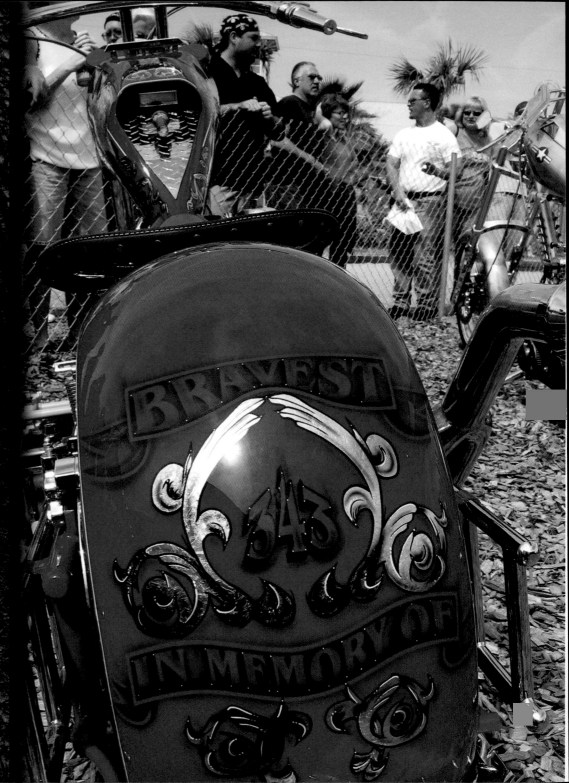

For a one-of-a-kind feat marked by imagination and emotion, it's hard to top DaVinci Performance's "fire hydrant" carburetor. Dan DaVinci personally escorted the gleaming masterpiece from his Texas headquarters to the OCC shop. He may be exhausted, but he's equally fulfilled by his part in the Fire Bike assembly.

"This project had more than mechanical aptitude and ability; it had deep, deep meaning," he says. "We're very, very proud to be involved with this thing and give something back—just a small token [for] what these people do for us."

Meanwhile, whaddaya know? When the rear fender returns from the paint shop, Senior raves about how its rounded edges achieve a vintage firetruck look. "You know, it's funny," Paulie says later, noting the irony, "even when my father admits that he's wrong about something, he somehow makes it seem like he was right all along. You would've thought that the way the rear fender turned out was the way he wanted it to look in the first place."

Celebration and Remembrance

After a breakneck final three days during which Paulie and Vinnie clock nearly 60 hours, the moment of truth arrives as the bike is lowered off the lift and gassed up. "You could've heard a pin drop in the shop when it

came time to start it," Paulie recalls. When it sparked up, adds Senior, "Paulie was grinning from ear to ear." That was a magical moment for both Teutuls, one that sticks in the mind, if not the throat, of Paul Sr. when he says, "I don't think I've ever been prouder of my son."

Maintaining the spirit of generosity that inspired the project, the Teutuls bestow test-ride honors on their right-hand man. "It was very important for me to see Vinnie ride this bike first," Senior says. "He worked so hard, and he really hung in there day and night with me... so it's well deserved."

A shocked Vinnie is visibly touched. "Just being involved in the creation of this bike was an honor," he says, "and having Paulie and Big Paul ask me to take it out for a first ride, it just blew me away. It's a moment that I don't think I'll ever forget."

Next the boys make their way back to the Bronx. As Paulie motors up to the entrance of Engine 75/Ladder 33, a group of New York's Bravest stand silent, slowly taking in the bike's thoughtful design details and sheer beauty.

But Paulie has saved the best for last, as atop the gas tank he affixes the bike's final piece— a bolt recovered by a firefighter from the ashes of the World Trade Center.

"It just shows what kind of a person Paul really is, that he put a little piece of 9/11 in there," says a knocked-out Al Ronaldson. "That was a class act."

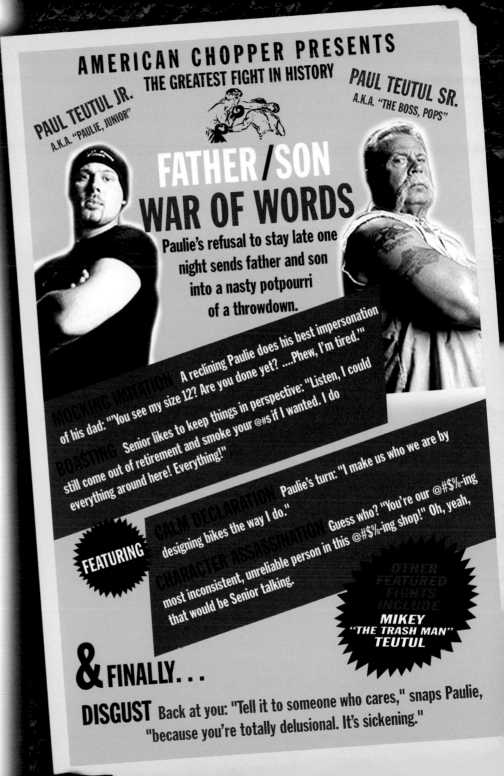

AMERICAN CHOPPER PRESENTS
THE GREATEST FIGHT IN HISTORY

PAUL TEUTUL JR.
A.K.A. "PAULIE, JUNIOR"

PAUL TEUTUL SR.
A.K.A. "THE BOSS, POPS"

FATHER/SON WAR OF WORDS

Paulie's refusal to stay late one night sends father and son into a nasty potpourri of a throwdown.

MOCKING IMITATION A reclining Paulie does his best impersonation of his dad: "You see my size 12? Are you done yet?Phew, I'm tired."

BOASTING Senior likes to keep things in perspective: "Listen, I could still come out of retirement and smoke your @#$ if I wanted. I do everything around here! Everything!"

CALM DECLARATION Paulie's turn: "I make us who we are by designing bikes the way I do."

CHARACTER ASSASSINATION Guess who? "You're our @#$%-ing most inconsistent, unreliable person in this @#$%-ing shop!" Oh, yeah, that would be Senior talking.

FEATURING

OTHER FEATURED FIGHTS INCLUDE
MIKEY "THE TRASH MAN" TEUTUL

& FINALLY...

DISGUST Back at you: "Tell it to someone who cares," snaps Paulie, "because you're totally delusional. It's sickening."

Old School CHOPPER

EPISODE
8&9

ORIGINAL AIRDATES

June 16 and June 30, 2003

Parting was such sweet sorrow when the Cody Project was sold at 2003's Daytona Bike Week. "God, I'm gonna miss that thing," said its teenage namesake as the chopper rolled off to a new home.

But the Boss has no time for nostalgia; he's got a new idea. Paul Sr. suggests that the shop's oldest and youngest guys team up for a new project all their own. And how apt that they decide to create a chopper that is both nostalgic and state of the art!

"The old-school chopper really became popular in the late '60s," says Senior, "especially after the movie Easy Rider. And I gotta tell you, I've always liked that look."

But what exactly makes a bike "old school," anyway? Well, spoked wheels, a kick start, foot clutch, sissy bar, "ape hanger" handlebars... and a no-nonsense work ethic enforced by a gruff, buff, middle-age boss.

This project will be a huge leap forward for Senior's 15-year-old protégé. "Cody's like everybody's little brother in the shop, and he's a quiet kid," Vinnie confides. "But if you know him like we do, you can tell he's pretty stoked up about this bike."

Cody has quickly become a favorite of viewers too. He breezes around Mikey on the bike-assembly learning curve, and with Senior looking on approvingly the youngster seems to be on pace with Paulie, learning skills in his teen years that many pros would envy. But is he tough enough for the long haul? Old enough to understand Old School? The guys in the shop and the viewers at home are about to find out what the kid is made of...

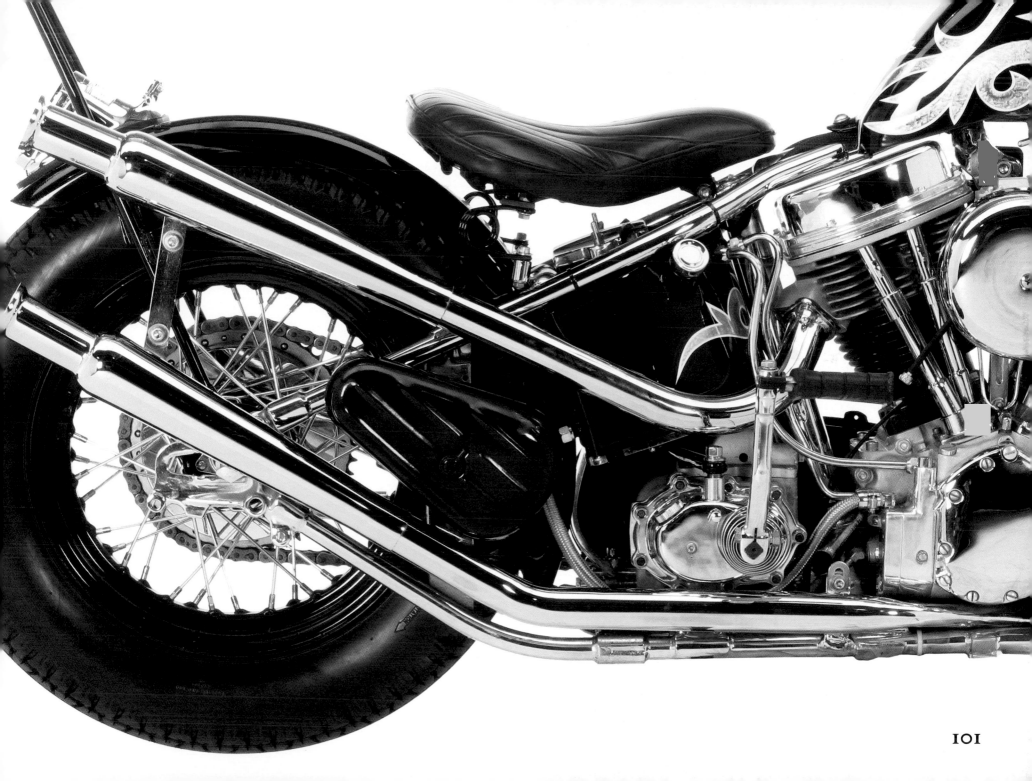

"Working with Cody's been almost like a vacation compared to working with my son. 'Cause, you know, there's always been a clashing of heads between me and Paulie, but [Cody and I] work on the same level."

—Paul Teutul Sr.

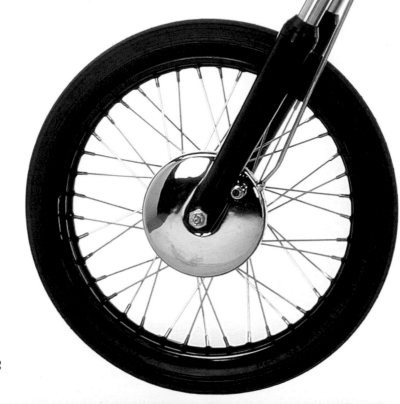

PAINT
Cody gets to oversee the powder coating on the tins. "A very high-gloss, wet-looking black with a lot of depth... like a mirror," promises painter Tom March.

ENGINE
Crack mechanic Steve McPhillips builds the bike's 40-horsepower, 80-cubic-inch panhead motor from scratch—in about an hour. The cylinder heads resemble upside-down frying pans, hence the name.

GAS TANK
Justin Barnes crafts wicked gold-leaf scrolling for the gas tank's sides, creating a classy contrast to all the silver and black.

FRAME
Senior specs out a smaller-than-usual frame— looks like "a little toy," he jokes—and arranges to have it chromed to a slick, glassy finish.

CLUTCH
Featuring bygone parts and assemblies that don't appear on modern choppers, the retro bike turns out to be especially edifying for Cody. "On most of the bikes that we build," he says, "clutches have a concealed bearing system, but the clutch on this has wheel bearings. They need to be greased and assembled before they can be put on the bike, and that's something I've never done before."

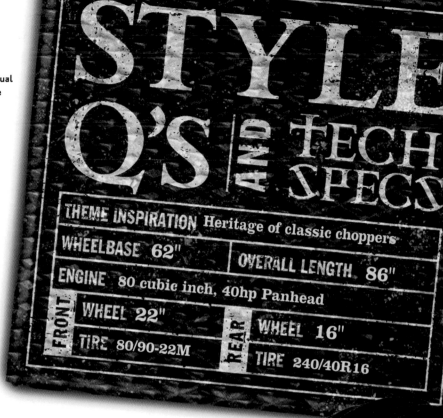

STYLE Q'S AND TECH SPECS

THEME INSPIRATION	Heritage of classic choppers	
WHEELBASE 62"		OVERALL LENGTH 86"
ENGINE	80 cubic inch, 40hp Panhead	
FRONT WHEEL 22"		REAR WHEEL 16"
FRONT TIRE 80/90-22M		REAR TIRE 240/40R16

RAW MUSCLE
The Old School Chopper's rear wheel has a look of sheer power, not unlike one of Senior's well-tooled biceps. It's truly form following function—and looking mighty good as a result. Bike and builder seem to share a no-nonsense message: "Don't mess with me."

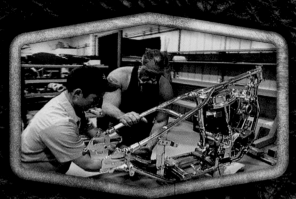

GRASSHOPPER
Ah, a young man learning at the hands of a master... It's something new and refreshing, even a little heartwarming for regular viewers of AMERICAN CHOPPER.

GETTING AN "A" IN OLD-SCHOOL
Gold leaf on the tins "nailed the look that we were going for," says Senior, admiring the fresh paintwork as parts are unloaded at the door.

ODD MAN OUT
Chief designer and eldest son Paul Teutul Jr. finds himself on the outside looking in at the Old School Chopper project, as Senior and Cody work out the details in another shop.

With business booming at Orange County Choppers, space has been a little too tight in its "dirty dungeon," as Paulie describes the shop. A new two-story expansion has popped up to give the boys and the bikes some room.

The Old School Chopper is the maiden project for the new space, so what better time for Senior to (once again) lay down the housekeeping law? "That shop upstairs is gonna be like a hospital," he announces. "And that's the way it's gonna stay."

Like Father, Like Cody

As the project moves from design to fabrication, the process turns out to be a refreshing experience for the senior Teutul.

"It's been a little while since I did this much assembly on a bike," he says. "It's kinda nice to get back in there—you know, skin my knuckles a bit and get my hands dirty."

Still, whenever possible (and because he still has a business to run), he leaves Cody to forge ahead on his own, which both exhilarates and worries the apprentice. "To be honest, I'm a little nervous to be working on this bike by myself," Cody admits as he looks at the scope of the job. "It's a lot of responsiblility, and I really don't want to screw anything up."

It doesn't take long for Senior to see that Cody's nervousness is unfounded: "The amount of passion that Cody seems to have for this stuff kinda reminds me of how I was when I was his age," he says. "He's so eager to learn things and get things done."

Never one to pass up an opportunity for a dig at his flesh-and-blood protégé, he says of Cody, "He doesn't diddle-daddle around like somebody else I know."

Mmmm...that one felt so good he decides to lay it on a little thicker: "Working with Cody's been almost like a vacation compared to working with my son. 'Cause, you know, there's always been a clashing of heads between me and Paulie, but [Cody and I] work on the same level."

Other than a couple of holes in the frame that have to be drilled out and a resetting of the transmission, the Old School Chopper does proceed through fabrication remarkably smoothly. Paulie, whose ears must have been burning while Senior lauded the shop's new prodigy, pops upstairs to have a look at the seat, which appears to be mounted just a mite too low.

"Now the Monday-morning quarterback wants a piece of the pie," Senior grouses. "He sees it coming together."

To add insult to... well, insult, Paul Sr. asks Vinnie—not Paulie— to assist Cody with the tranny's C-clamps. When Paulie gripes that he needs Vinnie's help downstairs, Senior barks, "Get out.... Beat it!" and makes a mocking face as his defeated son retreats.

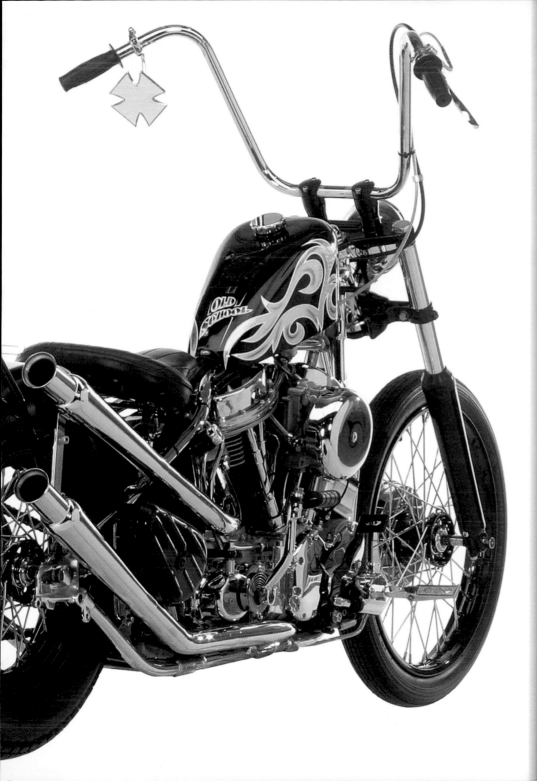

SENIOR MOMENTS

How's that again?

Paul Teutul Sr. adds a little attitude to his outlook toward things. Among insights he shared while building the Old School Chopper:

- "WHAT WAS, WAS; AND WHAT IS, IS. AND WHAT IS IS WHAT'S HAPPENING RIGHT NOW!"
- "I'M ON A ROLL...KICKING @#$ AND TAKING NAMES!"
- "YOU CAN'T BUILD BIKES HANGING OUT IN THE BACK TALKING ON THE PHONE AND SMOKING CIGARETTES."

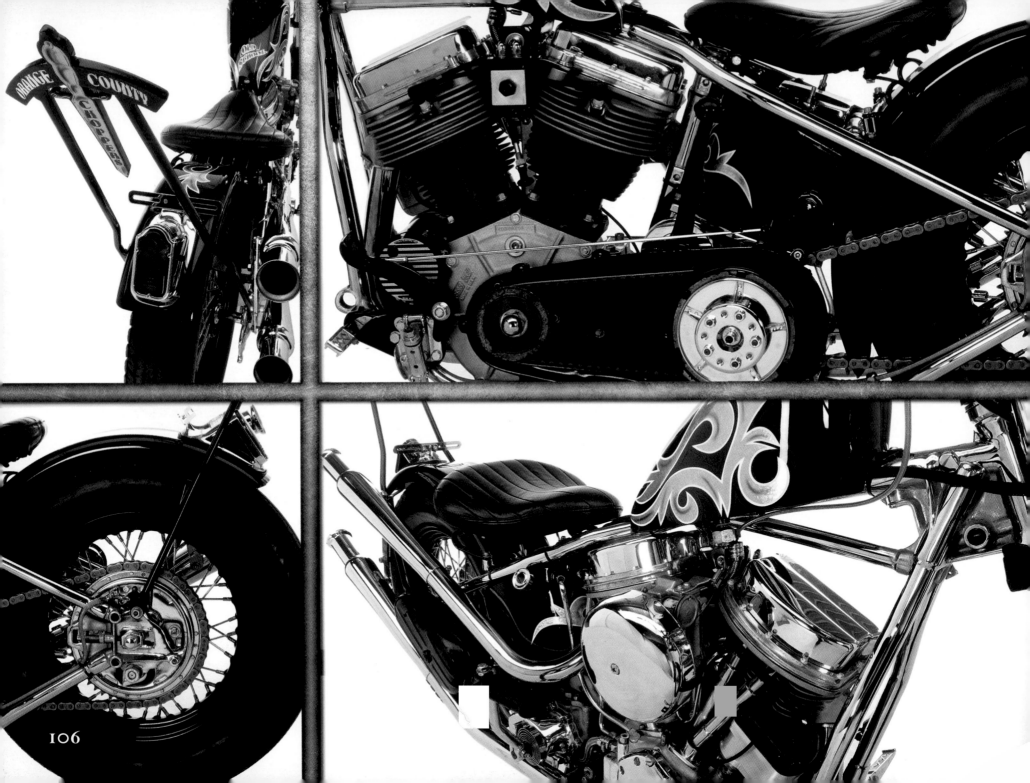

As the project nears completion, Cody and his mentor have formed a mutual-admiration society. "He's been taking a lot of time showing me how to do things," a grateful Cody reports. But what might be the greatest compliment to the trainer is this observation: "[Senior] really doesn't get aggravated if I make a mistake or if anything goes wrong."

Far from it, says Senior: "When Cody started working with us about a year and a half ago, he really didn't know all that much about building bikes. And to look at him and see how far he came makes me proud, and that's really rewarding."

To conclude—and to get in one more familial jab—Senior adds, "If he keeps going the way he's going, he's got the potential to be as good, if not better than Paulie someday." Now, that's saying something!

Young and Gifted

Cody takes the inaugural test-ride and then another as he gets to tool down the road side-by-side with Paul Sr. As thrilling as that is, nothing prepares him for what happens when Senior calls him into his office. There, The Boss hands over the keys and tells Cody that the Old School Chopper is his to keep.

The elated young man stammers a thank-you that seems hopelessly insufficient, then rises to give his mentor a grateful hug. Senior, too, couldn't be happier: "He really deserved that bike," he says, " 'cause, bottom line, he's really not an employee; he's part of the family."

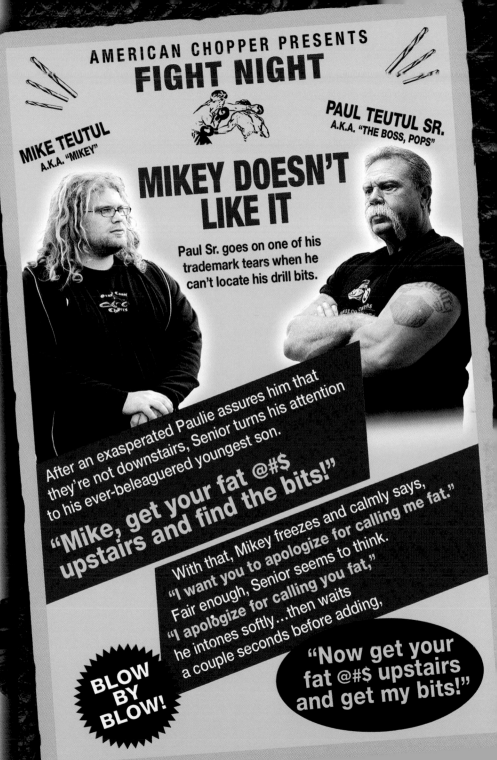

AMERICAN CHOPPER PRESENTS
FIGHT NIGHT

MIKE TEUTUL
A.K.A. "MIKEY"

PAUL TEUTUL SR.
A.K.A. "THE BOSS, POPS"

MIKEY DOESN'T LIKE IT

Paul Sr. goes on one of his trademark tears when he can't locate his drill bits.

After an exasperated Paulie assures him that they're not downstairs, Senior turns his attention to his ever-beleaguered youngest son.

"Mike, get your fat @#$ upstairs and find the bits!"

With that, Mikey freezes and calmly says, "I want you to apologize for calling me fat." Fair enough, Senior seems to think. "I apologize for calling you fat," he intones softly…then waits a couple seconds before adding,

BLOW BY BLOW!

"Now get your fat @#$ upstairs and get my bits!"

COMANCHE BIKE

EPISODE
9, 10, 11

ORIGINAL AIRDATES

June 30, July 7, and
July 14, 2003

HIGH ADVENTURE

The Comanche Bike represents a novel design concept: a chopper modeled after *a chopper*! But not just any old whirlybird: For this project, Paulie sets out to capture the character of the Army's sleek, mean recon machine.

THIS MISSION WAS CONCEIVED by a retired lieutenant colonel who saw the aeronautically inspired Jet Bike on the Discovery Channel and thought, why not take the idea and march a few steps further?

Paulie did his own reconnaissance at test-flight headquarters in West Palm Beach, Florida, where Col. Bob Birmingham, the copter's project manager, gave him an up-close look at the amazing machine. As usual, Paulie took copious mental notes before heading home to launch his two-wheeled version.

Also as usual, the Teutuls and crew will operate under a crushing deadline. The plan is to unveil the Comanche bike at an upcoming motorcycle rally in Myrtle Beach, South Carolina. The project has to go from drawing board to completion in just three weeks, with a measly 10 days for design and fabrication. Paulie and Vinnie know they face a tough deadline, but they can't foresee a last-minute, nail-biting catastrophe.

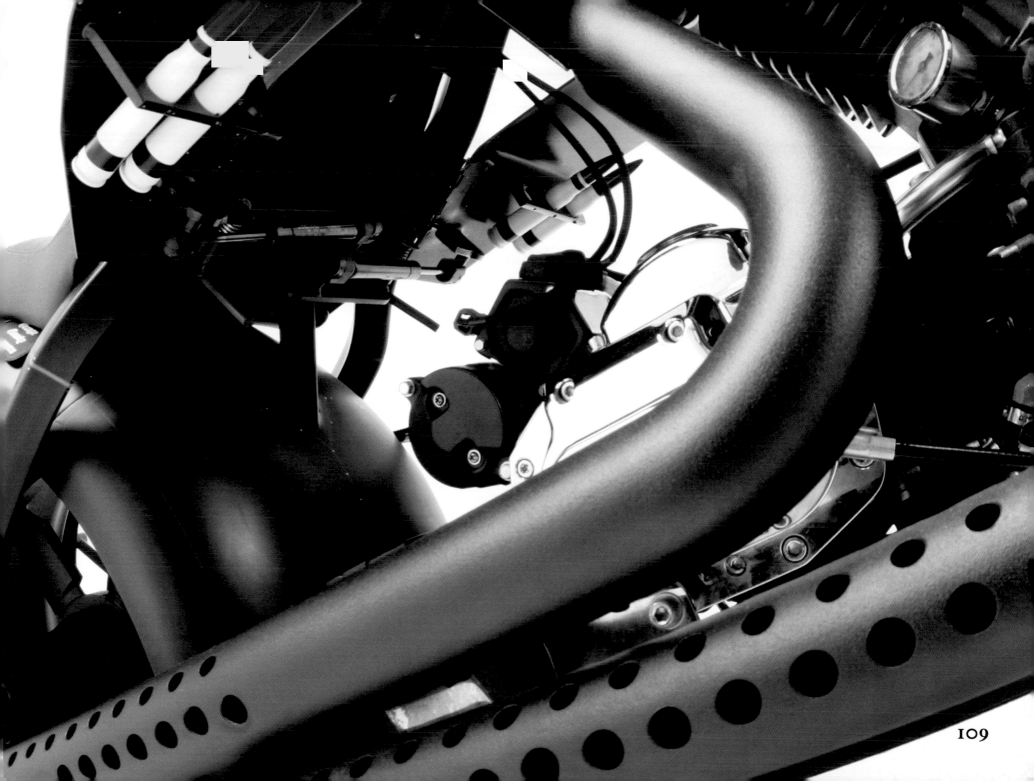

STYLE Q'S AND TECH SPECS

THEME INSPIRATION Military helicopter	
WHEELBASE 92"	OVERALL LENGTH 123"
ENGINE H&L Performance 131	

FRONT		REAR	
	WHEEL 22"		WHEEL 18"
	TIRE 80/90-21M		TIRE 240/40R18

HYDRAULIC MISSILE FLAPS

The Comanche Bike's quirkiest design accent is a pair of missile flaps attached to the frame under the seat. A pair of small hydraulic cylinders— "strongarms"—operate the flaps, which are each loaded with .50-caliber dummy ammo.

"It took me and Paulie the better part of a day to get [them] working the way we wanted them," Vinnie recalls. "It was worth it," he says, "because I'd be willing to bet there's not another bike in the world that has hydraulic-operated missile flaps!"

FENDER

Paulie fabricates a rear fender with a "three-dimensional, diamond-shaped" tail, using 16-gauge cold-rolled steel.

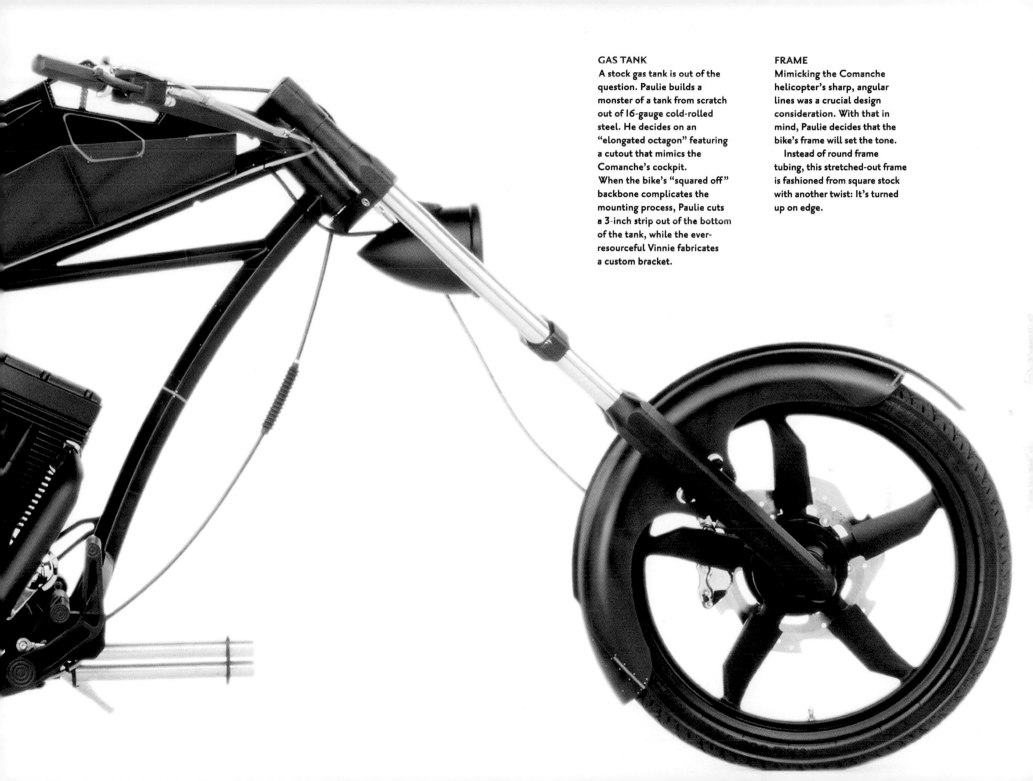

GAS TANK

A stock gas tank is out of the question. Paulie builds a monster of a tank from scratch out of 16-gauge cold-rolled steel. He decides on an "elongated octagon" featuring a cutout that mimics the Comanche's cockpit.

When the bike's "squared off" backbone complicates the mounting process, Paulie cuts a 3-inch strip out of the bottom of the tank, while the ever-resourceful Vinnie fabricates a custom bracket.

FRAME

Mimicking the Comanche helicopter's sharp, angular lines was a crucial design consideration. With that in mind, Paulie decides that the bike's frame will set the tone.

Instead of round frame tubing, this stretched-out frame is fashioned from square stock with another twist: It's turned up on edge.

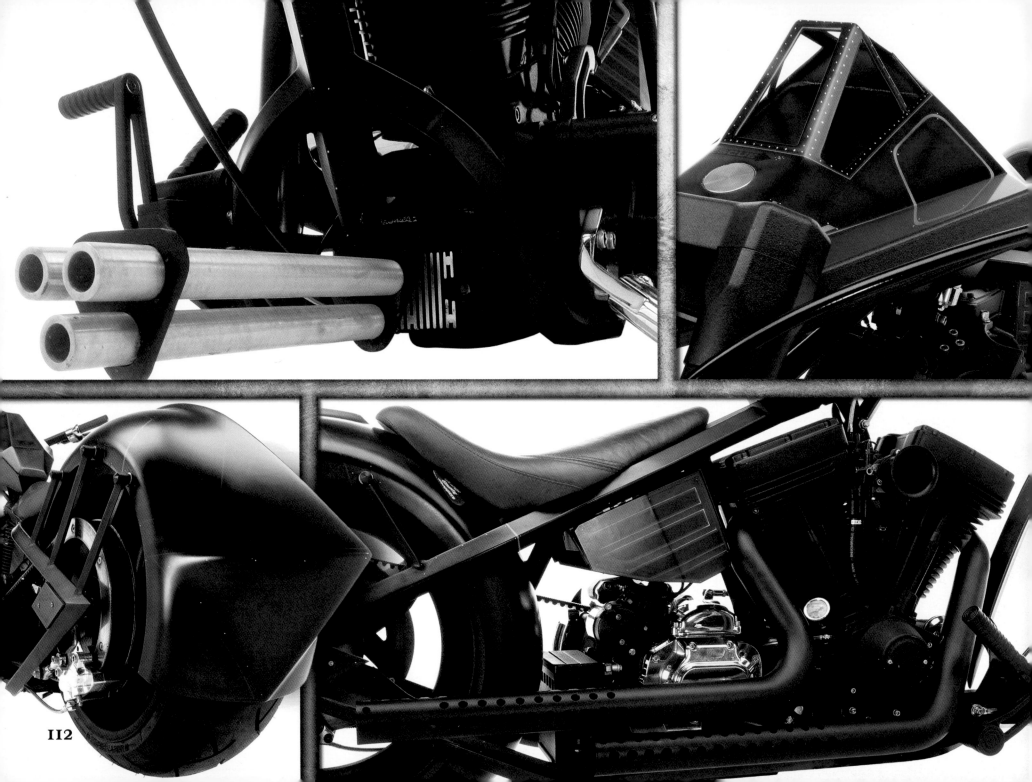

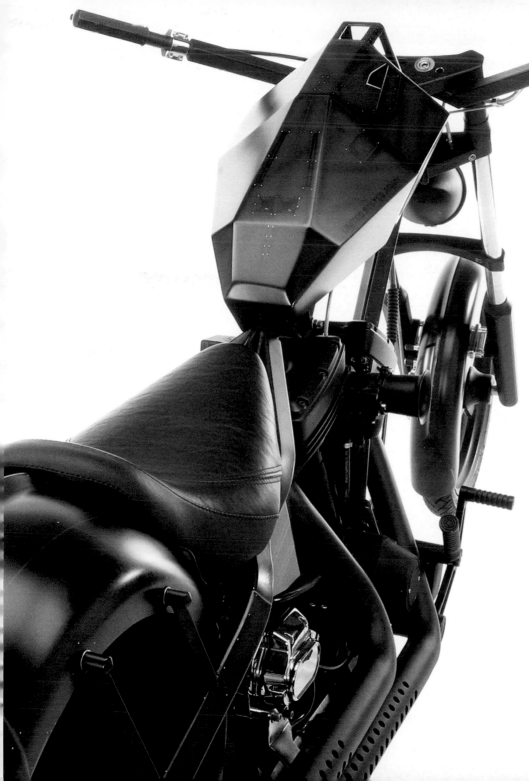

Easy Bake Burnout

Paulie and Vinnie experiment with a "seat pan in a can," creating a mold from duct tape and modeling clay, then filling it with liquid fiberglass resin. Great idea? Not exactly. Overnight, their concoction sets up a little too well. After struggling to remove it the following morning, the guys finally turn to their tools of last resort: muscles and hammers.

when he opts to accent the black with a military olive, keeping the stealth while adding some flair.

While the Teutuls' paint debate grows colorful, Vinnie tries to mock-up the drive train and learns that a unique frame can cause unique problems. First, the square tubing stands in the way of the engine's offset plate. As soon as Vinnie cuts a chunk out of the frame to solve that glitch, he realizes that the rear wheel's pulley is also

> « Here we are, already behind schedule, and Picasso is changing his mind about what he wants on this bike," grouses Paul Sr. when Paulie decides that the Comanche's belt drive is "just blah. »

"The whole 'Easy Bake oven' seat pan idea didn't work out too well," Paulie admits. "It took so much time to put on, and even longer to get off." The experiment sends them running back to conventional pan fabrication.

More than any other element, the Comanche's paint scheme will proclaim the bike's (and the copter's) guiding aesthetic: stealth. Paulie plans to use pitch black and flat black. Senior isn't buying that idea. He suggests brushed aluminum to provide better contrast—but to no avail.

"Sometimes when Paulie gets something in his head, there's no changing his mind," Senior says. Painter Justin Barnes does just that, however,

butting up against the frame. The solution? Another cut and some innovation—adding a spacer to correct the wheel's tracking.

What's a Comanche without weaponry? Paulie fabricates a replica of the copter's three-barrel turreted 20-millimeter gun and affixes it to the frame's front downbar. The result is slick and stealthy: "Mounting the gun underneath the motor was a cool idea," he says. "But really the nice part about it is, it hid the voltage regulator."

Senior is less impressed: "The clock is ticking down on this project, but you'd never know it looking at Paulie—he's still fussing around with these little details."

TASTELESS?
In a tension-breaking moment of silliness, Paulie and Vinnie decide their special-formula goo isn't going to work out as a seat-pan mold. But it might make a tasty dip?

CHOPPERS
Viewers get a rare glimpse of the Army's Comanche helicopter as it flies alongside its namesake theme bike. True to its roots, Paulie says, the Comanche Bike "gives you this feeling of flying."

REVELATION
Myrtle Beach fans are wowed by the Comanche Bike's unveiling. They've never seen anything like it. There's never *been* anything like it, because AMERICAN CHOPPER theme bikes are one-of-a-kind originals.

A whirlwind trip to New Orleans adds to the Comanche Bike's deadline drama. After visiting a bike show at the Superdome, Paulie and Vinnie rush back home and complete the Comanche, just in time to take off for Myrtle Beach.

"The fabrication on the Comanche wasn't as intense as some of the other theme bikes that we've done," Paulie reflects. But the bike is truly one-of-a-kind. "It's a kind of crazy feel, but I'm real happy with the overall look," Paulie says. "It's very innovative and very modern, and this is the first time that I've really tried to pull off that kind of a feel."

Myrtle Beach Bomb?

His serenity is cut short, however, when the guys encounter a nail-biting crisis on the eve of the Comanche's unveiling.

During a final test-run in Myrtle Beach, the Comanche's engine seizes up. With Paulie and Senior busy overseeing their booth at the show, it's up to Vinnie to find a solution.

"The cam bearing spun inside the cam cover," he explains, "and it chewed everything up. It put a lot of filings in the motor, which ruined the oil pump return."

As night turns to day, engine specialist Joe Malloy jets down from New York to lend a hand. Hours are lost trying to dislodge the pump shaft. After failures with a screwdriver, a hammer and chisel, and a propane torch, a welder is called in with

a cutting torch. That does the trick, and Vinnie leaves to join Paulie and Senior for the helicopter ride that will deliver them to the unveiling.

At 9:10 p.m., 20 minutes before showtime, Nick and Christian pitch in to get the bike started, but on only one cylinder. Nick feverishly rewires the bike's ignition, and the Comanche is up and running with mere minutes to spare.

With the bike's successful debut and all the stress behind him, Paulie takes delight in the way the Comanche turned out. "The way you sit on this bike is very stretched out, and the hand position is rather unusual," he says. "I think there was a little sacrifice there for the look as opposed to the comfort.

"But when you're riding this thing, it gives you this feeling of flying. Because you're so leaned forward and stretched out, you just feel like you're reaching through the air.... This bike not only looks mean, but when you're riding this thing, it really feels mean!"

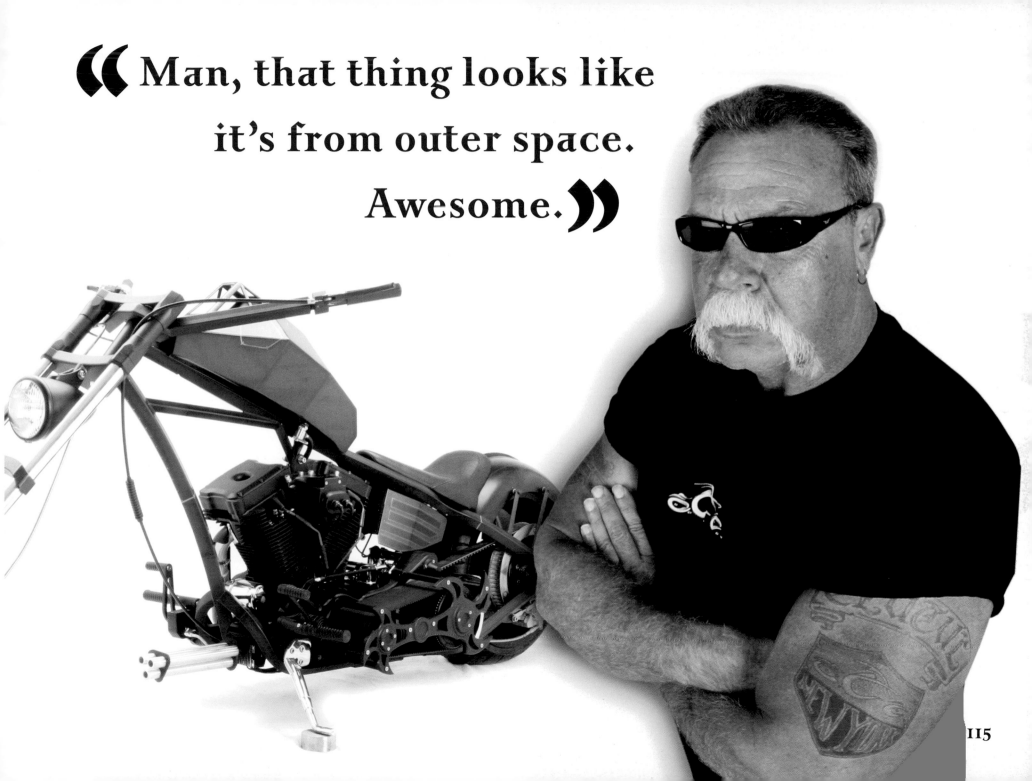

Man, that thing looks like it's from outer space. Awesome.

MIKEY'S BIKE

EPISODE
12, 13

ORIGINAL AIRDATES

August 11 and 18, 2003

Oh, Brother, Where Art Thou?

Two things seem clear about Paul Sr.'s relationship with his youngest son:
1) He can't say no to him, and
2) He can't take him seriously.

So when a "bored" Mikey asks if he can build a blues theme chopper, The Old Man naturally gives him the thumbs-up. Naturally but warily—especially after he sees Mikey's design notes, a chaotic "list" of scrawlings and doodles.

"Is this going to be painful?" Senior asks.

"Yes," Mikey replies. "Very."

With that in mind, The Boss lays down three conditions: Mikey must continue to perform his duties around the office; Paulie has to work with him (nice buck-passing there, Pop!); and the bike must be finished in time for the upcoming Laconia Bike Week.

Mikey readily agrees. He even comes up with the bike's motif (a vintage, shark-finned Cadillac), but Paulie sets the tone for this build from the get-go: "Mikey's always goofing around the shop, and that's a lot of fun and everything," big brother says. "But I can tell you, I'm not going to build this bike for him.... I don't mind helping, but he's really got to do most of the work on this bike himself."

Fasten your seat belts—it's gonna be a bumpy ride.

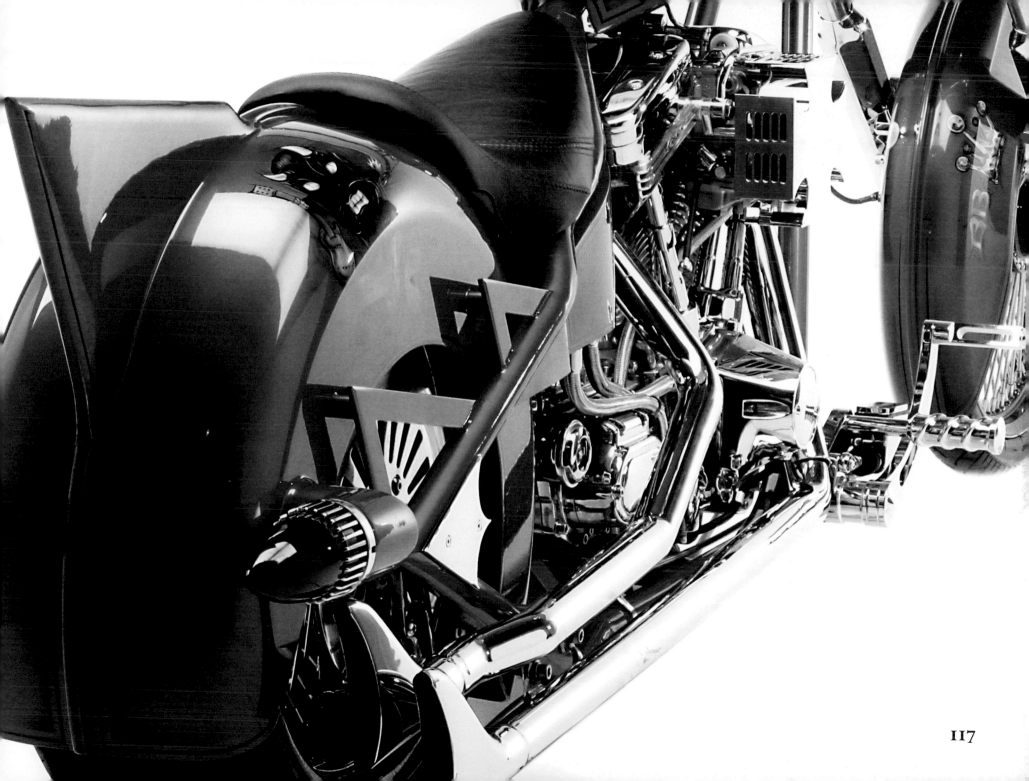

"I've learned a lot about how tedious everything is in bike building."

—Mike Teutul

TAIL OF WOE
Senior and Paulie clash over the best way to mount Mikey's taillights. Neither one wins, exactly. The result doesn't reflect either of their original ideas. It's not even a compromise, just another idea altogether (another idea from Paulie, for those keeping score). Rising from such a cauldron of conflict, the light glows a nice, angry red.

BAR FIGHT
Mikey and Paulie square off on the choice of handlebars. The issue: high ape hangers or a lower beachcomber style. The decision: beachcombers. The winner: Paulie.

GRACE NOTES
Artwork on the tank and fenders provides visual tributes to legendary blues musicians.

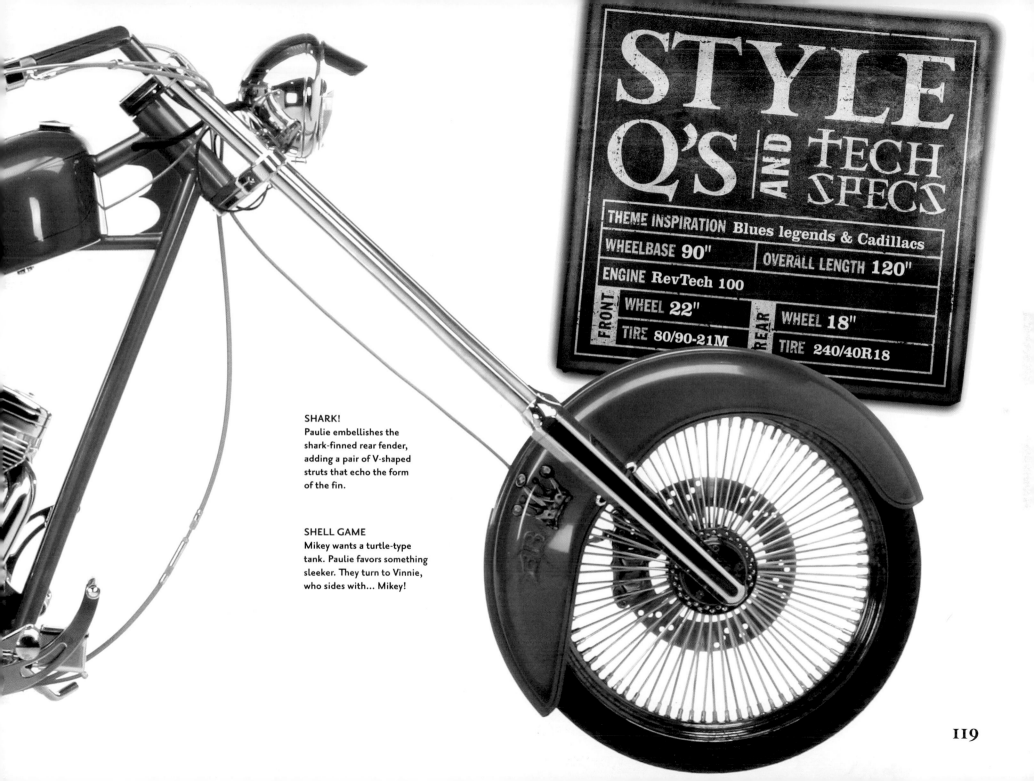

STYLE Q'S AND TECH SPECS

THEME INSPIRATION Blues legends & Cadillacs				
WHEELBASE 90"		**OVERALL LENGTH 120"**		
ENGINE RevTech 100				
FRONT	**WHEEL 22"**	**REAR**	**WHEEL 18"**	
	TIRE 80/90-21M		**TIRE 240/40R18**	

SHARK!
Paulie embellishes the shark-finned rear fender, adding a pair of V-shaped struts that echo the form of the fin.

SHELL GAME
Mikey wants a turtle-type tank. Paulie favors something sleeker. They turn to Vinnie, who sides with... Mikey!

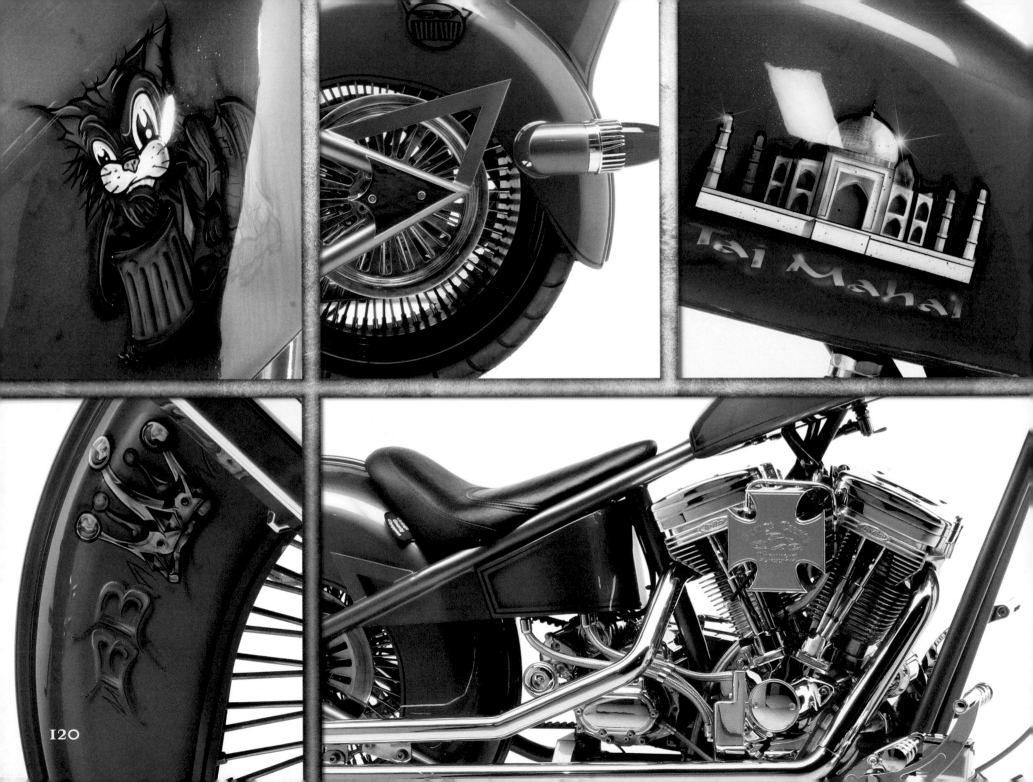

Alas, Mikey realizes that he may have a hard time calling the creative shots. After he chooses a bulbous "turtle" gas tank from the shop's shelves, Paulie successfully persuades him to switch to a sleeker, less "tubby" tank.

More disappointing: Though Paulie provides aesthetic "guidance," he's not exactly chomping at the bit to do the actual labor. Finding himself at 10 p.m. still waiting for Paulie to return from a "quick break" that began hours ago, Mikey sighs: "I have to depend on my brother." Unfortunately, he adds, "I really don't think Paulie is into building this bike. It's really hard to get him to stay focused and help me do any of the work."

Senior can relate: "It has not taken Michael too long to start feeling the same frustrations that I've been feeling for years about Paulie's work ethics." When he hears about the gas tank switcheroo, Pop offers some advice: "Mikey needs to stand up to his brother a little bit and build the bike that he wants to build, not the bike that Paulie wants to build."

Tanks for Nothing

After persuading Mikey to make another design change—talking him into using beachcomber handlebars instead of a pair of ape hangers—Paulie states his case: "I know this is Mikey's bike, and he's looking for a certain look," he says. "But I've been doing this a lot longer than he has.... I just want to help him avoid any design errors that are not going to look very good."

Despite Paulie's design pressure and spotty attendance, Mikey does pick up one central truth:

"I've learned a lot about how tedious everything is in bike building." Still, he admits, "Even though it looks like you're moving slowly, you're really making progress because it's such fine detail.... Besides, it sure beats taking out the trash and manning the phones."

The younger son's new focus does his father proud. "It's nice to see Mikey enthused about something for a change," Senior says, "because he's been kind of lost in knowing what he wants to do in life."

In keeping with the Cadillac theme, Paulie stretches the gas tank along the frame, but his efforts are in vain. After the fenders arrive from Milwaukee Iron, Senior is more convinced than ever that Mikey's turtle tank was the way to go. When the two Pauls reach a standoff, Vinnie casts the deciding vote—he's pro-turtle!

While Senior and Mikey get to making the switch, Paulie moves on to the shark-finned rear fender, which he complements with a pair of V-shape struts. He adds a pair of parallel exhaust pipes with fins of their own and a pair of vintage, chrome-ringed taillights.

Then another design spat: Pop suggests cutting a sleeve into the fender to effect a more unified, streamlined look, while Paulie prefers a simpler mounting on the frame.

"It kills me," says an aggravated Senior. "When Paulie's building his bikes, he's always adding and changing stuff right up to the last minute. But he acts like putting these taillights on Mikey's bike is a big problem.... He's looking to do it the easiest way possible, no matter how bad it looks."

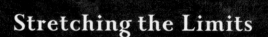

Senior Moments

Stretching the Limits

DURING THE DEVELOPMENT OF MIKEY'S BIKE, VIEWERS LEARN THAT EVEN THE IMPRESSIONABLE MIKEY HAS HIS LIMITS.

NOTICING PAULIE'S CHOSEN GAS TANK, VINNIE REMARKS, "HE FORCED YOU INTO THAT TANK."

MIKEY REPLIES ROBOTICALLY, "I WAS FORCED INTO THAT TANK."

SENIOR GETS INTO THE ACT: "BECAUSE YOU GOT NO MIND OF YOUR OWN."

AGAIN MIKEY PARROTS, "NO MIND OF MY OWN."

PUSHING THE GAG, SENIOR ADDS, "BECAUSE YOU'RE A SIMPLETON." AT THAT, MIKEY HOLDS HIS TONGUE. WHEN RIDICULE FAILS, SENIOR HANDS MIKEY A HATCHET AND SUGGESTS HE SIMPLY DESTROY PAULIE'S TANK. MIKEY GENTLY PINGS THE UNPOPULAR PIECE BUT CAN'T BRING HIMSELF TO DO ANY REAL DAMAGE.

"YOU AIN'T GOT A MEAN BONE IN YOUR BODY," HIS DAD SAYS BEFORE DELIVERING THE COUP DE GRÂCE: "YOU'RE A DISAPPOINTMENT."

121

"LIKE THIS"
Armed with his own doodles and catalog illustrations, Mikey tries to convey his vision for the blues-theme bike to his father, who seems both skeptical and encouraging.

THAT'S MY BOY!
Chrome-capped, Mikey plants a kiss on the cheek of his mother, Paula Teutul. She has made a rare on-air appearance to congratulate her son as he prepares to test-drive his new ride.

BLUES, BROTHER
The test ride is such fun that Mikey stretches it out a while. Back at the shop, viewers get a rare glimpse of paternal concern, as Senior worries about the novice rider. No need; Mikey returns triumphant.

Giving in, Paulie fabricates a funnel of sorts with pipe and mounts the lights the "right" way.

When mock-up's finally complete (a couple of days late, says Mikey, thanks to tardy delivery on the taillights and "Paulie checking out every five minutes to God knows where"), the bike goes off to the painters. Mikey heads off too, to apply for his motorcycle license. The good news? He gets a 90 on the written test. The bad news? He fails his first road test and has to do it over.

When the frame comes back—dazzling in electric royal blue—Mikey finds OCC fabricator Christian Welter eager to help with assembly. In short order, they mount the motor, belt drive, foot pegs, and triple trees.

"The difference between working with Christian and my brother is like night and day," Mikey says. "Christian took the time to actually show me things and explain how things work...and that's all I really wanted. "

With the arrival of the rotors and wheels, Cody pitches in while Vinnie shows Mikey the basics of bike wiring. "The past couple of days I feel like everybody around the shop here has kind of been like my big brother," says a rueful Mikey, "except for my big brother."

Paulie's comeback? "If Mikey knew a little bit more about building bikes, things would go a lot faster... but the truth of the matter is, he's just learning and he gets distracted very easily."

Singing the Blues

Brilliant tinwork by Justin Barnes drives home the chopper's musical theme: The gas tank features India's Taj Mahal (alluding to the venerable musician of the same name) on one side and a cat (a nod to the nickname of crooner Tom Waits) on the other; on top is a simple line drawing of a crossroads, recalling the title of a classic Robert Johnson tune. The rear fender displays a guitar-playing devil, whom Johnson claims to have encountered at the crossroads in his song.

The front fender wears a "BB" and a crown, honoring B.B. King.

If all that progress sounds too smooth to be true, it is.

A sticking rear wheel has to be disassembled, and Paulie must replace its bearings and cut a new spacer for the rear axle. When that doesn't work, Senior breaks the news that the wheel has to be replaced with one that won't match the front wheel's paint scheme.

"I got one foot in the bank vault and the other one sitting in a pile of @#$%," says a bummed Mikey.

"You'll have one foot in your @#$ in about two seconds," quips the sardonic Senior, who's driving the boys to finish up already.

> **❝I got one foot in the bank vault and the other one sitting in a pile of @#$%.❞**
> — Mike Teutul

But wait, there's more! "Holy mackerel!" says Paulie as he realizes that, during the gas-tank switch, he forgot to fabricate a pitcock (the hole in the bottom that feeds fuel to the engine) in the turtle. Mikey's annoyed but admits, "It was a bit more embarrassing for my brother than anything."

Any embarrassment is temporary, however, and the bike ultimately gets completed on time.

To celebrate the achievement, the guys' mom, Paula Teutul, comes by to congratulate Mikey and take some photos. With her blessing still fresh in his mind,

> **"You'll have one foot in your @#$ in about two seconds."**
> — Paul Teutul Sr.

Mikey takes to the road for a test-ride, where he discovers a kinship with his dad and big bro. "[They're] always going on and on about how great it is to ride these bikes," he says. "Now I know exactly what they mean." As Mikey makes his way back to the shop, Senior says, "I never thought I'd see the day when I'd see Mikey tooling around on a bike, let alone one that he designed himself."

Forget about the kicking wheels; it was Senior's proud smile that capped it all for the first-time builder. "It felt good," Mikey says, "damn good!"

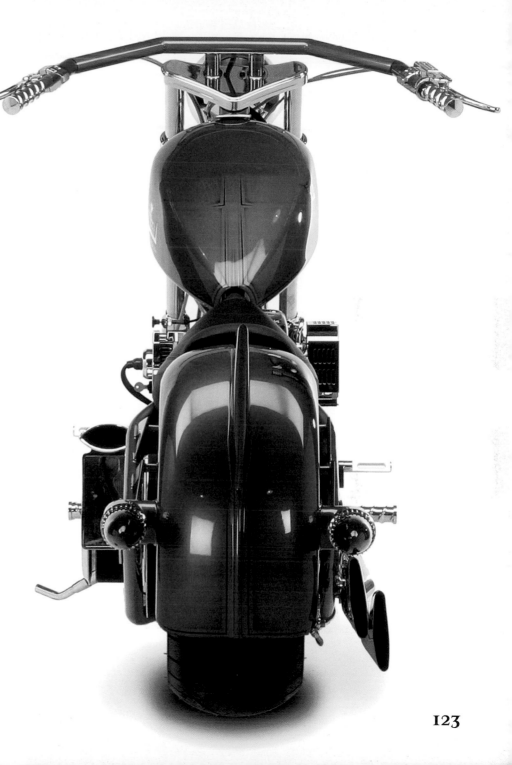

TOOL BIKE

EPISODE 14 & 15

ORIGINAL AIRDATES

December 8 and December 15, 2003

Wrenching Attention

There are corporate bikes, and then there are corporate bikes. In some cases, it takes real head scratching before Paulie finds a way to marry the ideals of the client company and motorcycling.

Not so with OCC's commission from the folks at Snap-on, which allows Paulie's imagination to run wild in ways big and small. They're a tool manufacturer, for crying out loud!

As usual, Paulie goes straight to the source—Snap-on's Milwaukee headquarters—where he checks out the process of churning out wrenches. Inspired, he heads home where his gung-ho turns to gung-whoa-ho-ho.... What's this new distraction? Paul Sr. has to ratchet up the tension in the shop when he finds his son sidetracked by a new blonde squeeze. Will their battling throw a monkey wrench into the custom chopper project?

To help get the project rolling, Snap-on ships hundreds of their raw products (unfinished and untempered so they can be bent and welded) to the Teutuls' shop. It's inspiration by the boxful for Paulie but a day of drudgery for poor Mikey, who has to unpack and categorize every last one of them.

"If you ask me," he sighs, "this is about as low as you can go on the totem pole. At least when I get to answer the phone I can talk to people, and when I take out the trash I get some fresh air, but this was just endless."

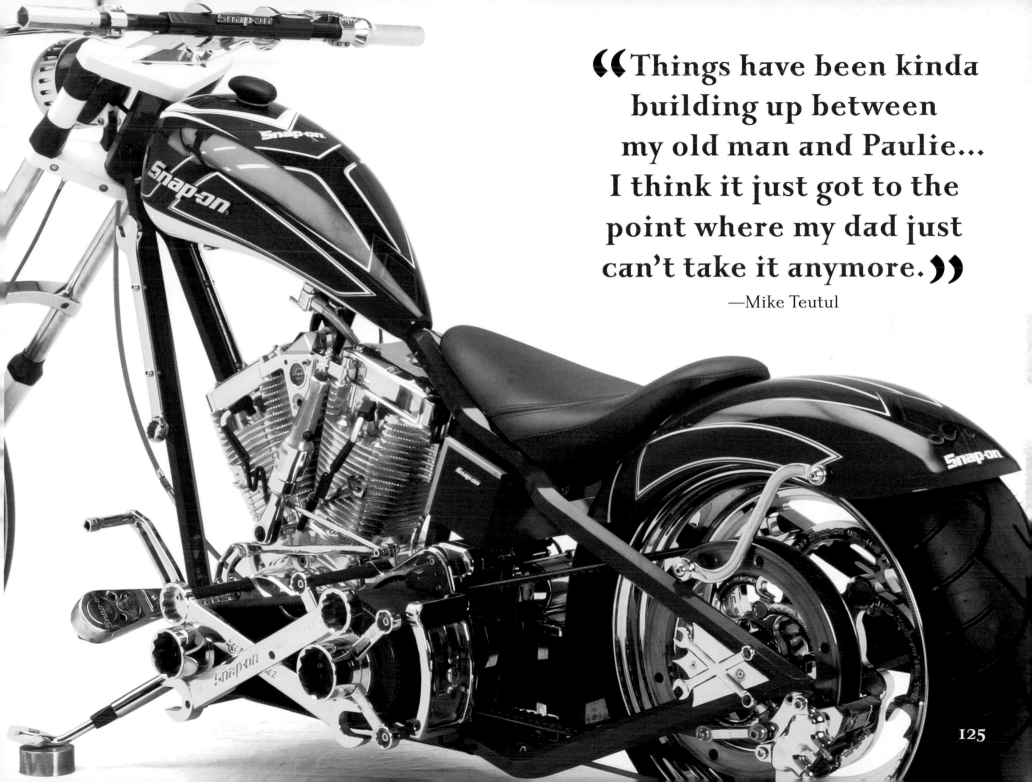

"Things have been kinda building up between my old man and Paulie... I think it just got to the point where my dad just can't take it anymore."

—Mike Teutul

125

FRAME

"This is the most difficult frame we've ever built," says Sam Wills of Racing Innovations. Paulie's plan calls for using solid hex-shaped metal bars instead of conventional round tubing, suggesting a giant allen wrench. After the heavy bars are hollowed out, they're bent with an acetylene rosebud torch. The finished frame is still heavy but a big hit. "I couldn't have been happier," says Paulie. "The craftsmanship and the attention to detail that went into it was incredible."

REAR STRUTS

Complementing the bike's contours, curvy closed-end "S" wrenches serve as rear struts. What could be simpler? Well, as Vinnie recalls, "Once he started trying to mount the rear struts... whatever Paulie tried to do became a problem." First, he drilled straight through the fender and punctured a tire, then found he had to heat and bend the left strut in order for it to clear the pulley. Surely annoying for Paulie, but as Vinnie admits, "kinda funny to watch."

HEX-SHAPE EXHAUST SLEEVES

Using the press break at the Teutuls' metal shop, Paulie painstakingly bends sheets of 16-gauge cold-rolled steel to create hex-shape exhaust covers. Cool-looking and practical, they'll prevent the pipes from "blueing" as they age and protect riders' legs from the heat of escaping fumes.

TRANSMISSION DETAILS

A pair of bent chrome allen wrenches add a little snap to the appearance of the transmission. They replaced blue T-handle allen wrenches that didn't look right to Paulie. "It seems like it's kind of a minor thing," he admits, "but if something doesn't feel right or it looks wrong, no matter how small it is, I gotta fix it."

MINI TOOLBOX

Contrasting the bike's giant allen wrench and turnbuckle ideas, Paulie downscales with a miniature toolbox mounted in the oil tank's usual position. Senior, recalling the rejected toolbox he fabricated for the Fire Bike, is less than wowed: "To hear him tell it, you'd think it was the first time anybody came up with an idea like that," he sniffs, "but let me tell you, I know better."

WRENCHES ON DOWNTUBES

Sometimes a simple decorative flourish goes a long way. Consider the large wrenches that Paulie attaches to the frame's downtubes. "That part of the frame needed some accents to tie it into the rest of the theme," he explains.

RISERS

Snap-on's signature tool, the wrench, naturally takes center stage. At Senior's suggestion, Paulie employs a couple of open-ended variations to serve as handlebar risers. Unseen "plug welds" (placed roughly an inch inside the bar) create the illusion that the grip extensions are screwed into the bar.

SUICIDE SHIFTER

A large air ratchet makes for a killer suicide shift—and a big headache for Vinnie, who has to remove its mechanical innards to make it work. It's linked to the motor with some box-end wrenches.

HANDLEBARS

Shooting for an oversized look, Paulie wants the handlebars to look like a giant turnbuckle. To pull that off, he utilizes hex tubing for the center section and threaded round bars at either end.

RATCHET KICKSTAND

Paulie builds the bike's kickstand from a ratchet wrench, a clever hidden detail. "I think that's important when you're building these theme bikes," he says, "because you want the person to discover new design details every time they look at it."

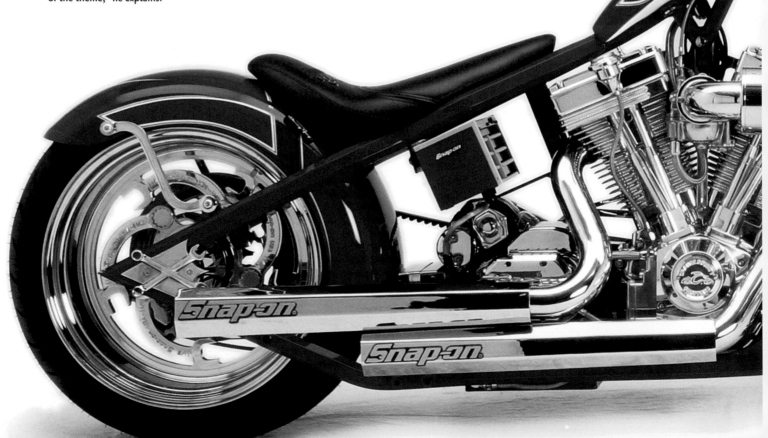

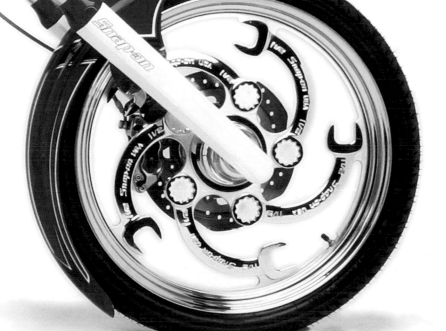

FRONT END

Senior is relieved and delighted by the bike's front forks. "I was a little worried that they were gonna look like candy canes or barbershop poles," he says. "But once more and more chrome pieces got put on, it really had a nice overall balance."

WHEELS

The folks at Rowe Machine Company fashion a curved-wrench design on the front wheel, using acid etching to add the toolmaker's logo.

PAINT

Snap-on supplied its official red color, but that doesn't stop painter Justin Barnes from being creative. "I wanted to have some different shades of red on this bike," he says. "So after the base coat was laid down, I sprayed it with semi-transparent candies and some red flake." White pinstriping offsets the hot hybrid red.

STYLE Q'S AND TECH SPECS

THEME INSPIRATION	Corporate client, toolmaker		
WHEELBASE 102"		**OVERALL LENGTH** 121"	
ENGINE	H&L Performance 131		
FRONT	**WHEEL** 22"	**REAR**	**WHEEL** 18"
	TIRE 80/90-21M		**TIRE** 240/40R18

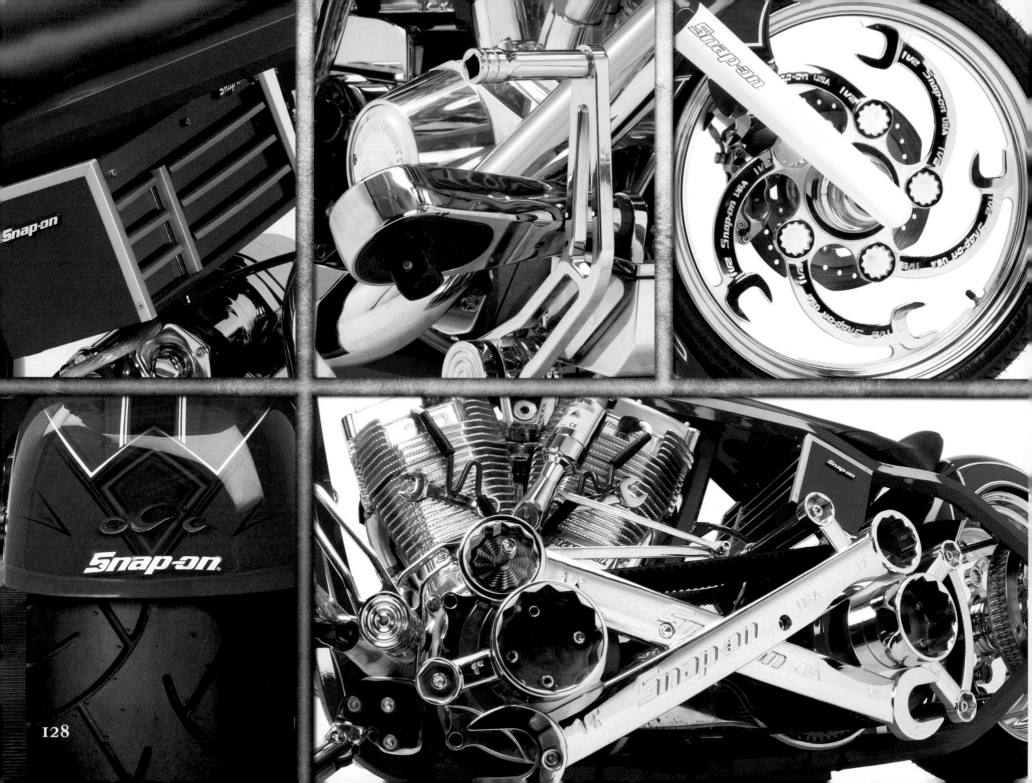

Skirting Responsibility

The Tool Bike project is marked by especially high tension between the Pauls, even though the bike never gets into serious scheduling trouble. "For the last couple of months," sneers Senior, "getting Paulie to focus and actually do some work around here has been like pulling teeth."

Hmm… that's just about as long as Paulie has been with his current girlfriend, Whitney. Coincidence? Nah, says a smitten Paulie, who feels entirely entitled to stop and smell the roses. "For the past couple of years I've really just been focusing on work and helping my father build the business," he says. "But there's more to life than just work—and meeting Whitney has made me realize that."

Pish-posh, says Senior, who finally erupts when he catches Paulie consulting with Vinnie instead of cleaning the shop. Well, pish-posh or something to that effect: "You don't do a @#$% thing around here!" he yells. "You're #@#$% every two @#$%-ing minutes, and nothing gets done!"

As usual, Mikey saw this coming just as clearly as if it had been on Doppler radar. "Things have been kinda building up between my old man and Paulie," he says. "It's not exactly like Paulie's been killing himself around the shop these days, and I think it just got to the point where my dad just can't take it anymore."

In his defense, Paulie alleges that tardy parts and longer-than-expected fabrication were the only bumps in the road to completion of the Tool Bike. "The exhaust covers and the suicide shift took a little bit longer than Vinnie and I ever thought it would. But, you know, I really can't let the pressure of a deadline inhibit me creatively. Because if I did, I don't think the bikes would turn out as good as they do."

Senior's rebuttal? "Sometimes I really think that Paulie likes when the parts are late, because it gives him a chance to drag his feet," he says. He dismisses the exhaust covers and other accent pieces as "last-minute doodads."

With the frame back and one week till the bike's scheduled unveiling, Senior turns up the heat: "I better see Paulie turning wrenches and whatnot… because this here drag-@#$ attitude ain't cutting it no more."

Relief and Pride

In the end, the bike is finished on time, an experience that's always satisfying for Paulie and especially so this time. "When you take on a theme bike like this, especially one for a big client," he explains, "you're always really excited, but there's always a little bit of fear because there's a lot of money involved and basically OCC's reputation is on the line. So when you finally lower the lift and are really proud of it, it's kind of a relief."

By project's end, Senior's aggravation has faded, replaced by obvious pride in the bike. "This one I think stacks up with some of our best," he says, "I mean, it's got everything—power, style… and it handled like a dream."

SENIOR MOMENTS

Paul Sr. takes time during the Tool Bike project to share insights into matters of character and shop production:

- "HERE HE GOES AGAIN, DRAGGING @#$ WHEN HE SHOULD BE KICKING @#$!"

- "IF HE KEEPS DOING THE WAY HE'S BEEN DOING, HE'S GONNA GET A GOOD LOOK AT THE WRONG END OF MY SIZE 12, I CAN TELL YOU THAT."

Risky Business

IT'S DOUBLE-BARRELED IRRITATION FOR SENIOR WHEN HE FINDS PAULIE NOT ONLY DISOBEYING HIS SHOP-CLEANING EDICT BUT CONSPIRING WITH VINNIE TO MOUNT THE TOOL BIKE'S HANDLEBARS IN A BOLD NEW WAY.
"IT'S NOT HAPPENING!" THE BOSS DECLARES.
PAULIE ASKS FOR PATIENCE, ASSURING HIS DAD, "I STARTED WITH AN IDEA AND I'LL PERFECT IT, AND IT'LL BE STRONG; YOU CAN STAND ON IT."
DAD, HOWEVER, AIN'T HAVING IT. "YOU WANT TO BE CREATIVE AND GO PUT YOUR METAL TOGETHER? GO DO IT! BUT DON'T EXPERIMENT WITH SOMEBODY ELSE'S LIFE!"
SINCE ASSURANCE DIDN'T WORK, PAULIE TRIES REASSURANCE: "LISTEN, I WOULDN'T PUT ANYTHING ON THERE THAT WOULD BE DANGEROUS, OK?"
"HOW DO YOU KNOW IT'S GONNA WORK?" SENIOR FUMES. "ARE YOU AN ENGINEER?! *ARE YOU AN ENGINEER?!*"
SINCE DEBATE ISN'T GOING TO WORK, PAULIE TRIES A BROADER TACK: "WHAT IS UP YOUR @#$ THIS MORNING?"
SENIOR, ALWAYS HAPPY TO PROVIDE A SIMPLE ANSWER TO A SIMPLE QUESTION, REPLIES, "YOU'RE UP MY @#$!"
ANY OTHER QUESTIONS?

CHRISTMAS BIKE

HOLIDAY EPISODE

ORIGINALLY AIRED
December 22, 2003

Holiday Spirit

Let's face it, Paul Sr.'s just a giving kind of guy—giving orders, giving warnings, giving grief... But the holiday season arouses a different kind of generosity, both jollier and more serious, as Senior plays Santa for some children who lost parents in the devastation of the World Trade Center.

AH, BUT WHAT'S KRIS KRINGLE WITHOUT A SLEIGH? To make his appointed rounds, Senior decides he needs to travel in style. His Christmas wish? A wild, wacky, original creation. "The most important thing about this bike is to remember that it's for the kids," he tells his mechanically minded minions. "So it's gonna be big, bright, and colorful—kind of like a cartoon... It's all about fun and making the kids happy."

That idea brings a "Bah, humbug!" from Paulie, who opts to stay upstairs and work on customer bikes with Vinnie. So Senior recruits skilled fabricators Rick Petko, Mike Campo, and Mikey as his right-hand men. Mikey?? Oh well, two out of three ain't bad...

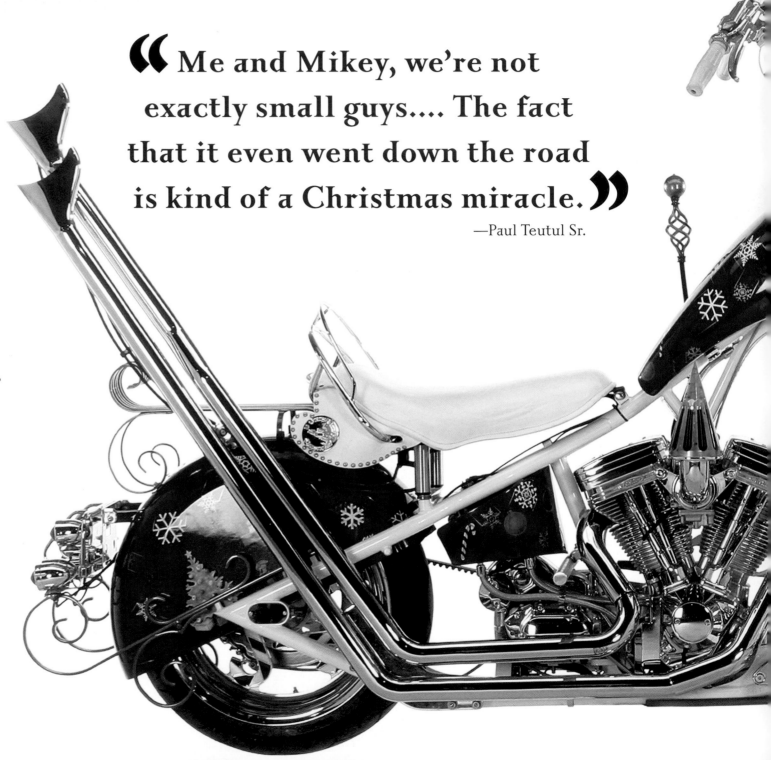

HANDLEBARS

They're antler-bars! But their spiky ends threaten a Yuletide impalement. "You've got to watch your head when you get on this bike," Petko laughs. "Oh, that's me, baby," Senior says as he tests the reach from a seated position. "It's screaming reindeer right now," a bemused Campo says.

TINS

"This was one of the most fun bikes I've ever painted," says Justin Barnes, OCC's go-to tin man. His strategy? "I really just thought a lot about what I would like if I was a kid." The result is a festive array of snowflakes, Christmas balls, candy canes (which would also adorn the wheels and front fork), and a big fat Santa smack on top of the gas tank. Keeping in the spirit of things, a satisfied Senior jokes, "Oh, Magoo, you've done it again!"

IRON "SLED" RAILS

Senior harkens back to his ironworking days for the bike's mock sleigh skis. He knows just what it needs: "curlicue doodads on the back to give it more of a sleigh look." A trip next door to the ironworks provides the material, which he bends and tweaks to achieve just the right curve and length. Though Senior initially wanted chrome skis, they end up decked out in holiday gold.

> **Me and Mikey, we're not exactly small guys.... The fact that it even went down the road is kind of a Christmas miracle.**
>
> —Paul Teutul Sr.

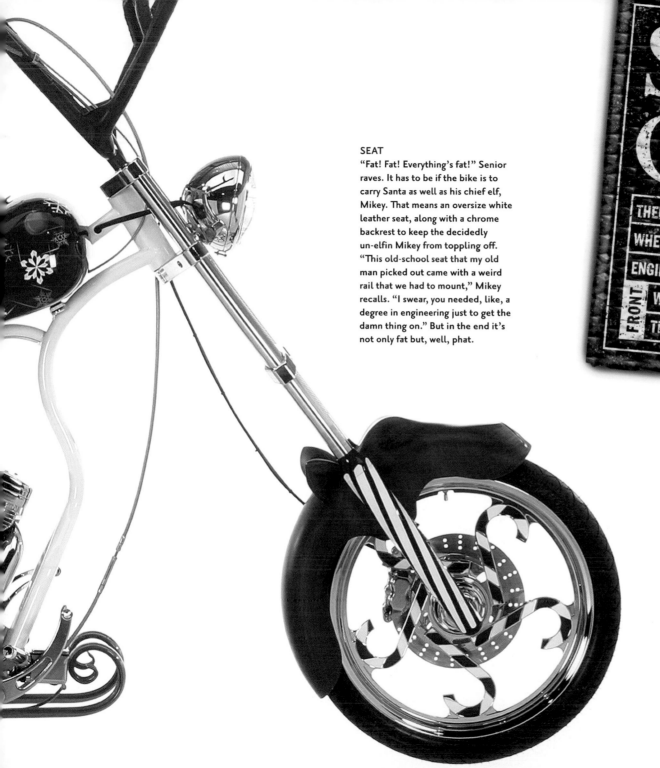

SEAT

"Fat! Fat! Everything's fat!" Senior raves. It has to be if the bike is to carry Santa as well as his chief elf, Mikey. That means an oversize white leather seat, along with a chrome backrest to keep the decidedly un-elfin Mikey from toppling off. "This old-school seat that my old man picked out came with a weird rail that we had to mount," Mikey recalls. "I swear, you needed, like, a degree in engineering just to get the damn thing on." But in the end it's not only fat but, well, phat.

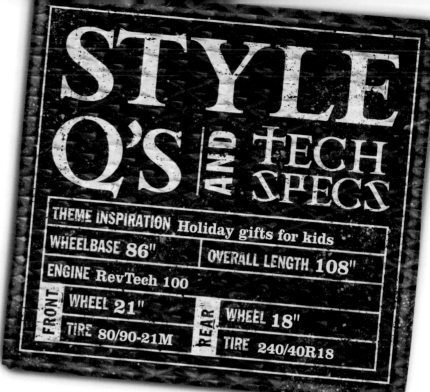

STYLE Q'S AND TECH SPECS

THEME INSPIRATION Holiday gifts for kids	
WHEELBASE 86"	OVERALL LENGTH 108"
ENGINE RevTech 100	
FRONT WHEEL 21"	REAR WHEEL 18"
FRONT TIRE 80/90-21M	REAR TIRE 240/40R18

LIGHTS

According to Vinnie, the Christmas Bike features the most involved wiring system ever created at OCC. "There's as many lights on this as most people have on their Christmas tree," says Paulie. "I know this bike is getting a little bit more complicated than we first intended," Senior admits, "but when you come up with all these good ideas, you just can't ignore them." Even the looming deadline can't shake his confidence: "I think we've got a little Christmas magic on our side."

FRONT FENDER

"I consider myself a pretty serious artist," says ace metal sculptor Mike Campo. "I spent a lot of time trying to create a slick and aggressive style." But the positive vibes around the Christmas Bike trump his aesthetic standards. Voila: a reindeer fender! "I really wouldn't say this front is slick or aggressive, but it's really not meant to be," Campo says. "It's supposed to be fun, so that's fine with me."

133

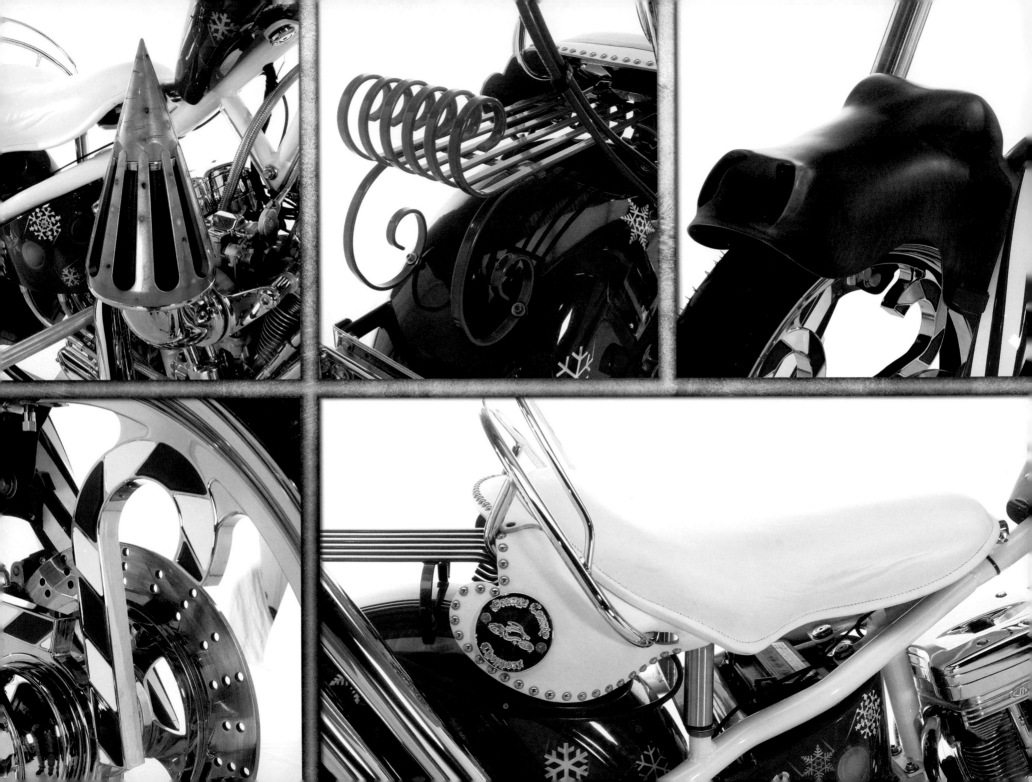

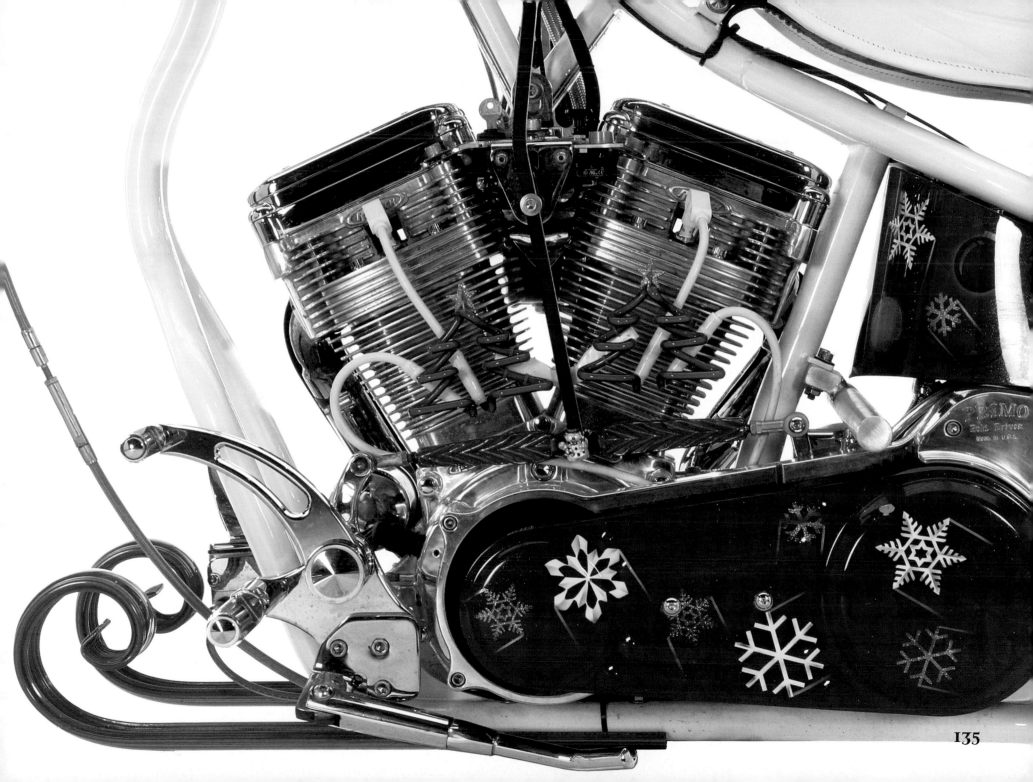

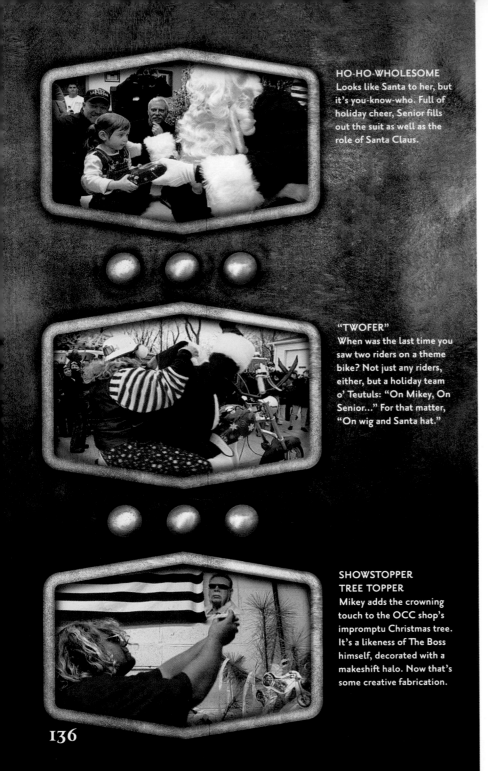

HO-HO-WHOLESOME
Looks like Santa to her, but it's you-know-who. Full of holiday cheer, Senior fills out the suit as well as the role of Santa Claus.

"TWOFER"
When was the last time you saw two riders on a theme bike? Not just any riders, either, but a holiday team o' Teutuls: "On Mikey, On Senior..." For that matter, "On wig and Santa hat."

SHOWSTOPPER TREE TOPPER
Mikey adds the crowning touch to the OCC shop's impromptu Christmas tree. It's a likeness of The Boss himself, decorated with a makeshift halo. Now that's some creative fabrication.

O Tannen-bomb

The project begins smoothly enough, and it's beginning to look a lot like Christmas as Cody joins Petko and Campo in yet another down-to-the-wire theme-bike assembly.

"I was walking around the shop today and, I swear, I actually started feeling like Santa Claus," says Senior. "It's kind of like I had all of my little elves hammering away, grinding, and just trying to get everything done.... It's a pretty good feeling."

Smack-Talking

While one son is goofing off, the other is mouthing off. After Paulie disses the Christmas Bike, Senior gets in his face. "He was saying that it was silly-looking and embarrassing and whatnot," he recalls later.

No, that's not right, Paulie insists: "I'm just saying it doesn't fit our style at all."

No matter, Dad carps: "That really gripes my @#$, because if you ask me, he's missing the whole point of what and who this bike is for."

> **I've got to be honest. When my father started this Santa bike project, I wasn't all that into it. But, you know, all that changed when I saw how the kids reacted to everything.** — Paul Teutul Jr.

Mikey has taken his holiday spirit outdoors, where he lops off the top of an evergreen tree and decorates it with toilet paper to create a one-of-a-kind Christmas tree for the shop.

"Working with Mikey can be frustrating because he gets distracted so easily," says an exasperated Senior. "He better get with the program or he's gonna get a size 12 in his stocking."

Still, when The Boss sees Mikey's inspired treetop ornament—a photograph of Senior with a halo over his head—he can't help cracking up.

What started as simple chop-busting gets a bit more personal. "I think my father just misunderstood what was said and what I was concerned about," Paulie recalls. "But it seems like we're always misunderstanding each other, so why should the holidays be any different?"

Senior offers this take on Paulie's "slick" viewpoint: "We're building it for the kids. He's building it... for his ego. That's the difference."

Ultimately, Paulie pitches in to get the bike finished. As does Vinnie, who has a decidedly

different perspective on the project. "I'm really glad Senior asked me to help put it together," he says. "It's great what he's doing for those kids. And I don't care what Paulie says; I think the bike looks great."

Senior Claus Is Coming to Town

As the big day dawns, Senior and Mikey get into costume while the rest of the crew engage in a hurried gift "wrap-off" to prepare the kids' bundles of goodies.

"This is truly embarrassing," moans Senior as he gets a look at himself in the Santa getup. But with enthusiasm outweighing embarrassment, he and Mikey finally make their way to the Montgomery County firehouse, where they're greeted by a crowd of beaming parents and awed little 'uns.

Even the day's raw cold and light snow can't chill the big-hearted climate. "My knuckles were numb from trying to hold on to my father's hat and beard," Mikey says afterward. "[But] to see the looks on the children's faces, it warmed my knuckles right up."

After a few minutes of gawking at the festive two-wheeler, the children get ushered inside for their visit with ol' Saint Nick. By that time even Paulie has become a believer: "I've got to be honest. When my father started this Santa bike project, I wasn't all that into it. But, you know, all that changed when I saw how the kids reacted to everything."

The children aren't the only ones with sugarplums dancing in their heads. "This year, for me, Christmas came early," says a very satisfied Senior. "The smiles on those kids' faces and all the excitement that they had looking at that bike and getting those presents—that's the only gift I need this year. Because that's what Christmas is all about."

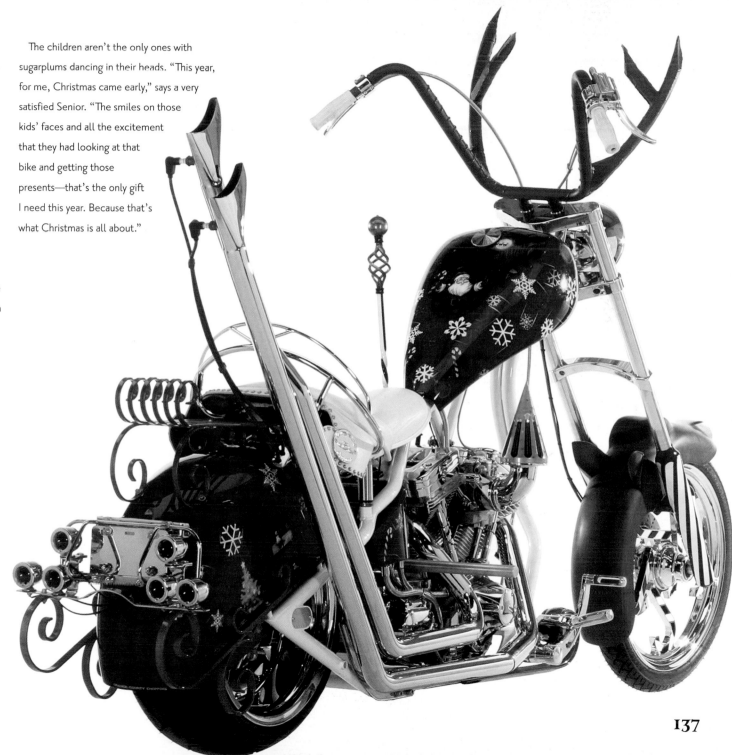

FOOTBALL BIKE

EPISODE 16

ORIGINALLY AIRED
February 2, 2004

138

Motorcycles and football. They go together like brats and beer, "first and 10," powder-coating and chrome.

AND WITH THE TEUTULS NOW HOMETOWN HEROES, who better to have on your side to help drum up team spirit? So it is that the New York Jets summon the men of AMERICAN CHOPPER to help them kick off their 2003 season with a rocking theme bike.

"Football's always been a pretty big part of the Teutul family," says Paul Sr. "Paulie and his brother Danny played in high school, and they were pretty good."

The prospect of visiting the Jets training camp, then, has Senior and Mikey more than a little psyched—though Paulie admits to feeling "a little weird" about shilling for a team other than his favored New York Giants.

But, as they say, business is business. And the job at hand allows the OCC team only ten days to fabricate, paint, and assemble the bike. A piece of cake, so long as there are no breakdowns, blowups, or distractions running interference between them and the endzone...

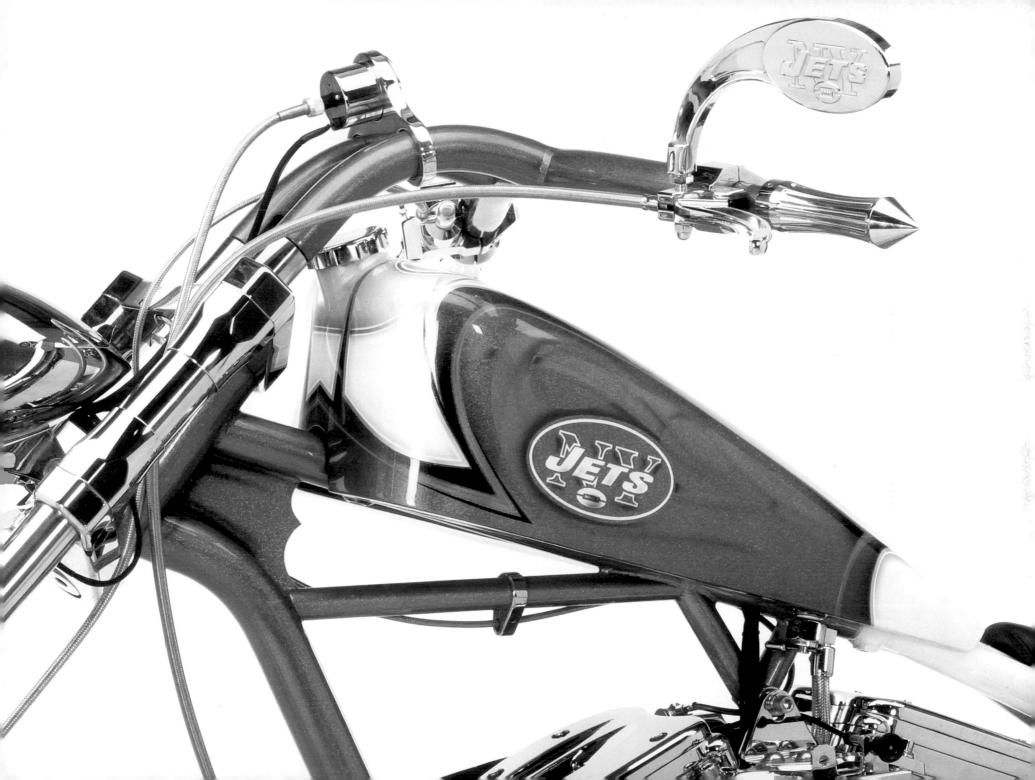

REAR FENDER

An extra-wide tire and an extra-round fender ape the shape of a football helmet. The head-butting begins when the soft-tail frame threatens to bottom-out on the rear end. "Right from the start we had a problem with the rear fender," Paul Sr. recalls, "but all Paulie wanted to do was jabberjaw about it instead of getting to work and fix it." The fix: stabilizing the rear end with a pair of adjustable hydraulic shocks.

LOGOS

This isn't a complicated bike, Senior allows, "but sometimes keeping things simple actually works better, design-wise, than putting on a lot of doodads and elaborate features." The simple solution here: Play up the team logo, which gets emblazoned on the frame, the wheels, the gas tank, the primary cover, and even in neon form on the engine.

GAS TANK

Vinnie states OCC's version of Murphy's Law: "It seems like every time we think we're going to breeze through something, we run into some kind of delay." In the case of the gas tank, it's an especially niggling holdup—the inability to drill two simple mounting holes. "This should've taken about 15 minutes, but instead we were working on the holes for about two hours. Nothing worked," says Paulie. "I mean, we must've sprayed a gallon of lubricant, and all that did was get us wet." Two hours, five drill bits, and three batteries later, the job is finally done.

FRAME

To achieve the team's signature colors, the Teutuls opt for something more personal than powder-coating. After a quick priming, the frame is dispatched to Justin Barnes, who works his usual magic, sandwiching white between two green sections and adding sparkle to make the skeleton even sportier.

HANDLEBARS

Sometimes a fabrication glitch can turn into a design asset. When the pitch of the handlebars has them banging into the gas cap, Paulie and Vinnie simply add a couple of 2-inch riser extensions to get the clearance they need. Later, the extensions get chromed, making for a cool band of contrast with the painted bars.

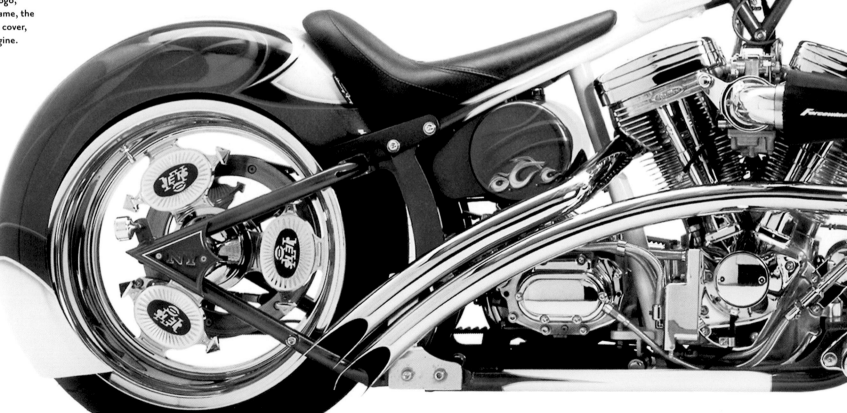

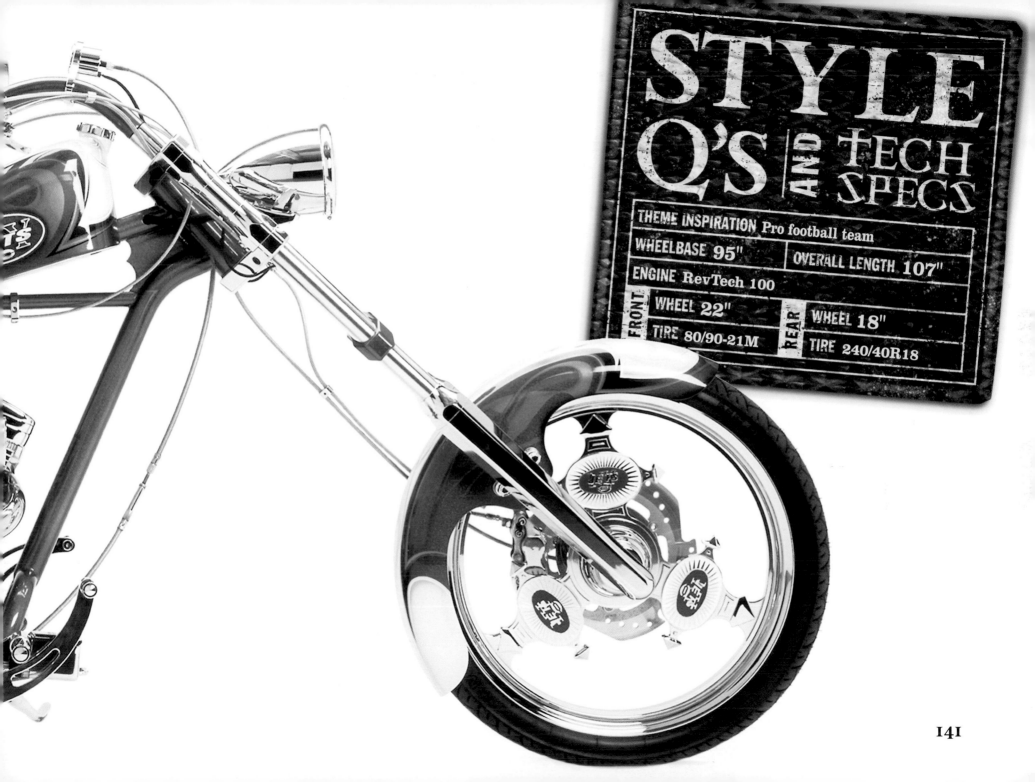

STYLE Q'S AND TECH SPECS

THEME INSPIRATION Pro football team			
WHEELBASE 95"		**OVERALL LENGTH 107"**	
ENGINE RevTech 100			
FRONT	**WHEEL 22"**	**REAR**	**WHEEL 18"**
	TIRE 80/90-21M		**TIRE 240/40R18**

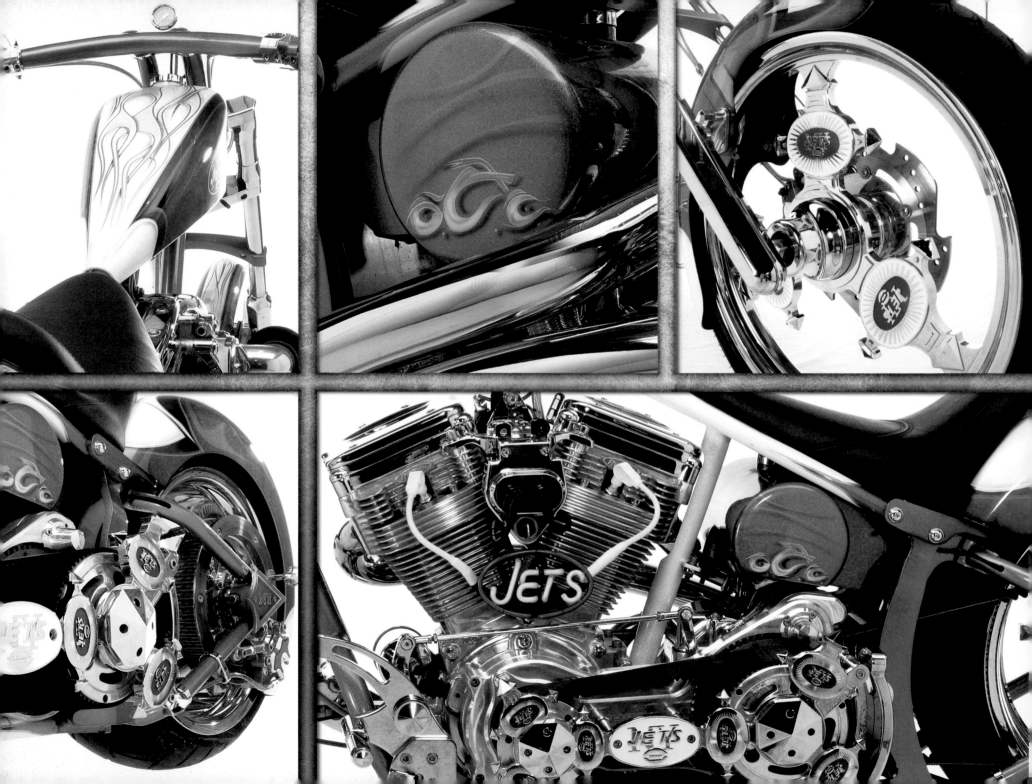

The project gets off to a less than auspicious start when the Teutuls set off for the Jets training camp and suffer a mishap on the jam-packed Cross-Bronx Expressway. Seems their trailer came undone after it was secured with the wrong hitch ball—talk about your backfield in motion! It all adds up to lost yardage on the opening play of this drive.

Fate may not have been on their side, but Karma is, for who should pull up to help out but the Teutuls' buddies from the New York Fire Department. In fact, it's the boys from Bronx-Harlem Rescue No. 3! With an escort from the NYPD, the trailer is towed back to the firehouse, where a few well-placed welds get the show back on the road.

No-Go Cart

Senior isn't exactly thrilled when Paulie decides to devote precious work time to child's play—building a go-cart for the big race at an upcoming celebration. He's downright irate, however, when he finds out the project is "wasting Vinnie's time also."

After Vinnie scrams, Paulie asks if Mikey can assist. "He doesn't even show up for work—he's gonna *help* you?" scoffs Senior, who offers his own services, only to receive a diplomatic rebuff.

"If it wasn't so frustrating it would be funny," Paulie sighs, then offers a snide take on the strange but typical exchange: "I don't think it's that my father has a problem with someone helping me. It's more [that] he wants to be the

one telling me who it's going to be... because, you know, he's the boss."

Senior finds himself a bit chagrined when the cart (ridden by young Christina Rinaldi, the daughter of OCC secretary Marie Rinaldi) wins its race. "I realize that I got on Paulie's case...about making that go-cart," says the old softy. "But when I saw how happy that made Christina... I got to admit, it was all worth it."

Gridiron Glory

While the Teutuls and Vinnie attend the festival parade, Christian, Nick, and Cody wrap up assembly on the Jets bike, less than 24 hours before gametime. Senior gives it a test-ride the next morning; then they're off to New Jersey's Meadowlands for the big game.

As the stands fill up and the excitement escalates, Senior, Paulie, and Vinnie wait anxiously in the stadium. Finally, after the team introductions, the OCC team gets its cue and the guys rumble out under the goalposts, each astride an OCC chopper—the Fire Bike, the Black Widow, and the new Football Bike. Slowly, triumphantly, they travel the length of the field, to the deafening cheers of more than 50,000 fans.

"When we actually started driving those bikes across the field," Senior recalls, "I thought my heart was going to jump right out of my chest. [It] was probably the most incredible thing we've done so far."

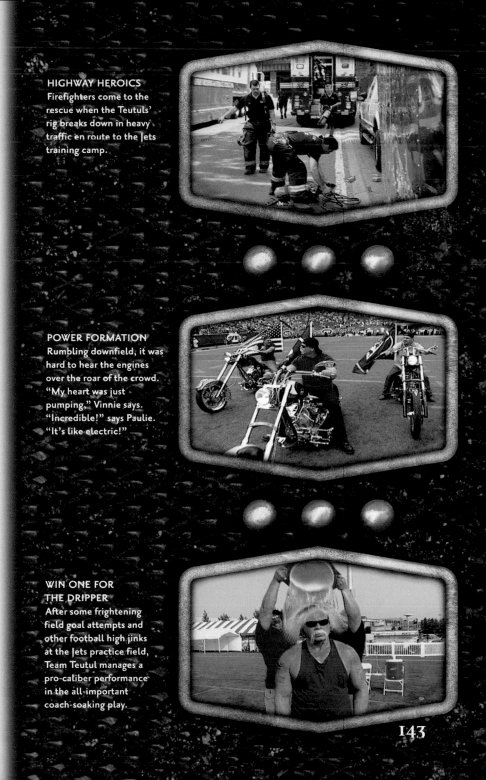

HIGHWAY HEROICS
Firefighters come to the rescue when the Teutuls' rig breaks down in heavy traffic en route to the Jets training camp.

POWER FORMATION
Rumbling downfield, it was hard to hear the engines over the roar of the crowd. "My heart was just pumping," Vinnie says. "Incredible!" says Paulie. "It's like electric!"

WIN ONE FOR THE DRIPPER
After some frightening field goal attempts and other football high jinks at the Jets practice field, Team Teutul manages a pro-caliber performance in the all-important coach-soaking play.

143

POW ★ MIA BIKE

EPISODE
17, 18, 19

ORIGINAL AIRDATES

January 12, January 19, and January 26, 2004

"**Gone but not forgotten...**" This simple phrase has come to express America's enduring regard for those who could not return from the Vietnam War. So when Paul Teutul Sr. decided that a tribute bike was in order, he envisioned a chopper that would be equally unforgettable.

FOR AMERICAN CHOPPER, the 2003 International Motorcycle Show in New York City was an enriching experience in more ways than one. Not only did it mark the debut of the Black Widow, it set the wheels in motion for a more meaningful creation. Among the fans at the show were a couple of Vietnam vets who belonged to the Nam Knights of America motorcycle club. Founded in 1989, the organization honors veterans and police officers who have died in the line of duty.

Inspired by his chance meeting with the Nam Knights, Senior took some of the OCC crew on a road trip to Washington, D.C., and the Vietnam Veterans Memorial, to contemplate the sacrifice of the 58,235 Americans whose names are engraved there in stunning black granite.

"There was a lot of controversy about that war," Senior says, "and I just think that none of [the people in it] got the recognition that they really deserved." To set the record straight, Senior embarks on a creative path that, like the war it commemorates, will be arduous, complicated, and provocative.

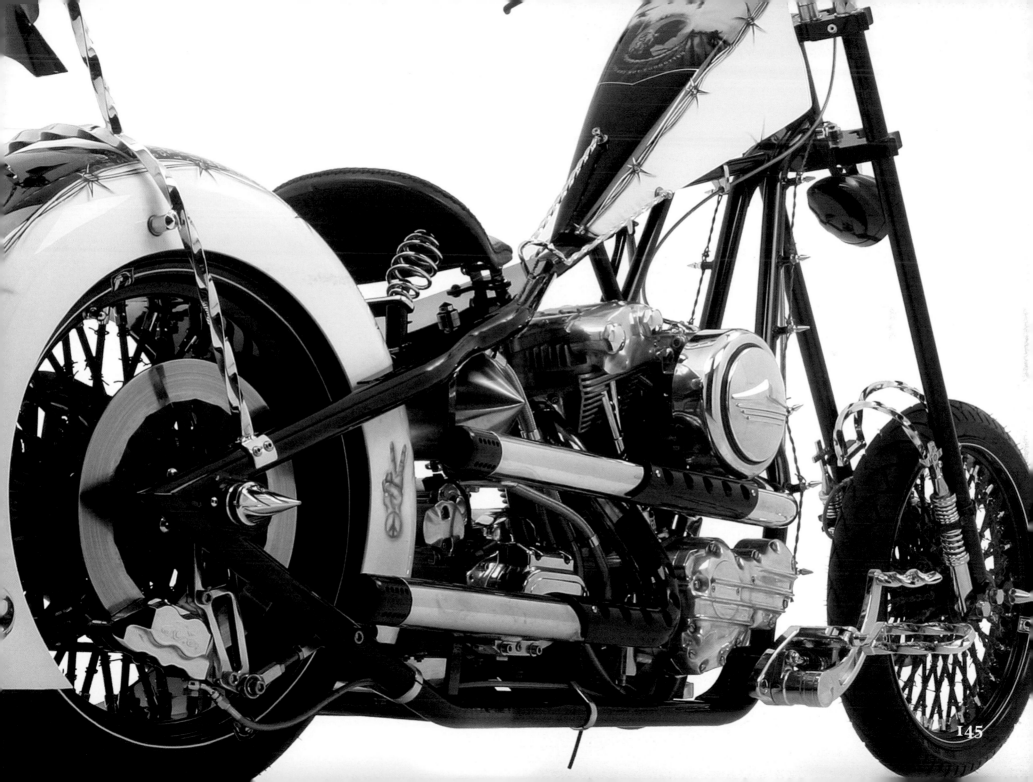

GAS TANK

To fit the look that Senior envisions, Rick Petko starts with a stock tank and slices around its circumference, pries it open, and inserts a sheet metal band. He fabricates an accent piece from bar-stock that complements the sissy bar and lengthens the tank's profile.

SISSY BAR

The sissy bar, although not part of the original concept, is stronger and more appealing than the first simple struts. Campo adds a final detail, a rough-cut ace-of-spades symbol that draws high praise from The Boss: "The more I work with Mike Campo," Senior says, "the more I'm impressed with his abilities."

REAR FENDER

Campo develops the stencil-like POW/MIA logo on the rear fender. Behind the logo, a stainless steel plate and a light create a silhouette effect. Senior's idea was "pretty radical," Campo says. "A lot of people would've just painted the emblem on, but as an artist, I appreciate that he wanted to cut it out and use negative space. It gives the bike a really unique effect."

BELT GUARD

Senior goes really old-school when he hires blacksmith Greg Phillips to hammer out the bike's belt guard, forging it from iron rods. "It's got this really rugged, handmade look, and that's just what I was looking for," Senior says. The ace of spades makes another appearance, at the end of the guard. It's an appropriate symbol, Senior adds, explaining that soldiers often wore the card on their helmets, "almost like a good luck thing."

PAINT

"Of all the bikes I've done for OCC," says Justin Barnes, "the graphics for this one are, without a doubt, the most complex." As if Campo's silhouetted logo weren't impressive enough, Senior suggests that the rear fender also replicate a section of the wall at the Vietnam Veterans Memorial. To accomplish that, Justin sets the names using an adhesive-backed vinyl stencil. He later peels off the vinyl to reveal a granite gray color, which he airbrushes to create a three-dimensional look.

His haunting gas-tank mural depicts a soldier carrying a wounded colleague while bombs burst overhead. The foreground features the POW/MIA emblem and quietly promises "You Are Not Forgotten." Senior is moved by the results and by the abilities of his crew. "Just when I think that there is no way Justin can top himself," he says, "he comes up with something that just blows me away and takes his work to a whole new level."

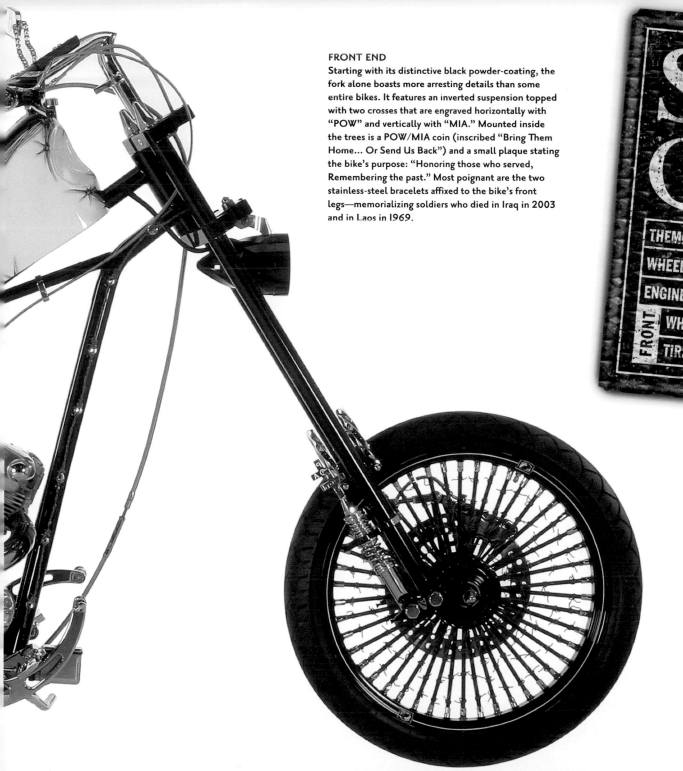

FRONT END

Starting with its distinctive black powder-coating, the fork alone boasts more arresting details than some entire bikes. It features an inverted suspension topped with two crosses that are engraved horizontally with "POW" and vertically with "MIA." Mounted inside the trees is a POW/MIA coin (inscribed "Bring Them Home... Or Send Us Back") and a small plaque stating the bike's purpose: "Honoring those who served, Remembering the past." Most poignant are the two stainless-steel bracelets affixed to the bike's front legs—memorializing soldiers who died in Iraq in 2003 and in Laos in 1969.

STYLE Q'S AND TECH SPECS

THEME INSPIRATION	Vietnam vets tribute		
WHEELBASE 108"	OVERALL LENGTH 120"		
ENGINE RevTech 100 knucklehead			
FRONT	WHEEL 21"	REAR	WHEEL 18"
	TIRE 80/90-21M		TIRE 240/40R18

WHEELS

This chopper is a collection of contrasts—past/present, shiny/rough, bold/reflective... The wheels bring that tension into sharp focus. Thick spokes are painted "candy copper" to create a rusty effect and wrapped in glinty twists of barbed wire.

Mikey seems genuinely impressed. "Everybody thinks that Paulie is the designer at OCC," he says. "But you know, the ideas my old man came up with for this bike are really pretty innovative. I'll bet there's not one other bike in the world that has barbed wire spokes."

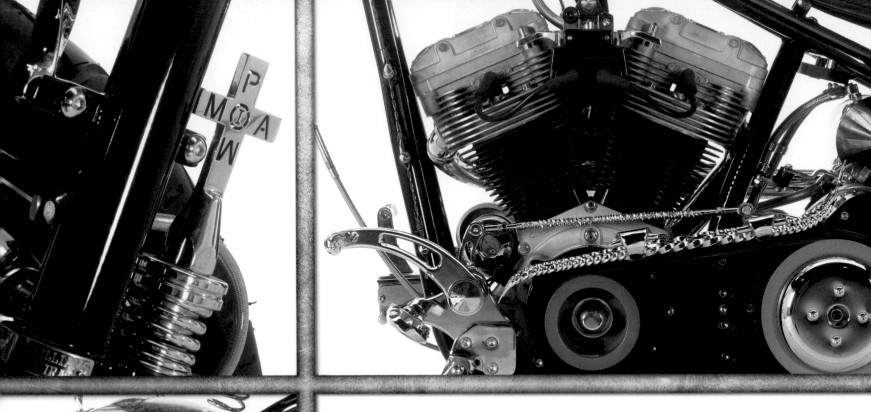

School of Hard Knocks

"When I first started working at the shop, I couldn't have cared less about building bikes," says Mikey. "But the more projects I get involved in, the more I enjoy doing this kind of work." Well, good news for Mikey: The POW/MIA Bike project marks his first opportunity since his blues bike to get really involved with a project from start to finish. The bad news? Paul Sr. will be his teacher.

Work begins with Mikey griping, "Nobody taught me @#$% when I built my bike." His dad replies by laying out the rules of his classroom: "Nobody's gonna teach you anything," he barks, "and every time you screw up, I'm gonna smash you in the head with something, all right? That's the way you learn!" Master and Grasshopper, it ain't.

The first week of fabrication finds Mikey struggling to light the welder, clumsily attempting to bend square bars, cutting a crooked mounting bracket for the sissy bar, and for good measure, backing up the family pickup truck into a parked car.

"I don't think that I can be accused of being a patient man," Senior admits, "but I'm giving it my best shot when it comes to Mikey because I know he's still learning. But jeez, sometimes you gotta wonder what's going on inside his head."

After a brief banishment from the shop, Mikey struggles to redeem himself by steering clear of The Old Man's wrath and singlehandedly installing the bike's kickstand.

Men of Steel

Having impressed Senior with their work on the unconventional Christmas Bike, Rick Petko and Mike Campo return to ride shotgun on the POW/MIA project. Good thing too, because the bike's sophisticated metalwork requires some serious expertise. Rick, an experienced sheetmetal wrangler, takes on the daunting job of heightening and artfully "caving in" the gas tank. Campo, OCC's resident artiste, goes about sculpting the rear fender's elaborate

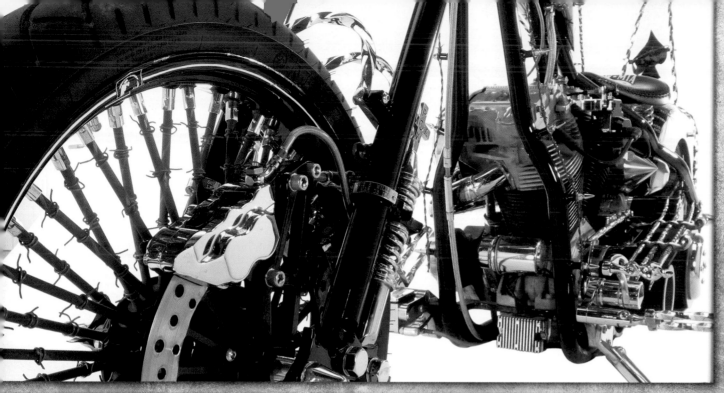

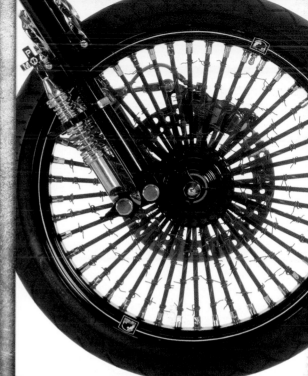

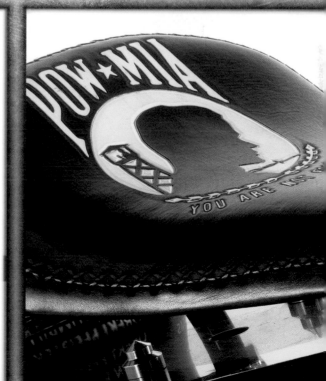

silhouetted logo. It is meticulous, grueling work that threatens to throw the bike off schedule. Frustrated but forgiving, Senior is all too happy to draw a few withering comparisons:

• "When I'm working with Paulie and we get behind schedule... I get pretty aggravated, but that's because he's usually dragging his feet. With Rick, I know that he's just taking his time to make sure that everything's perfect."

• "The more I work with Mike Campo, the more I'm impressed with his abilities... Between him and Rick, I think that this is some of the best fabrication OCC has ever done on a bike."

• "[Rick's] knowledge of metal fabrication is as good, or might even be a little better, than Paulie's. Plus, he seems pretty enthused about doing this project—and in my book, that goes a long way."

With the spotlight on Senior, both Paul Teutuls find themselves unable to resist the competitiveness that always seems to be simmering just below the surface. About a week into the POW/MIA

Bike's fabrication, Paulie drops by the downstairs shop and The Boss proudly shows him the in-progress rear fender. "It looks a little caved in," Paulie murmurs, before grudgingly admitting, "It looks okay, I guess." Senior's take? "I think his face changed about three shades of green—you know, with envy," he says. "But I can tell you one thing: He knows for sure... the old man's still got it."

Still, Senior turns to Paulie for help when he runs into difficulty cutting some risers for the handlebars. "For the last couple of weeks or so, me and my dad haven't had much to do with each other... not that I'm really complaining," Paulie reflects. "I mean, the truth is, if we always worked in separate shops, I think our relationship would be a lot healthier."

After making the necessary cut, Paulie sends his father away by saying, "All right, I'm going back to work. Thanks for bugging me." Determined (as usual) to get in the last word, Senior snaps back, "Great taking the time to bother with me... @#$%&."

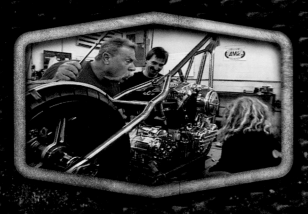

LIFE'S LESSONS
Mikey gets an earful from The Boss as he learns another valuable lesson in chopper fabrication. It's an incentive program, Senior explains: "Every time you screw up, I'm gonna smash you in the head with something, all right?"

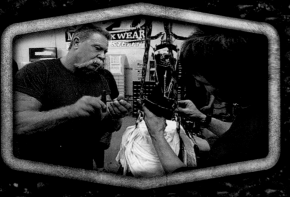

THREE ACES
Ace fabricators Paul Sr. and Rick Petko affix an ace-of-spades emblem on the sissy bars. The card often decorated the helmets of U.S. soldiers in Vietnam, Senior explains.

MUTUAL ADMIRATION
There's a whole lot of pride and respect in front of the lens as the OCC crew and members of the Nam Knights pose with the new POW/MIA Bike.

Mission Accomplished

Despite the fabrication logjam caused by the intricate gas tank and fender, the POW/MIA Bike comes together faster than most of the shop's theme bikes, according to Senior. It is doubtless the most satisfying project for him as well.

"Out of all the bikes we've built, I think he's put more time and more of himself into this one than any of the others," Mikey observes. "That really makes me proud of him."

out," he says. "This bike may have taken three weeks to build, but for me it's been a year in the making. I've been thinking about it a lot ever since I met those veterans at the Javits Center."

It is soon time to meet those vets again—on a road trip to Albany, New York, where the POW/MIA Bike will be photographed for the cover of Hot Bike magazine. As the bike goes before the camera's lens, Nam Knights Bob Colaneri and Fred "Fritz" Reiman look on in

> **❝I don't know what it is, whether this project has been blessed or something somehow. But I think it went together faster and easier than any other theme bike that we've done.❞**
>
> — Paul Teutul Sr.

After the DC trip and pitching in on the bike's assembly, young Cody reflects on an unexpected benefit from the experience: "When Paul Sr. started this project, I really didn't know too much about the Vietnam War. But just talking with Senior and really working on this bike has taught me a lot," he says. "It's kind of funny, because the last thing I thought I would get working at the shop was a history lesson."

Like a proud papa, Senior decides to come in early on the day of the test-ride for some quality time. "I don't know why, but I kind of wanted to be alone for the first time that I took this bike

wonder, then step up for a closer view. "For somebody like Paul to do what he has done—building this bike, and the craftsmanship that he put into it—it means a lot," Reiman acknowledges. "He's not only a great custom bike builder, but he's got a heart of gold—and thank God, because we need people like him."

The experience is equally gratifying for Senior. "I'm from that era and I know what went on," he says. "So to me, the more recognition the bike gets, the more recognition they get."

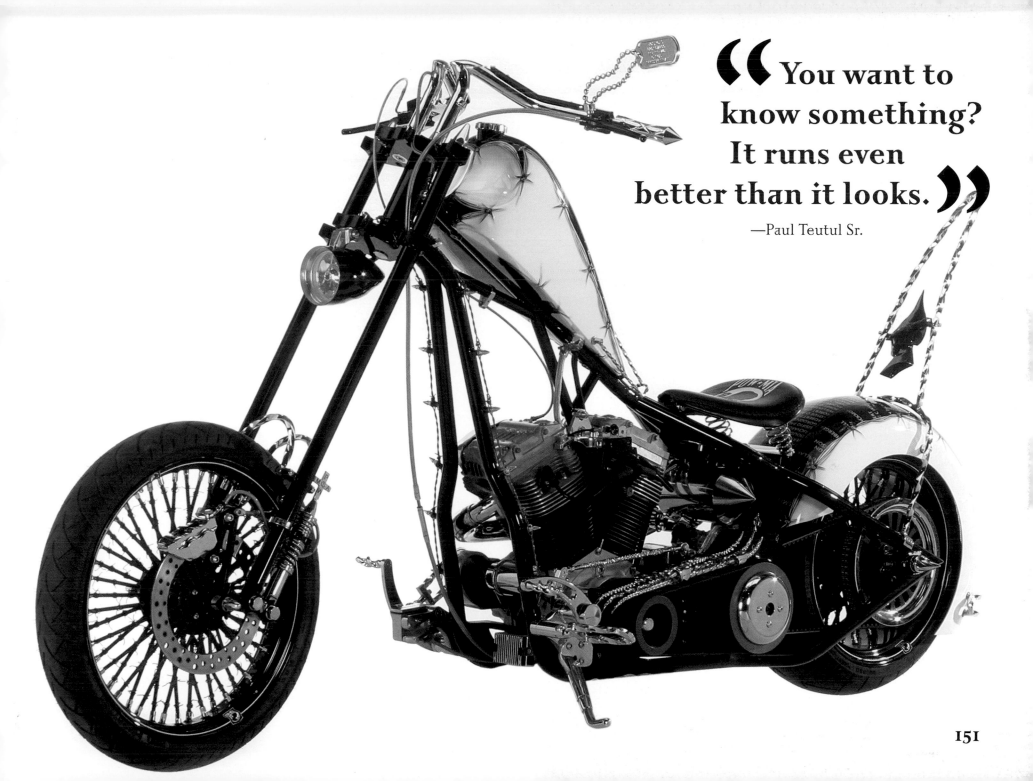

"You want to know something? It runs even better than it looks."

—Paul Teutul Sr.

Senior Moments

A brief, haiku-esque exchange gets to the heart of the Teutul sensibility, as Senior complains, "You're not happy unless you're aggravating me." Mikey snaps back, "You're not happy unless you're aggravating." Senior has to admit, "That's true too."

POW ★ MIA

YOU ARE NOT FORGOTTEN

JOE, G. I.
329197300
11—11—48
O POS
PRESBYTERIAN

LIBERTY BIKE

EPISODE
24 & 25

ORIGINAL AIRDATES

April 12 and
April 19, 2004

Bring me your tired,

your poor fabricators yearning to create the perfect vehicle to celebrate freedom. There may be huddled masses of woe in store, but this epic theme bike gets a little help from the big green Lady herself.

IT LOOKS LIKE A MOMENT OUT OF MISSION: IMPOSSIBLE when three strangers stride into OCC headquarters carrying mysterious aluminum briefcases. Turns out the prospective clients are representatives of Gold Leaf Corporation, an official licensee of the Statue of Liberty Restoration.

Their precious cargo? An array of metal components removed during the monument's exhaustive 1980s makeover. As Gold Leaf founder Richard Stocks explains, "We've been safeguarding and warehousing these artifacts for 20 years now, and we always wanted to do something very exclusive with the materials." Well, they've come to the right place.

OCC's mission, should they decide to accept it? To build a monumental bike, Stocks says—one that "stands for something for Americans and anybody that views it." With that, the Teutuls board a chopper of the flying kind and head for New York Harbor. There, at the base of Lady Liberty, Paulie concocts a revolutionary plan: He'll plate the entire bike in copper! Not just any old copper either, but the melted-down remnants of the statue's original components. If only the rest of the project would come as easily as that brainstorm...

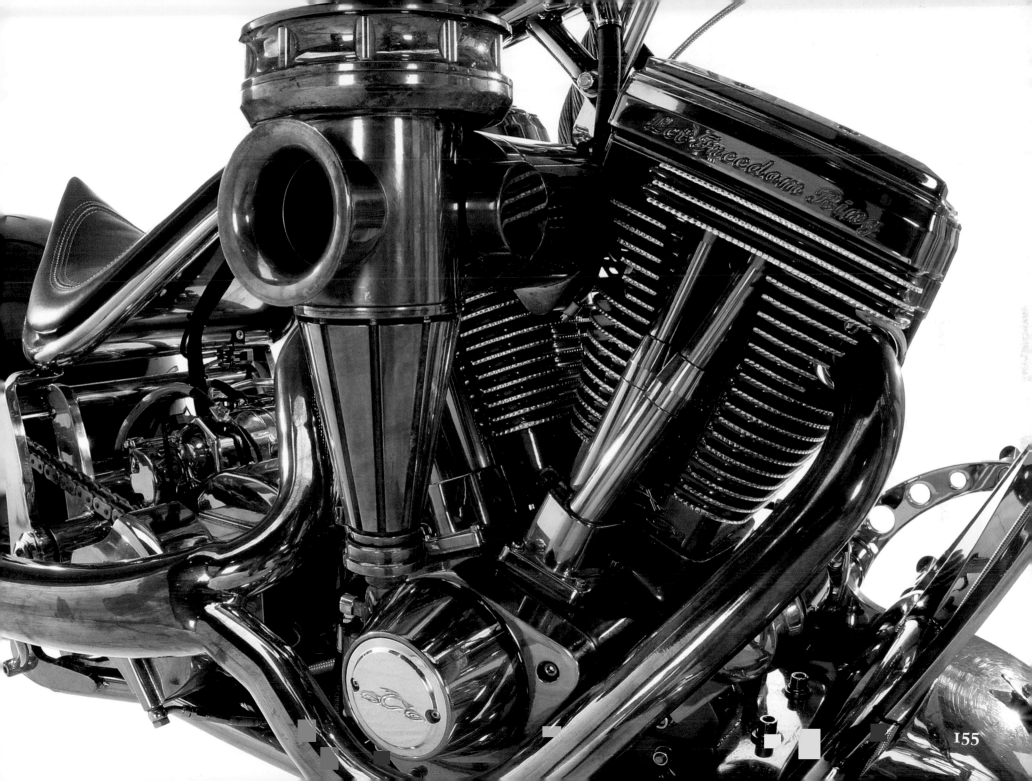

EXHAUST

The third time's the charm for the exhaust system. The first set of pipes didn't fit, and the second set tailed off in ear-splitting, hair-igniting proximity to the rider. Senior's solution: "Just weld the hell out of it!" But the guys try once more—the magic third time—and Paulie finds a solution to fitting it around the carburetor. He had to; as he recalls, "We couldn't afford any more mistakes."

DRIVETRAIN

The drive features two innovations, one of them planned and the other one improvised. Contrary to convention, the Liberty Bike's drive line is on the right side of the engine. "It's really gonna make the bike stand out," Paulie says, "and I think it's really gonna surprise a lot of people." The bike ends up with a slender chain-and-sprocket drive when Vinnie discovers that a belt drive would be obstructed by the frame.

OIL TANK

The low-slung seat requires an unorthodox placement for the oil tank—outside the frame, in front of its downbar. Like seemingly everything else on this project, the tank doesn't fit as planned. "It would have taken weeks to build a new one with the correct specs, so we really had to make this one work," Paulie says. Paul Sr. gets credit for the solution, a neat bit of fabrication. "I guess my father might know a thing or two about metalwork," Paulie jokes later. "It was kinda satisfying to pull it off."

CARBURETOR

"Get the hell outta here!" blurts an astounded Senior, delighted by the bike's "torch" carburetor. The project leaves carbmeister Dan DaVinci as exhausted as the Teutuls are exhilarated. "The process for machining the carburetor was one of the most complex projects we'd ever started," DaVinci says, adding, "It's quite a piece, and it will run perfect."

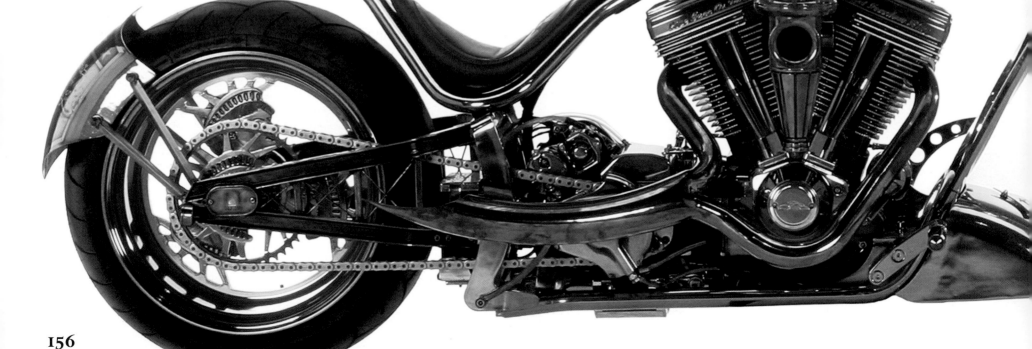

SWING ARM/FRAME

A swing arm holds the rear wheel and pivots against the frame to cushion the ride. When that flexibility causes the bike's rear tire to bind, Paulie comes up with a bold idea: heating the affected frame area and prying it upward. "I was pretty amazed Paulie wanted to bend that frame," Vinnie recalls. "That's a pretty radical solution… You can kink or stretch the tubing and ruin the whole frame." The risk pays off, however, as they slowly torch the tubing to red-hot temps, then gingerly lift the frame section using a metal bar as a lever. The end result? Crucial clearance.

STYLE Q'S AND TECH SPECS

THEME INSPIRATION Statue of Liberty			
WHEELBASE 96"		OVERALL LENGTH 119"	
ENGINE H&L Performance 131			
FRONT	WHEEL 22"	REAR	WHEEL 18"
	TIRE 80/90-21M		TIRE 280/40R18

PLATING

Though shiny as a new copper penny, the Liberty Bike is considerably more valuable. The copper plating (using metal preserved from the Statue of Liberty's restoration) takes place at Chromemasters in Nashville. After a thorough scrubbing, the parts undergo an electrocleaning process to remove impurities, then a neutralizing acid bath. Next up: a protective nickel plating for the aluminum components and a good, long soak in the copper plating. In the final step, says Charlie Jackson of Chromemasters, "all the recesses will be blackened, and then we repolish the copper and leave the recesses with that dark, or antique, finish." A clear-coat finish prevents oxidation (the process that gives Lady Liberty her distinctive green complexion).

FENDERS

The fenders make two design statements yet are completely complementary. In front, Paulie arches round bars to create a design homage to the skeletal interior of the Statue of Liberty. The rear fender takes a more inspirational tack; it's a crest-like American flag medallion emblazoned with a relevant Bible verse: "Now the Lord is that spirit; and where the spirit of the Lord is, there is Liberty."

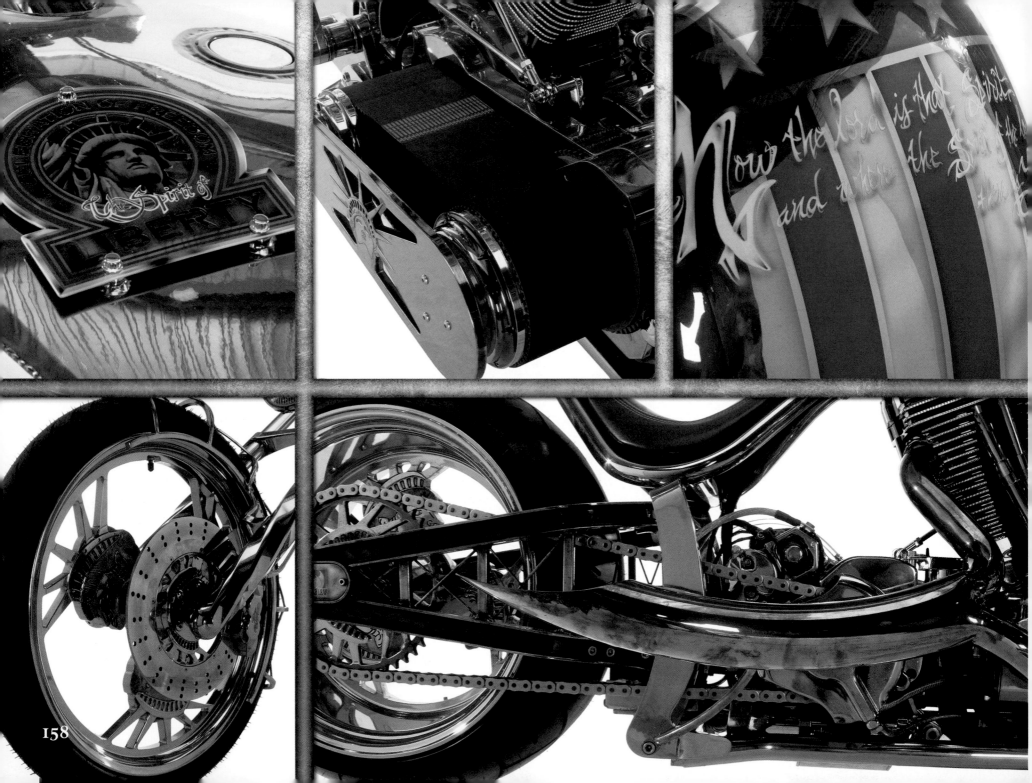

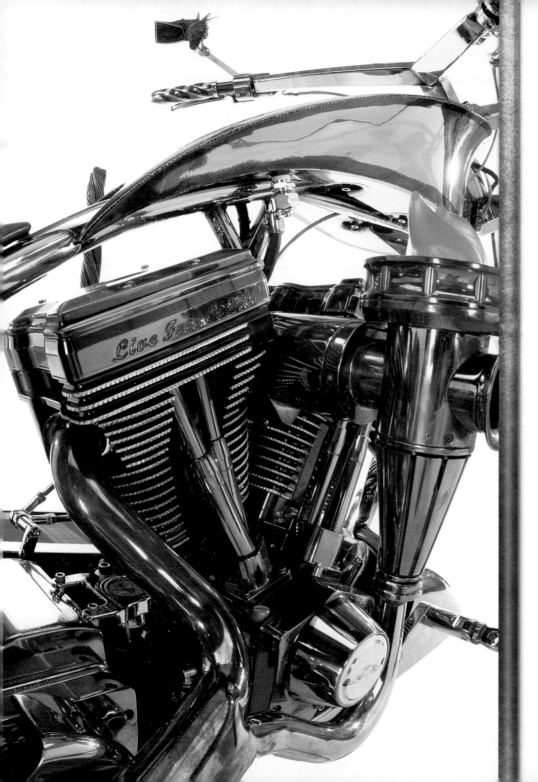

Talk about tempting fate! No sooner has Paulie unwrapped the Liberty Bike's first piece than he breezily predicts a three- or four-day mockup process and confidently announces, "I'm really not anticipating any problems."

Ha!

Within minutes, of course, he notices that the bike's frame is bearing down on the rear wheel. The next day brings Vinnie's discovery that the swing arm impedes the belt drive. A day later brings a one-two punch: The gas tank arrives in the morning, and it's too short. After lunch they receive the misfitting exhaust (the first misfitting exhaust, that is). Less than 24 hours later comes the defective oil tank. Is the project cursed?

"Nothing works on this bike! Nothing! Nothing! Nothing!" wails a fed-up Paulie. "I'm ready to just give up altogether and go to Florida."

As if dear old Dad would let him get off that easily. In fact, Senior compounds Paulie's equipment-related headaches with some confusing criticisms. "You know, it really gets me," he gripes when he learns about the rear wheel butting up against the frame and that Paulie has increased the bike's rake (the angle of the front fork). "First, Mr. Innovation messes up the frame design; now he's changing the angle of the front end, which is only gonna give us more aggravation down the road."

Paulie has a ready defense: "Well, we had to do something different than the same old crap every single time."

The following week, however, finds both Pauls singing a different tune. When Senior realizes that Paulie plans to use a cutout rear fender on the Liberty Bike (as he had done on another chopper) *and* that he'll be securing it with square-bar struts (ditto), The Boss furrows his brow and professes to the camera, "My biggest fear is Paulie getting lazy and falling back on old designs."

An incredulous Paulie has heard quite enough: "One day my father's telling me I'm too innovative," he says, "and the next day he's telling me I'm not innovative enough! I just wish he'd make up his mind." And so it goes, with Senior insisting, "You need to change it up a little bit," and Paulie reasoning, "Can't you just have a bit of a style, where it's consistent?"

D.I.Y. or C.O.D?

You want consistency? Well, there's the Teutuls' ongoing disagreement over the replacement gas tank for the Liberty Bike. While Paulie favors having their original contractor redo it, Senior thinks the time has come for OCC to rely more heavily on in-house metalworkers Rick Petko and Mike Campo. "We're fabricators— that's what we do!" he rails.

"One of the last things I wanted," says Rick, "was to get pulled into an argument between Senior and Paulie." He opts out, claiming that the super-smoothness needed for the copper plating process would be more quickly achieved by a specialist. That silences Senior... until the contracted fabricator blows the deadline.

JOLLY GREEN GIANTS
A nifty hat gets Mikey into the spirit of the moment, as the Teutuls visit Lady Liberty seeking inspiration for their latest theme bike.

SMOOTH OPERATORS
The arrival of an artfully formed gas tank stops work at OCC just long enough for the fabricators to admire the new tank's complex curves.

COPPER CHOPPER
After the fabrication comes the admiration, as fans are dazzled by the copper brilliance and symbolic majesty of the Liberty Bike.

"That's why I like to do everything in-house and @#$% everybody else!" Senior bellows.

Exasperated, Paulie reminds him that Rick declined the job. "What's your problem?" he pleads. "The guy said he couldn't do it. Why can't you live with that?"

Senior still insists that Rick only passed because Paulie didn't believe in him. When the new tank finally comes in, Paulie praises its smoothness, saying it's "like a piece of glass."

reference, Campo painstakingly bends, shapes, and cajoles a sheet of metal until the world-famous profile begins to emerge.

"I know Paulie wants the fender to match the Statue as close as possible, so that requires a lot of attention to detail," he says. "I just hope I get the time I need, because I know these guys have a lot riding on this."

But as the work drags on, it become evident that time won't be Campo's biggest problem.

> ❝ **We just hope that someday they look at our bike as a symbol of freedom just as they do the Statue of Liberty.** ❞
> — Paul Teutul, Sr.

Guess who agrees? The tank "looked pretty good on that bike," Senior says, but not without adding, "I still think Rick could do just as good a job as anybody." Yup, he gets the last word again.

Losing Face

But it's the heartbreaking, not the head-butting, that makes for the Liberty Bike's most painful episode. Having gone with a 280 rear tire and a corresponding 13-inch-wide fender, Paulie thought, why not use that expanse to display a work of art—specifically, a three-dimensional replica of Lady Liberty's face?

With that he calls in OCC's ace sculptor, Mike Campo, who eagerly takes to the task. With a handful of photos by his side for

More troublesome are the dubious looks from Paulie as he glances over at the challenging task.

Finally after about eight nonstop days of fabrication and a pained night of reflection, Paulie decides to go another way with the fender. "I know Campo worked really hard on that rear fender," Paulie says, "but it just wasn't working for me." He sighs heavily, then adds, "It's times like these that being a boss isn't much fun."

Campo, for his part, struggles to keep his chin up. "I was genuinely hurt when he didn't want to use it, but I can understand," he says later. "These are his projects... and if he doesn't want one aspect of it being too dominating, or overshadowing another part, I can respect that. He is my boss."

Still, the dejection is hard to hide. "Poor Campy," says a consoling Vinnie, who half-jokingly offers his bummed-out coworker a hug.

At the end of the day, however, nothing smooths over spats and heals bruised feelings like success. And the OCC crew experiences that in spades when the completed Liberty Bike is every bit the gleaming masterpiece they'd hoped it would be. The crowd at Michigan's Birch Run Expo Center validates their pride at the bike's debut. The auditorium full of chopper fans reverberates with chants of "OCC!" as Paulie wheels the bike onto the display floor. After a brief rundown of the project's history, he offers the most important reason for the homage: "It's all about freedom."

It's a little bit about stardom too, judging from the winding lines of attendees hoping to snag an autograph from the Teutuls. Senior reckons that the Birch Run response was OCC's most explosive, while Vinnie testifies, "We've still got a long trip home, but I'd gladly turn around and do it again for this kind of reception."

A quieter but no less significant scene unfolds later, when the Liberty Bike is presented to the Gold Leaf Corporation in Gotham's Battery Park, with New York Harbor and the great Lady herself as a backdrop. "They have more than exceeded our expectations producing this bike," says Richard Stocks. After expressing his amazement, Stocks offers his gratitude in the form of an inscribed replica of the hallowed statue.

SENIOR MOMENTS

"THEY'LL GET WHAT WE GIVE 'EM!" SENIOR BLUSTERS WHEN HE HEARS WHAT SOME VENDOR WANTS FROM OCC. LUCKILY PAULIE KNOWS WHEN POP SHOULD JUST TALK TO THE HAND: "SOMETIMES MY FATHER'S A LOOSE CANNON AROUND THE SHOP, MAKING ALL KINDS OF SUGGESTIONS," HE SAYS. "AND WHEN HE GETS THAT WAY, I CAN'T TAKE HIM SERIOUSLY... 'CAUSE IF I DID, I'D NEVER FINISH THIS PROJECT— OR ANY PROJECT, FOR THAT MATTER."

The Teutuls have modeled motorcycles after jet planes, firetrucks, helicopters, and even national monuments. But a lawn mower? That's just wacky.

But that's exactly how Dixie Chopper, a manufacturer of heavy-duty mowers ("choppers," get it?), wanted to celebrate its 25th anniversary. As the Teutuls and Vinnie would learn on their visit to the company's plant in Coatesville, Indiana, Dixie's machines are capable of shearing an entire football field in a mind-blowing nine minutes. With power like that, the guys reasoned, why not use one of Dixie's stock engines to power the bike-to-be?

That's just one of several novel ideas that fueled this project. "I decided I wanted to go extreme and make it look real 'science fiction,'" says Paulie. "Like, with fins and curved lines and circles and stuff." There is nothing novel, however, about Paulie and Co. struggling with a weighty deadline—in this case, it's having the Dixie Chopper Bike ready for Daytona Bike Week, a mere four weeks away.

Piece of cake, right?

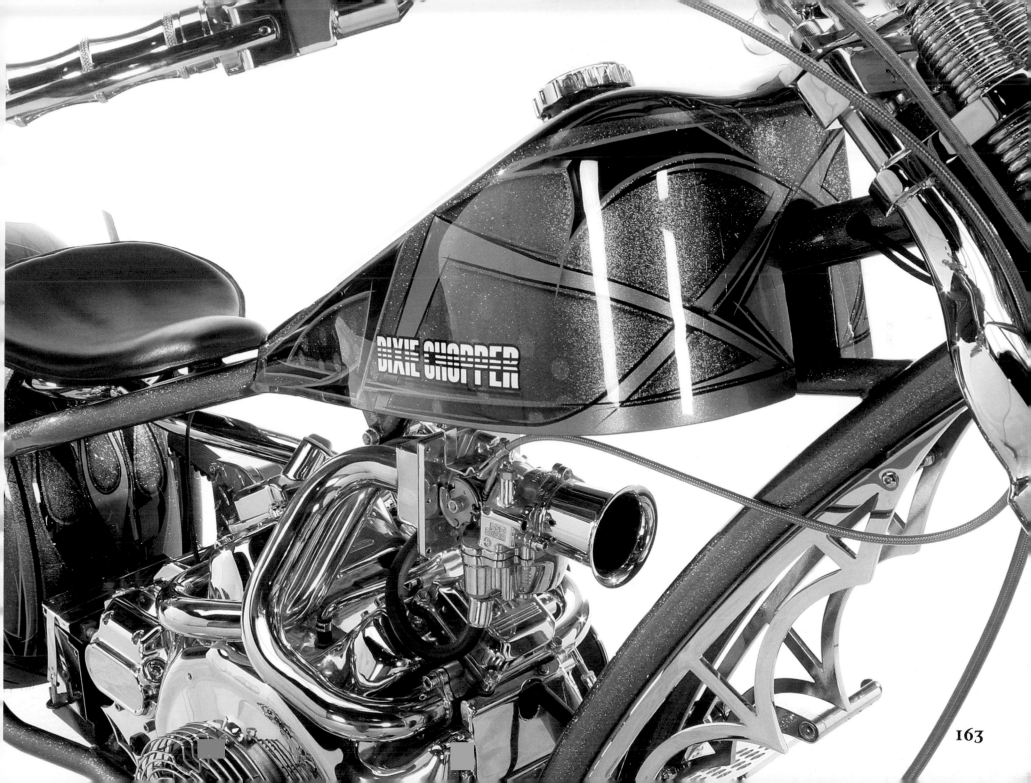

GAS TANK

Rick has plenty to be nervous about with the tank. For one thing, the Teutuls won't be around during its fabrication. "I don't really feel too good about working on this thing with them not here," he frets. What's more, this is the first theme-bike tank he's ever built! "To build a tank by hand," he says, "I had to learn a lot of tricks about shaping metal." And for this tank, Rick says, "I think I used every one of them!"

EXHAUST

The engine has a somewhat elevated exhaust manifold, so Senior and Paulie are concerned that a conventional placement would crowd the rider's left leg. Their solution? Directly under the top bar, a single exhaust pipe splits, wishbone-like, into twin pipes, which exit under the seat, flaring outward and upward.

RUNNING BOARDS/ HANDLEBARS/STRUTS

Pondering Dixie mowers, Paulie seizes on the design of their discharge chute. The perforated sheet-metal device, which protects people from blade-tossed stones and grass clippings, inspires artsy running boards, handlebars, and struts. The project gives Vinnie a chance to run the shop's new Flow Jet machine, which carves out such pieces with a few computer keystrokes. The results leave Paulie impressed yet cautious. "I gotta be careful," he says. "When it's so easy to cut out a part, you could overdo it with ornamental shapes and doodads."

PAINT

Painter Justin Barnes gets clear instructions from the Teutuls: "Freak this bike out!" And boy, does he ever. "Since I know the bike's being debuted in Daytona," he says, "I thought I'd use some silver flake to make it really sparkle out in the sun and catch everyone's attention." A black base coat yields to heavy silver and blue flake—then the bike's main color, pagan gold. The gold interacts with the blue to produce a sparkly green. Next, a coat of "organic green candy," complemented by the more "grassy" green accenting the tins. Finally, Justin stencils subtle circles on the gas tank to match the discharge-chute motif. "Holy cow!" says a thrilled Paulie. "She's the mustard machine!"

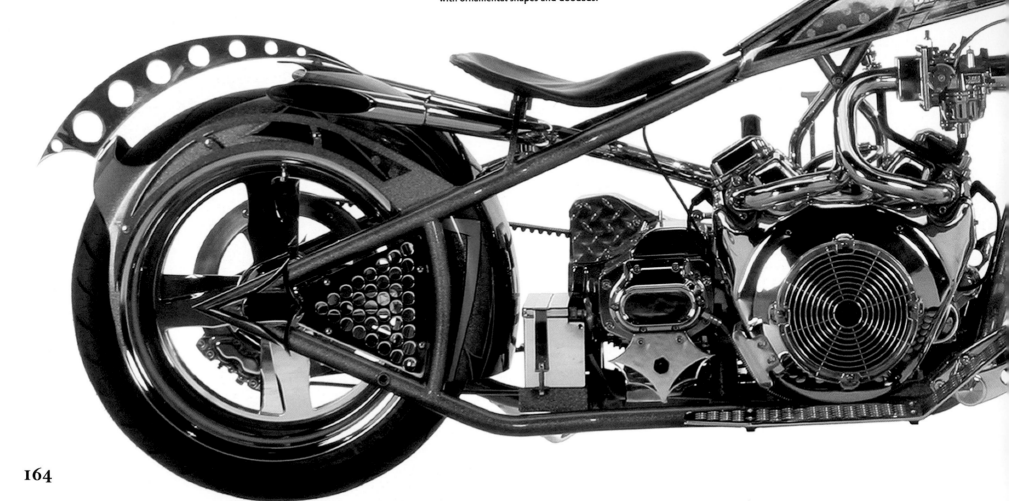

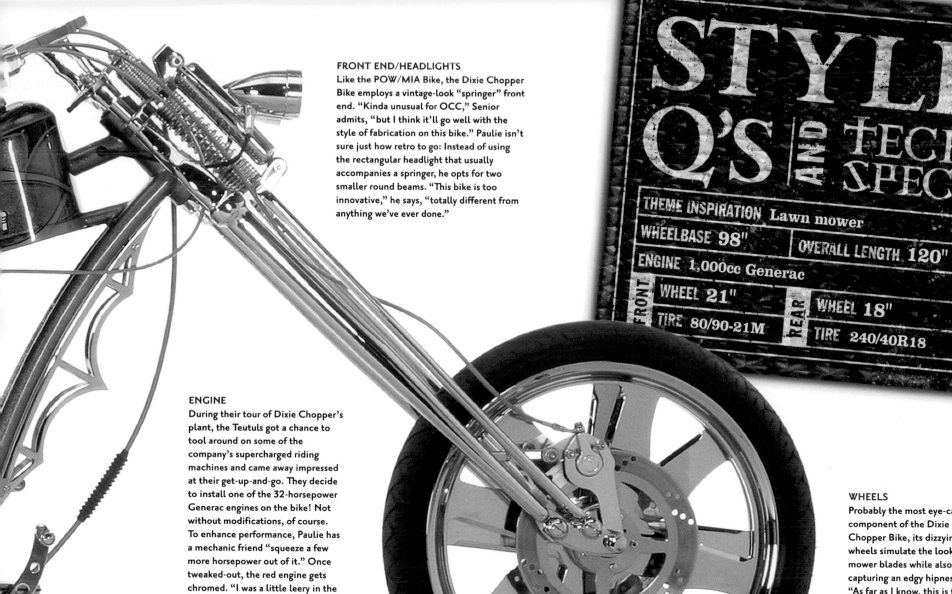

FRONT END/HEADLIGHTS
Like the POW/MIA Bike, the Dixie Chopper Bike employs a vintage-look "springer" front end. "Kinda unusual for OCC," Senior admits, "but I think it'll go well with the style of fabrication on this bike." Paulie isn't sure just how retro to go: Instead of using the rectangular headlight that usually accompanies a springer, he opts for two smaller round beams. "This bike is too innovative," he says, "totally different from anything we've ever done."

ENGINE
During their tour of Dixie Chopper's plant, the Teutuls got a chance to tool around on some of the company's supercharged riding machines and came away impressed at their get-up-and-go. They decide to install one of the 32-horsepower Generac engines on the bike! Not without modifications, of course. To enhance performance, Paulie has a mechanic friend "squeeze a few more horsepower out of it." Once tweaked-out, the red engine gets chromed. "I was a little leery in the beginning," a giddy Senior would later say of the engine, "but it gave me just a great ride."

WHEELS
Probably the most eye-catching component of the Dixie Chopper Bike, its dizzying wheels simulate the look of mower blades while also capturing an edgy hipness. "As far as I know, this is the only bike in the world that has double spinners for wheels," says a psyched Paulie. "You actually see three wheels in there spinning away. It really makes them pop."

STYLE Q'S AND TECH SPECS

THEME INSPIRATION Lawn mower				
WHEELBASE 98"		OVERALL LENGTH 120"		
ENGINE 1,000cc Generac				
FRONT	WHEEL 21"		REAR	WHEEL 18"
	TIRE 80/90-21M			TIRE 240/40R18

165

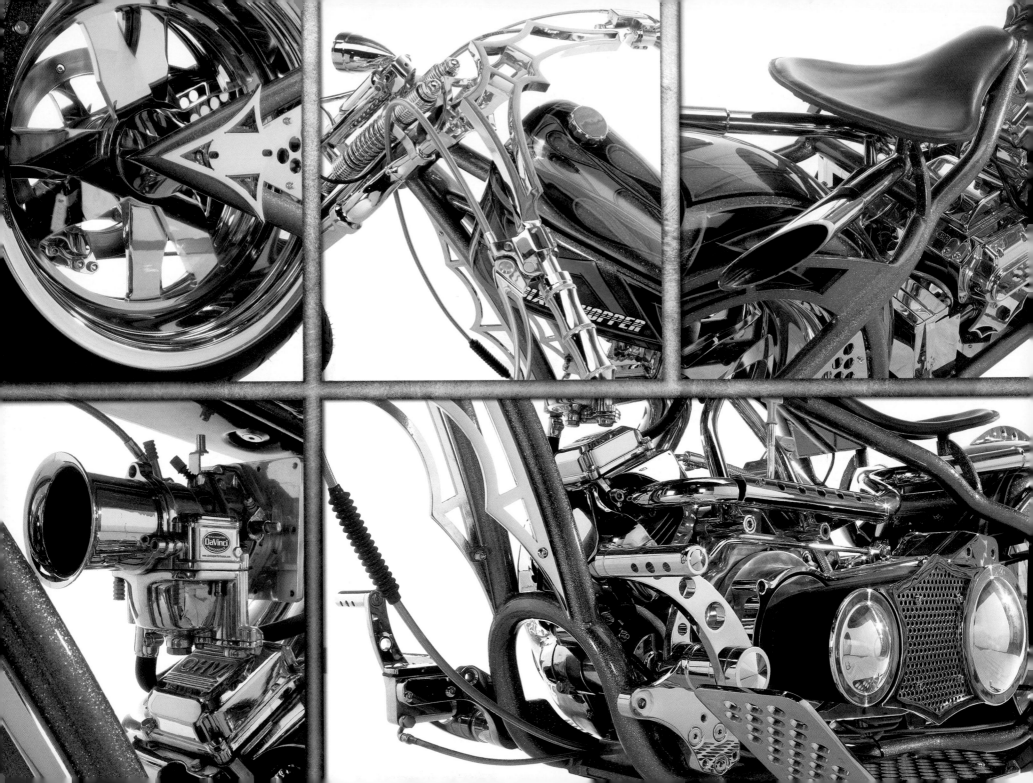

The Sound and the Fury

Midway into the Dixie project, the sounds of carpentry join the shop's usual metal-to-metal din. It's another OCC expansion under way. This one will double the size of the "upstairs" shop, as well as Senior's lair.

"The guys really need the floor space to build all the bikes that are coming up," he says, "and I sure need the office space."

A less pleasant audio track follows when a radio station sends a singing telegram. The catch? It's delivered by a man sporting a diaper—and a voice better suited to any other line of work. "I'll tell you," says an amused Senior, "you never know what to expect around here."

Of course one thing everyone expects is father-son fireworks, and the Dixie Chopper build doesn't disappoint. Problems start right up front, when Paulie and Vinnie get puzzled by the wheel's spacers and brake-caliper bracket. Because Rick has had more experience with this setup, Paulie asks for his help. But Senior is having none of this on-the-clock training.

"Why do you gotta @#$% around with that when you don't know what you're doing?" he fumes, telling his son simply to let Rick handle it.

"It's a front wheel!" Paulie rails, adding that he could use the experience. "So let him help you with it," yells Senior, contradicting himself and setting up Junior for the slam:

"He *was* just helping when you came out screaming like a moron!"

Once Senior leaves, Paulie decides to let Rick do the front wheel after all. Inscrutable, huh?

Yup, but not nearly as baffling as what happens mere hours later, when Senior comes tooling into the shop aboard a brand-spanking-new, fully loaded Harley-Davidson Classic Electra Glide— and for no apparent reason gives it to Paulie!

"I was pretty taken aback, because me and my father don't exchange gifts too much," Paulie says, recalling his surprise.

"I felt a little choked up there," a farklempt Senior admits later. "Maybe it has to do with getting a little older; I don't know."

Leave it to Mikey to bring the mood back down to earth, however. "Where's my bike, Daddy?" he wails gleefully. "You don't love me!"

The project's biggest crisis comes during the tail end of the assembly, when the bike's rear end is discovered to be extremely, inexplicably crooked. A puzzled Paulie thinks the welding process may have warped the frame.

"I've never seen a fender that bad," he says, "and I've seen some hairy stuff."

Things get hairier as Paulie tries to pry the strut clear of the tire. "I pretty much had to close my eyes 'cause he was putting major stress on that paint," Vinnie says later. "If it chipped, there's no way Justin could fix it in time for Daytona."

Vinnie and Paulie try a variety of spacers before they resort to "plan Z," boring out the spacer. Still no luck. Finally, at Senior's suggestion, four guys simply apply brute force, yanking on the struts until they'd set things right.

Relieved, Senior says, "I didn't think this bike was ever gonna stop fighting us."

Look who's talking!

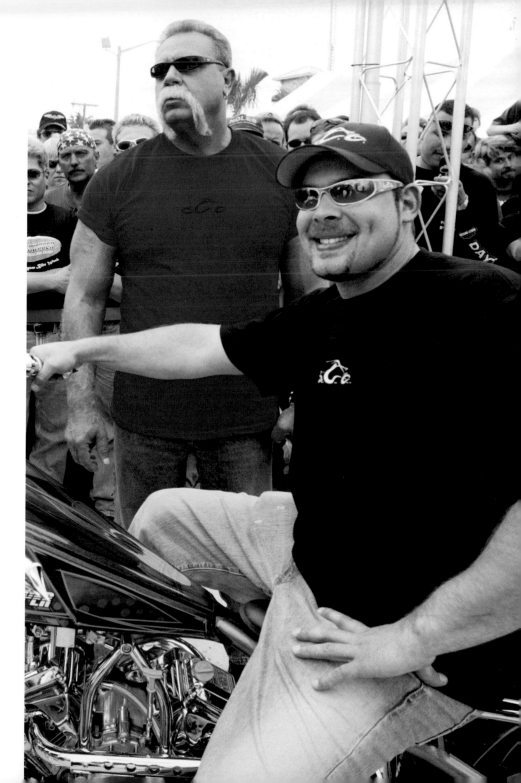

Paulie, Senior, Rick, and Vinnie apply some personal persuasion to the Dixie Chopper's stem. Mere steel can't stand up to the force of OCC muscle. The misaligned rear end suddenly lines up just fine.

FAN APPRECIATION
In Florida, where Daytona Bike Week draws tens of thousands of chopper fans, the Teutuls take time to meet with one in particular, devoted AMERICAN CHOPPER viewer Dave Galba Jr.

LIFE ON PARADE
"It's been a pretty great year for us," says Senior, riding with Paulie through the chopper-choked streets of Daytona. "We've come a long way... and had a lot of really good times."

Go Ahead, Make Their Day

Escaping New York's blanket of snow in favor of Florida's sunny skies, the OCC crew can spend their time in Daytona relaxed and proud. "Everything from the paint scheme to the parts we fabricated on the water jet—as well as the chromed-out lawn mower motor—were all things that we hadn't tried before," says Paulie, "and I think they turned out pretty awesome."

Even after riding the bike, Senior can't quite believe what they've wrought. "When that motor first fired up, I was amazed how it sounded," he raves. "I mean, we had a freaking lawn mower engine on a bike!"

As usual, Daytona is teeming with partying, gawking bike aficionados. Senior and Paulie take a break from the business and the bashes to pay a visit to one dedicated viewer: Dave Galba Jr., who never misses AMERICAN CHOPPER. His parents had contacted the Teutuls in the wild-card hope that it might actually lead to a visit.

"Immeasurable" is the way Dave Sr. describes his appreciation for the Teutuls' visit. "For them to come in here, as busy as they are, and be able to see somebody like my son... it's, just, you can't even explain it."

The Pauls seem just as happy to visit as the Daves are to receive them. "I honestly feel like we've been blessed with a lot of things," Senior says, "and for us to come down here and give back a little bit is, I think, what it's all about."

Capping off this Florida jaunt is the bike's unveiling, which takes place among a mob of tanned, enthusiastic onlookers as well as the fellows from Dixie Chopper. Their thunderous reaction says it all, as Paulie wheels his latest creation out from under the OCC tent.

"The boys at OCC are definitely artists," says Art Evans, Dixie Chopper's founder and president. "Anywhere you look on the bike, you see things that are representative of our product—from the engine to the footrests."

For Paulie, the Dixie bike represents an especially refreshing experience. "The nice part about this is it changed it up for us a little," he says. "It showed that we could do other things."

Senior is reflective, remembering how his crew got to cruise down Daytona's main drag on a fleet of their own creations. "It's been a pretty great year for us at OCC," Senior says. "We've come a long way from last year, and we've built a lot of really nice bikes and had a lot of really good times doing it.

"But," he adds thoughtfully, "I think the best is yet to come."

> **❝I think this bike's gonna be the cat's @#$!❞**
> — Paul Teutul Sr.

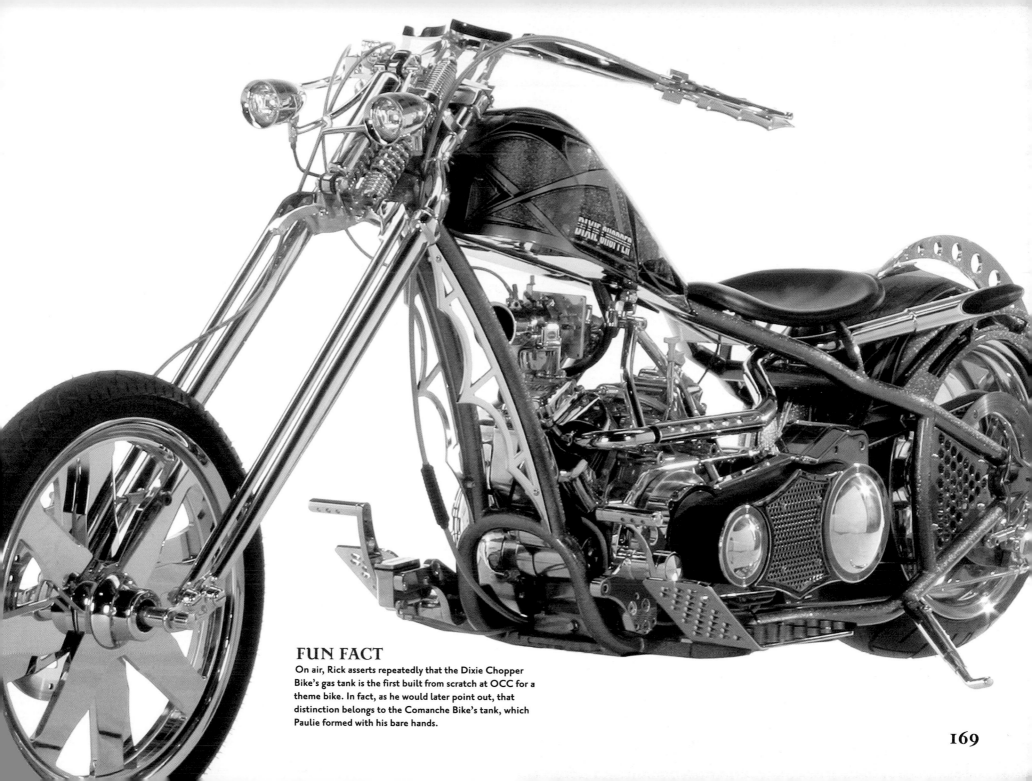

FUN FACT

On air, Rick asserts repeatedly that the Dixie Chopper Bike's gas tank is the first built from scratch at OCC for a theme bike. In fact, as he would later point out, that distinction belongs to the Comanche Bike's tank, which Paulie formed with his bare hands.

MIKEY/VINNIE BIKE

EPISODE
28&29

ORIGINAL AIRDATES

June 7^{and}
June 14, 2004

Hey, wait a second! That's not Paulie raising the garage door in the opening-credits sequence... It's Mikey! With that jolting image, CHOPPER launches a new season (its second), a new look (HDTV), and a project like no other, as the shop's biggest cut-up and ablest fix-it man join forces to create a bike they can truly call their own.

TRUTH BE TOLD, the Mikey-Vinnie bike came about out of scheduling necessity, as April 2004 found Senior and Paulie called away on other business just as production on the new season was set to begin. But, as Plan B's go, this one had plenty to recommend it.

For one thing, an accomplished gearhead like Vinnie is bound to have some arresting design ideas up his sleeve. "To build a bike with him is really kind of an honor," Mikey says, "since he knows so much about the technical aspect of things." As for Mikey's contribution... Well, predicts Vinnie, "I don't really expect a lot out of him as far as building the bike, but he's sure gonna make it fun—hopefully a lot more comedy than drama."

Uh, maybe not. To make sure things stay on track, Senior picks OCC's director of operations, Keith Quill, to be his substitute whip-cracker. "He's the closest person to myself that I could possibly find," The Boss explains. "He'll get out there and yell at people."

Uh-oh....

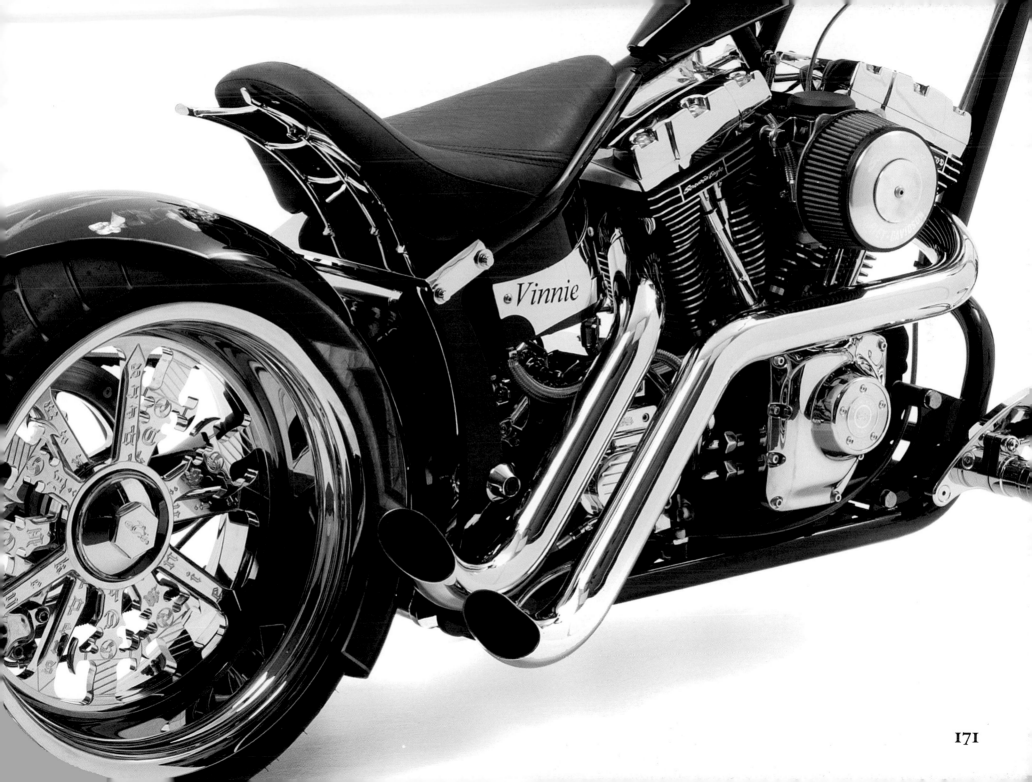

STYLE Q'S AND TECH SPECS

THEME INSPIRATION	Mikey and Vinnie	
WHEELBASE 100"	OVERALL LENGTH 120"	
ENGINE	Twin-cam Harley-Davidson	
FRONT	WHEEL 21"	REAR WHEEL 18"
	TIRE 80/90-21M	TIRE 240/40

ENGINE

In a first for OCC, Vinnie opts to use a V series twin-cam engine. "They perform very well and should have little or no vibration," predicts engine guru Joe Molloy. But that isn't special enough, so he and Vin swap out its heads, push rods, rocker arms, cams, and crankshaft. The result? A boost from 88 cubic inches to 103. The revamped engine may have 110 horsepower and, Vinnie predicts, "she's gonna run like a bear."

SUICIDE SHIFTER

This being a true biker's bike, Vinnie opts to fabricate a suicide shift… but with a twist. Usually, he notes, "You have to take your hand off the handlebar to reach down and shift. I figured you might as well use the clutch while you're at it." Which, ironically, makes using it a bit less suicidal, but way cooler looking.

MURALS

To immortalize the partnership behind this bike, an artist supplied a few sketches of the boys. One complements the "V/M" logo that Mikey created; another captures him giving Vinnie a laughably affectionate bear hug. Alas, Vinnie deems a third sketch—of Mikey squeezing his head in a vise—too comical for the bike (while hinting that it would make a nice T-shirt design).

DESIGN THEME

The Mikey-Vinnie Bike is designed to make a point—in fact, many of them. "Pointiness" defines the bike's theme. For example, Vinnie enlists Rick Petko's help with the accent piece on the gas tank, "to give it more of a protruding look." It complements the conical covers on the primary pulleys. The theme is most evident on the sharp cut of the fenders, leading Mikey to comment that they look phallic and Vin to ask what phallic means.

"You know, Vinnie might not be the sharpest knife in the drawer," Mikey remarks, "but I'll tell you what—he sure is a stickler for the details."

TRANSMISSION OFFSET

An invisible but crucial element: The bike's unusual swing arm also required a drastic adjustment in its transmission offset. For Vinnie, that meant placing a special order and hitting the books—well, one book anyway, the Harley manual. "The offset kit includes a main shaft that is exactly one inch longer than the original," he says. "Without the offset kit, the bike wouldn't go down the road."

HANDLEBARS

Vinnie utilized steel plating to fabricate the bike's very last piece. The shop's whiz-bang "flow jet" machine allows him to create a fairly sophisticated design quickly, but Vinnie considers it a rush job. "They kinda matched the theme a little bit with the points and everything," Vinnie says, while lamenting that he needed more time: "These bars are like everything else on this bike—they're almost what we had in mind."

ONE-SIDED SOFT-TAIL FRAME

The bike's most revolutionary—and coolest-looking—innovation is its one-sided soft-tail frame. But all that pizzazz required reinforcing the left side of the swing arm with two hefty supports, plus adding a metal plate on which to mount the rear fender. The unusually mounted fender, in turn, meant that Vinnie had to fabricate a special brace to support the back of the seat. Its weblike design may look familiar to some, but not Vinnie. "Paulie thinks I'm stealing it from his Black Widow Bike," he sniffs, "but he don't got nothing on there like that."